Driving across Kansas

Driving across

Kansas

A Guide to I-70

TED T. CABLE & WAYNE A. MALEY

© 2003 by the University Press of Kansas All rights reserved

Published by the University Press of Kansas (Lawrence, Kansas 66049), which was organized by the Kansas Board of Regents and is operated and funded by Emporia State University, Fort Hays State University, Kansas State University, Pittsburg State University, the University of Kansas, and Wichita State University

Library of Congress Cataloging-in-Publication Data Cable, Ted T.

Driving across Kansas : a guide to I-70 / Ted T. Cable and Wayne A. Maley.

p. cm.

Includes bibliographical references and index.

ISBN 0-7006-1260-2 (pbk.: alk. paper)

1. Kansas-Guidebooks. 2. Interstate 70-Guidebooks.

3. Kansas—History, Local. 4. Automobile travel—Kansas—Guidebooks. I. Maley, Wayne A. II. Title.

F679.3.C33 2003 917.804'34—dc21 2003005308

British Library Cataloguing in Publication Data is available.

Printed in the United States of America

10 9 8 7 6 5 4 3 2 1

The paper used in this publication meets the minimum requirements of the American National Standard for Permanence of Paper for Printed Library Materials Z39.48-1984.

Contents

Preface vii Introduction ix

WESTBOUND

Kansas City–Lawrence Area I
Topeka, the State Capital 2I
Flint Hills Region 27
Junction City–Fort Riley 44
Salina: Crossing the Center of the State 56
Smoky Hills Region 60
Hays 82
Entering the High Plains 122
Goodland 126

EASTBOUND

References 233 Index 237

Preface

The true West differs from the East in one great, pervasive, influential, and awesome way: space. . . . It's that apparent emptiness which makes matter look alone, exiled, and unconnected. Those spaces diminish man and reduce his blindness to the immensity of the universe; they push him toward a greater reliance on himself, and, at the same time, to a greater awareness of others and what they do. But, as space diminishes man and his constructions in a material fashion, it also—paradoxically—makes them more noticeable. Things show up out here. No one, not even the sojourner can escape the expanses. You can't get away from them by rolling up the safety-glass and speeding through, because the terrible distances eat up the speed. . . . Still, drivers race along; but when you get down to it, they are people uneasy about space.

-William Least Heat Moon, Blue Highways

So you are crossing Kansas on Interstate 70. Early pioneers heading west hesitated at the edge of the eastern forests, mustering courage as if the prairies were a lonely ocean or dangerous desert to be conquered. You will soon experience the vastness of the Plains and seemingly endless open spaces as you proceed across Kansas.

Some travelers still find the prospect of crossing the Plains daunting even in climate-controlled cars traveling at seventy miles per hour. To-day, as in the past, for many travelers the Plains are an obstacle to be overcome on the way to a *better* place—the Rocky Mountains, or maybe California. For eastbound travelers, the great eastern cities or Atlantic beaches beckon. Maybe hometowns with family and friends provide the ultimate goal and destination.

Least Heat Moon wrote of the Plains' "apparent emptiness" and "terrible distances that eat up speed." Ian Frazier, in his book *Great Plains*, noted that interstate highways seem designed to get people across the Plains "in the least time possible, as if this were an awkward point in a conversation."

This book's purpose is to guide travelers through the apparent empti-

ness, to interpret things that show up out here, and to break the silence in the awkward conversation. Rather than having sojourners trying to escape the expanses and being uneasy about the space, the goal is to encourage the traveler to revel in the spaciousness, to sail under spectacular skies, to perceive the beauty in subtle, understated earth-toned landscapes, to appreciate the buried treasures of rich soils and minerals, and to discover compassion and courage in the tales of others who traveled these lands. Our hope is that this book will make travel across the immense space of Kansas an enjoyable and enriching experience.

As you travel through Kansas using this guide, you will glimpse what Kansas was, and what it is today. You will be introduced to prehistoric animals, vast herds of bison and antelope, Native Americans, French and Spanish explorers, and European settlers, all of which have had an impact on the landscape and natural resources of Kansas. You will see that the Great Plains are more than they appear at first glance. These lands played an important role in the westward expansion of this country and in shaping our American heritage. These vast open spaces not only influenced our past but also continue to affect the lives of Americans from coast to coast, particularly at the dinner table. As you travel across Kansas, you may come to agree with Ian Frazier, who wrote, "The beauty of the plains is not just in themselves but in the sky, in what you think when you look at them, and in what they are not."

We wish to thank the many individuals whom we interviewed along the route of I-70. Their names appear in the references. We also offer our thanks to the many anonymous people who so generously volunteered information about a site or provided us with directions. In addition, the following individuals provided information or other assistance: Charles Anderson, Scott Bergstrom, Robin Grumm, Hank Ernst, Keith Lynch, Galen Pittman, Mike Rader, Scott Seltman, Jeff Sheets, Joan Shull, and Gene Young.

Most of all we would especially like to thank our wives, Marianne Maley and Diane Cable, who served as drivers and readers as we developed and tested this book.

Introduction

The state of Kansas was named after a tribe of Indians called Kansa or Kaw. This tribe arrived in what is now Kansas around 1720. They settled in temporary villages near the current cities of Leavenworth and Atchison. The tribe's name meant "People of the South Wind." Later, to be closer to the best bison hunting grounds, they established their principal village where the Big Blue River joins the Kansas River, near the present city of Manhattan.

From 1492 to 1845, land that became Kansas was at various times claimed by six different countries. The first European to see this land was the Spanish conquistador Francisco Vásquez de Coronado, who explored the area in search of Seven Cities of Gold in 1541. French trappers and explorers came to this land in the late 1600s and early 1700s. The United States bought the land that is now Kansas from the French in 1803 as part of the Louisiana Purchase.

Although the state's name honors the Kaw people, the first explorers to this region found it occupied by the Indians of Quivira, most likely the Wichita tribe and the Pawnee people. However, the Wichita spent most of their time in what is now Oklahoma and Texas. At the time when Spain ruled much of North and South America, Kansas was commonly called "Harahey." The people of Harahey were probably Pawnee. Native Americans played an important role in the history of Kansas and their heritage and influence will be apparent at many locations along I-70.

As you travel along I-70, you will also see the influence of the trails and rails that carried settlers, cattle, and supplies to the West. You also will see how the issue of whether Kansas would be a free state or a slave state resulted in the violent "Bleeding Kansas" period that shaped the history of eastern Kansas.

Kansas is not crowded. It ranks thirteenth among the states in size but only thirty-first in population. That leaves plenty of space for nature. Kansas is home to almost 800 kinds of vertebrates, including 141 species of fish, 32 kinds of amphibians, 14 types of turtles, 53 different

reptiles, and 87 kinds of mammals. More than 450 different bird species have been seen in Kansas. More than 2,000 kinds of plants grow wild in Kansas, including 200 types of grasses. You can see many of these plants and animals along I-70.

Traveling I-70 will be a trip through time as well as a tour across bountiful and beautiful lands. You will be traveling along an east-west transportation corridor that has existed since presettlement times. Early pioneers followed the major river systems westward from Kansas City because they provided water for people and livestock and because the river valleys were relatively flat compared with the surrounding hills. I-70 parallels such a trail—the Smoky Hill Trail, which was noteworthy as the quickest route to the Denver gold fields, discovered in 1858. In 1867, railroads expanded west and followed these routes to be close to water and wood for the ties. You will also be paralleling the Rock Island and Union Pacific railroad lines, which were built in the late 1800s.

Federal highways were built along the railroad lines to link towns that sprang up along the railroad and rivers. From Kansas City west to Oakley, I-70 follows and at some points is historic U.S. 40. From Colby to the Colorado line, I-70 follows old U.S. 24, a federal highway linking Kansas City to Denver. Completed in 1926, U.S. 40 was the nation's first federally funded coast-to-coast highway. U.S. 40's original 3,022-mile route connected Atlantic City with San Francisco. Unlike the more famous Route 66, U.S. 40 still is formally designated across the country. In the mid-1900s, interstates such as I-70 replaced many state and federal highways. In this case, beginning in 1956, some segments of U.S. 40 were transferred to I-70.

So, you will notice on your map that many highways and railroads follow routes parallel to each other, often adjacent to rivers, and see that I-70 is no exception. As you drive along, you will be following trails used by Native Americans and pioneers, rails used by early settlers, and highways used by drivers of the first automobile generation in the early 1900s. You undoubtedly will be traveling the route faster and more comfortably than any of your traveling predecessors, and hopefully enjoying it at least as much as they did. Horace Greeley, the New York newspaper man who encouraged westward travel with the exhortation to "Go west young man," said, "I like Kansas . . . better than I expected to." Like Horace, we think if you make the effort to slow down and look closely, you too will be pleasantly surprised by Kansas.

USING THIS BOOK

In this book, the I-70 mile markers are used to identify the location of features being described. Mention of a sight may not be precisely at the mile marker listed. The intent is to encourage a look ahead. Thus, east-bound and westbound references for the same feature may be at different mileposts. Moreover, because some stories are too long to tell in the short time it takes to speed by, we have cross-referenced multiple stories about the same place. To find out more information about a topic, we direct you using the mile marker number and either E or W for the eastbound or westbound texts.

Sketches in the book have been selected to serve as visual cues—aids for quickly identifying a subject visible along I-70. A photographic-quality presentation is not intended because the authors do not want readers searching to find the precise duplicate image. Rather, the authors hope that by using simple sketches travelers will efficiently locate the object and form their own visual image from their vantage point as they pass.

Miles on all interstate highways are measured from the westernmost or southernmost point in the state. At Kansas City you enter Kansas on I-70 at mile marker 423, meaning you are 423 miles from the farthest west point of the highway at the Colorado state line. Thus while you are heading west, the green mileage marker signs will be decreasing as you drive farther west and approach Colorado. For travelers driving east, the mile markers will be increasing as they indicate the number of miles you have traveled from the Colorado line. On a section of I-70 in eastern Kansas that is part of the Kansas tollway system, the green mile markers measure the distance from the Oklahoma line south of Wichita.

Driving across Kansas

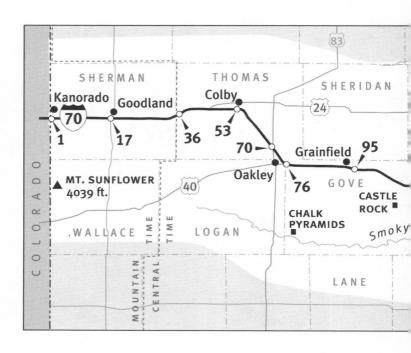

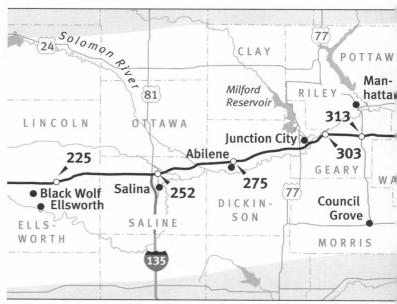

As 1-70 crosses Kansas from Kansas City to Colorado distance is posted on highway markers showing miles from the Colorado border. Where the route uses the Kansas Turnpike, distance is miles from Oklahoma.

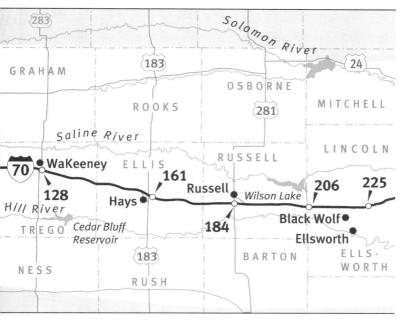

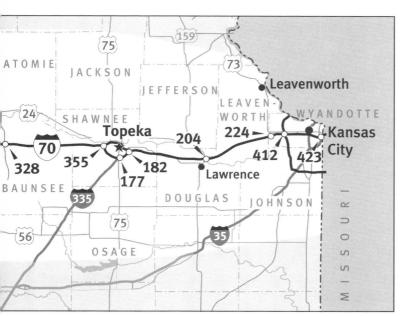

Westbound

KANSAS CITY-LAWRENCE AREA

423 Low Point of the Trip

Welcome to Kansas! This is the low point of your trip across the state. At the mouth of the Kansas River, where it joins the Missouri just to the north, the elevation is 760 feet above sea level. At its highest point, mile 3.7, Interstate 70 will have climbed to an elevation of 3,910 feet. The elevation change between here and the Colorado line is so gradual that few people perceive the difference. However, I-70 will take you over hills and drop you into valleys along the way, and you will see that, in spite of what you may have heard, Kansas is not really flat.

If you drove in from Missouri, you crossed the Kansas River near its junction with the wide Missouri River. These two rivers have played an important role in Kansas history ever since Lewis and Clark camped near here on their famous exploration in 1804 and again on their return in 1806.

422 Railroads

The importance of railroads in determining the Kansas landscape becomes evident as soon as you begin your westbound I-70 trip. The extensive rail yards you see on the left mark the termination for the rail lines that fanned out to the west and southwest. Railroads moved people across Kansas and carried Kansas resources and products. Today, building material, equipment, and supplies from industries in the East are taken across the state and beyond. Coming back from the West, trains are mostly transporting grain, that marvelous Kansas resource that is renewed every year.

Grain comes to Kansas City in gondola and hopper cars to be unloaded at a trackside elevator, one of the tall structures across the valley, where it is *elevated* by a conveyor to the top. Grain then flows by gravity into one of the round bins lined up side by side to form the structure called a grain elevator. As you travel westbound,

you will see many elevators where grain is stored in bins until it is moved to be processed into food.

The importance of the railroad cannot be overstated. For fifty years until the 1920s, when autos and paved highways finally crossed the country, every facet of life was affected by the railroad. As you will see ahead, the railroads determined which towns lived and which towns died. They stimulated commerce and brought people together.

420 Kansas City, Kansas

It is not easily identified, but you are in Kansas City, Kansas, as soon as you cross the Kansas River. This is not the biggest or most populated city in the state. It ranks second in population behind Wichita. The reason most people think this is the largest city in Kansas is that they consider the whole Kansas City metropolitan area, over half of which is in Kansas City, Missouri.

In August 1806, Lewis and Clark wrote a description of the area where the Kansas and Missouri Rivers meet—the location of Kansas City. As they saw it, the river junction provided a perfect place to construct a trading house or a fort. Although no immediate action was taken by the recipients of Lewis and Clark's news, as people passed by to go to Fort Leavenworth or to travel west up the Kansas River, they, too, reported that the area was an ideal business location. Finally, several businessmen organized the Kansas City, Kansas Town Company in 1868. By 1885 Kansas City, Kansas, was a thriving town and began to sprawl westward. Learn more about Kansas City at 412E (page 227).

418 Wyandotte County

You are traveling in Wyandotte County, named for the Wyandot Indians. After the Wyandots ceded their Ohio lands to the U.S. government, they moved to occupy land in the territory they thought the Shawnees had sold them. The Shawnees repudiated the agreement, and the Wyandots soon found themselves strangers in a strange land. They set up camp on a government-owned strip of land between the western boundary of the Missouri and Kansas Rivers, present-day Kansas City.

The Delaware tribe, distant relatives of the Wyandots who owned land on the north side of the Kansas River, came to the rescue and sold the Wyandots thirty-six square miles of land be-

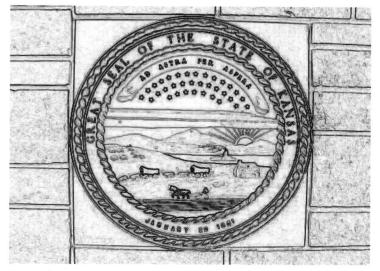

State seal

tween the fork of the two rivers so they could have a home. The Wyandots liked their new home but soon encountered several difficulties. The story of how sickness and floodwaters reduced their numbers can be read at 415E (page 228).

417 Official Kansas Welcome!

At the Travel Information Center ahead (Exit 410), you can obtain tourist information, a free cup of coffee, a friendly smile, and a warm welcome. The Kansas flag will be waving in the wind (we can almost guarantee the wind). In the center of the dark blue flag is the state seal, which paints a picture of Kansas history. The thirty-four stars represent the fact that Kansas was the thirty-fourth state admitted to the United States. The rolling hills depict those near historic Fort Riley, hills you will see later in your trip along I-70. Scenes on the seal—Native Americans hunting bison, wagon trains heading west, and steamships carrying supplies up the Kansas River—all represent important activities and eras in Kansas history. The farmer plowing fields near his cabin represents the fact that agriculture has always dominated the economy and landscape of Kansas. The state motto *Ad astra per aspera*, meaning "to the stars through difficulties," is included in the state seal. We

Grinter ferry (Kansas State Historical Society)

hope you do not experience any of these difficulties as you travel across the state. Welcome to Kansas!

415 Grinter House and Ferry

Two miles south of I-70, on Kaw Drive, lies the Grinter Place Historic Site. At this location, Moses Grinter traded with the Delaware Indians and maintained the first ferry to cross the Kansas River. For a time, it was the only ferry serving the important military road between Fort Leavenworth, along the Missouri River just to the north, and Oklahoma.

Grinter began his ferry operation in 1831. The ferry used a rope windlass to alter the angle of the hull into the current. This allowed it to be pushed across the river by waterpower rather than having to be pulled manually. Grinter charged fifty cents per person or two dollars per wagon to be taken across. Just think, that is more than the current toll for driving from Kansas City to Topeka!

Traffic increased for Mr. Grinter as more settlers began moving west. The government, at Grinter's request, set up a post office at the ferry landing. Grinter constructed a log cabin near the landing when he opened the ferry for business. However, he was a victim of the floods of 1844 and lost his ferry landing and home as a result of the high water. Grinter rebuilt the ferry, a new cabin, and his busi-

ness the following year. With no floods for the next several years and an increase in traffic, Grinter's business was again booming. As a result, he and his wife, Anne, a Delaware Indian, decided to construct a nicer home. The two-story red brick home built in 1857 is still standing today—the oldest unaltered building in Wyandotte County—and is used as a museum. Grinter is credited with being the first permanent white settler in Wyandotte County and one of the earliest settlers in the state.

411 The Kansas Speedway

The large complex seen to the right is the Kansas Motor Speedway, which has been hosting NASCAR and Indy Racing League races and other races since opening in June 2001. The state-of-the-art facility boasts that its grandstand has great views from every seat. The stands can hold more than 80,000 people, a crowd larger than the population of all but four Kansas towns. Only Wichita, Overland Park, Topeka, and Kansas City have more people than would fit into the grandstands. In fact, the entire populations of most Kansas *counties* could watch a race together and not come close to filling the grandstands. When people in their infield motor homes are counted, race attendance soars to more than 100,000 people.

As previously mentioned, this is also the location of the Kansas Travel Information Center.

At mile 410 you enter the Kansas Turnpike. The only indicator is that mile markers have changed. You are now at mile 226. The mile markers now indicate the distance along the turnpike from the Oklahoma border. When I-70 leaves the turnpike near Topeka, the numbering continues as miles from the Colorado state line. Read about the history of the turnpike at 184E (p. 217).

226 Fort Leavenworth

Fort Leavenworth and the town of Leavenworth lie about fifteen miles north of I-70 on State Highway 7. The fort was established in 1827 as a starting point for westbound explorers, settlers, and military expeditions. Since it was located on the banks of the Missouri River, supplies and men found their way there by use of keelboat and shallow water barges coming from St. Louis and the East. During the 1840s, thousands of wagons passed through the fort on

their way to California and Oregon. Read at 207E (page 224) about the history of Leavenworth, the fort, and the famous prison.

225 Agricultural Hall of Fame

At Exit 224 you may want to visit the National Agricultural Center and Hall of Fame. The Hall of Fame was chartered by Congress to honor America's farmers. Its Museum of Farming collection contains thousands of historic relics and pieces of farm equipment, as well as Harry Truman's plow. Interesting tales celebrating the achievements of farmers are told on this 172-acre site that includes an old country town, a farm pond, and a nature trail. The Rural Electric Conference Theater and outdoor exhibits schedule educational activities.

223 Leavenworth County

Just ahead you will enter Leavenworth County, established in 1855 as one of the first counties in Kansas. It was carved out of lands that belonged to the Delaware Indians and was named after Fort Leavenworth, the first fort west of the Missouri River. It is home to the famous federal prison that bears its name.

222 Beginning of Smoky Hill Trail

North of here at Fort Leavenworth is where the Smoky Hill Trail began. The Smoky Hill Trail, which follows the Smoky Hill River through western Kansas, was the quickest route to the Denver gold fields, which were discovered in 1858. The Butterfield Overland

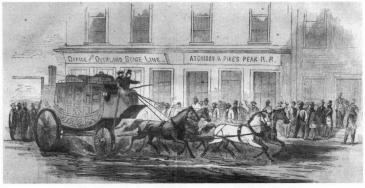

Butterfield's Overland Despatch coach leaves Atchison to follow the Smoky Hill Trail west. (Kansas State Historical Society)

Despatch (BOD) stagecoach line, owned by David Butterfield, traveled the Smoky Hill Trail to Denver from Atchison (north of here) three times a week. It took the BOD between eight and twelve days to make the trip to Denver, depending on weather conditions and delays. I-70 parallels this trail across much of Kansas; on this modern trail, you can almost travel the same route and distance in only eight hours!

Pioneers followed the major river systems westward from Kansas City because they provided water for people and livestock, and trees for fuel, and because the river valleys were relatively flat compared with the surrounding hills. Railroads, and then the early cross-country highways, followed these routes to be close to water and wood. You, too, will be following the trails used by both Native Americans and the pioneers, rails used by settlers, and early highways used by the first automobile generations as they headed west across Kansas.

221 Four Houses

Six miles south of the interstate along the Kansas River is the site of the earliest trading post and the first nineteenth-century fur depot in Kansas. The post, named Four Houses, was built by Sara and Francis Chouteau in 1822, and after the flood of 1826 destroyed the family's trading post on the Missouri River, other family members joined them here. Four Houses was located near the mouth of a small stream, now called Cedar Creek. It served as the Chouteaus' base of operations until 1828, when they moved eight miles east. No remains or relics marking this trading post have been found, but it appears on early maps.

220 Kansas Farmstead Barn

The white barn at the Tate farm ahead on the left is typical of those that served Kansas farmsteads for 100 years. The family farm needed a production center to house and care for livestock and storage for grain, so a design evolved with a high roof in the center and sheds on each side. You'll see similar barns of this type as you travel across Kansas. Many will have a silo at the end to store chopped green stalks for the cattle.

Mrs. Tate's parents built the center portion of this barn when they moved here in 1924. It has a high loft to store the hay needed to feed the horses and dairy cows. Later a wing was attached to

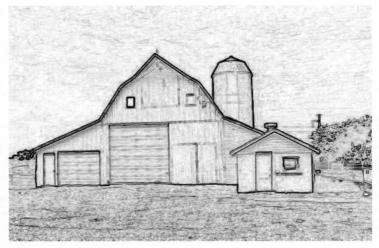

Typical Kansas barn with silo

each side. One side was enclosed to become the milking barn that accommodated the expanding dairy herd. The other side had horse stalls and some pens for calves. Other buildings were added to the farmstead—a chicken house, a storage shed, and grain bins—but the classic barn was the focus for farm production.

Writing in the 1924 Transactions of the American Society of Agricultural Engineers, E. S. Fowler explained the importance of good barns: "Farm buildings are the farmer's factory. In them raw materials are converted into finished products. Feeds grown on the farm may be compared to the raw materials in manufacturing, and the milk, butter, cheese, beef, pork, etc. to the finished products." He encouraged careful building design and construction so "that the animals housed in them will be comfortable, enjoy good health, and receive the greatest possible benefit from the feeds given them; also that the least amount of time and labor will be required in caring for them."

In the center of this general-purpose production barn, hay was stored in the high loft. Under the loft, wagons could be pulled inside to unload if a storm was approaching. In the shed attachments, work horse stalls occupied one side along with a small animal pen for baby animals. A shed on the other side was dedicated to stanchions for eight to twelve milk cows plus a feed room.

A milk house might be attached or adjacent, depending on where well water was found.

The farmstead here now serves primarily as a residence. For many years the Tate family grew corn and wheat on this farm, but today the land is leased to a neighbor for cropping.

218 Silo Collection

Just before the tollbooths you can see on the right a large group of grain storage bins. Bill Theno collects them to store grain, 100,000 bushels of grain. His primary operation has been feeding hogs, and he stores enough grain to feed 7,000 to 8,000 hogs per year. With shifting market conditions, you may be looking at a beef cattle feeding operation today. The long, horizontal buildings, 180 by 70 feet, can house 150 beef cows and calves.

The four tall blue silos are Harvestores. These glass-lined steel silos are filled from the top and have bottom unloaders so that the first grain loaded in is the first taken out. The thirteen other gray bins are connected to each other by conveyors. When grain is filled or moved, it is elevated to the top by the center column conveyor and then is diverted by gravity through one of the "spiderweb" chutes to the desired bin.

The Theno farm has grown from the 40 acres that Bill's dad owned in 1956 to 3,000 acres of crop and grassland. You will be driving along Theno acreage for several miles to the right of I-70. Fields near the highway may be planted to field corn, soybeans, or sorghum. Half of what is produced, about 135,000 bushels annually, is fed to the animals on the farm.

Besides erecting all that grain storage and housing for livestock, Bill built homes around an area where a one-room school he attended had stood. He then bought and moved eight houses from the Kansas City Raceway property and added them to the community.

216 Nature's Sanitation Crew

When animals try to cross the interstate, they often don't make it, but an animal killed in nature does not go to waste. Something will eat it and return it to the food chain. Such are the cycles of nature.

If you are traveling during the months of April through September, you undoubtedly have already noticed the large black birds soaring above the countryside with upraised wings. These amazing

birds are turkey vultures, often called "buzzards." By eating road-kills, vultures, which might be considered nature's sanitation crew, play an important ecological role in cleaning up and recycling dead animals. The turkey vulture's name reflects the fact that its bare, red head resembles the head of a turkey. The featherless head is an adaptation for the job; imagine the mess when the birds stick their heads into rotten carcasses if they had feathers on their heads. Vultures have strong hooked beaks for tearing apart the carcass; unlike hawks and eagles, however, they have weak feet because they do not need to kill their food.

Vultures are remarkable fliers. Watch them as they soar gracefully, rarely flapping their wings. They can be easily identified in flight because they soar with their wings in a V, with their wing tips above the horizontal. In contrast, eagles hold their wings flat when soaring. Vultures need the updrafts, or "thermals," to soar on, so don't expect to see flying vultures until after midmorning, when the sun has heated up the ground and atmosphere.

214 Ice Age Kansas

You are traveling in the Glaciated Region of Kansas. The land is dominated by rounded hills and broad valleys. Corn, soybeans, and hay are common crops on the productive farms. The region is bounded roughly by the Kansas River just to the south and the Blue River on the west (near Manhattan, mile 313).

This region differs from the other parts of Kansas that you will cross ahead. Twice during past geologic ages an eleven-county area in the northeastern part of the state was covered by glaciers. These massive sheets of ice moved slowly, transforming the landscape. As the glaciers advanced south from Canada, they gouged out valleys in areas containing softer rocks. Soil and rocks were carried by the ice for hundreds of miles from where they originated. When the glaciers began to melt, the debris that had been carried with them was deposited at the melting spot. The mixture of sand, rock, clay, and gravel that was left behind created a richer soil and interesting rock formations.

The elevation here averages 1,000 feet above sea level. Considerably more precipitation is received per year than in the other regions you will cross along I-70, around thirty-five inches per year. In addition, more trees grow here than in the other regions, and

they can be seen on the hilltops rather than only in the valleys as you will see ahead in the Flint Hills. The growing season is the longest in the state, averaging about 200 days. With the long growing season, adequate rainfall, and fertile soil, the area is good for agriculture.

212 Twisters

Ever since Dorothy and Toto were carried off from Kansas to the Land of Oz, Kansas has been associated with tornados. Although tornados have occurred in all fifty states, only Texas and Oklahoma have more than Kansas. However, Kansas has the distinction of having more F5 tornados (the most intense kind) than any other state because it's located where cold fronts coming down from the north meet hot, moist air from the south—ideal conditions for the formation of tornados. Almost every year between the months of April and July, tornados are seen somewhere along I-70 in Kansas.

Tornados are one of nature's most magical and menacing phenomena. They can be 2 miles across, with winds of 300 miles per hour. To see them from afar is awe-inspiring. To witness them up close is terrifying. If you see a tornado along the highway, do not try to outrun it! Experts suggest leaving your vehicle and lying flat in a roadside ditch. Seeking shelter under an overpass may protect you from severe hail, but most overpasses offer little protection from a tornado. In spite of the threat of tornados, like Dorothy, most Kansans believe there is no place like home. See mile 358E for a story of a tornado that hit Topeka.

211 Kansas Crops

The crop production you're most likely to see here in eastern Kansas is hay or grains. Alfalfa is the leading crop that is cut for hay. During the growing season, it is cut and then baled for transport to barns and feedlots. You can recognize a field of alfalfa by its rich green color and the uniform distribution of plants across the field. The small, round leaves add to the look of complete ground cover as you drive by. Alfalfa may have blue to purplish flowers.

The grain crops include corn, soybeans, sorghum, sunflowers, and small seed grains like wheat. Corn and sorghum are grass crops, with long, wide leaves on a single stalk. Corn grows eight to ten feet tall, with ears on the stalk. By contrast, sorghum starts to produce a grain head at the top when the plant is about ten inches

tall. However, some grassy sorghums grown for silage will reach a height of twelve feet. You may see rows of soybeans growing here in eastern Kansas. The plants appear rather bushy until the beans are ripe and the rounded leaves fall off, leaving a two-foot-high brown stalk with pods aligned in rows. You will see an increasing number of sunflower fields—which can be distinguished by the plants' yellow blossoms—as you continue west.

Wheat covers the entire field rather than being planted in rows. Kansas grows winter wheat that is planted in the fall. It sprouts and creates a bright green cover that becomes dormant in the winter. In the spring it grows again and brightens to a golden color for harvest in early summer.

207 Jayhawks

Looking ahead you can see red-roofed buildings of the University of Kansas, home of the Jayhawks. In 1866, a solitary building was erected overlooking the city of Lawrence on Hogback Ridge to start the University of Kansas. Hogback Ridge seemed to be an undignified name for the location of a dignified institution, and the name was soon changed to Mount Oread, in reference to Greek mythology. Mount Oread also happened to be the name of a girl's seminary in Worcester, Massachusetts, home of one of Lawrence's founding fathers. Today KU is a world-class university with more than 27,000 students. Read more about KU and its mascot, the Jayhawk, at 200E (page 222).

206 Douglas County

This county is named after Stephen A. Douglas, the Illinois senator who wrote the Kansas-Nebraska Bill that allowed the formation of Kansas and Nebraska and gave them the right to choose whether they would be free or pro-slavery. Clashes between free-state and pro-slavery forces dominated the establishment of Kansas and resulted in the state becoming known as "Bleeding Kansas." For more of the Douglas County story, see 188E (page 218).

The Astaris factory, off to the left beyond the sand quarry lake, is a chemical plant that manufactures food-grade phosphates and phosphoric acids. That's correct, phosphoric acid—the effervescence that produces the fizz in a fountain soda and in colas and other soft drinks. There's more about phosphate and the plant at 204E (page 223).

Three generations of workers employed here continue the tradition of supplying products for processing food produced on Kansas farms. The employees are proud of the wildlife habitat they have developed on plant property.

205 New Grass

Ahead on the right the Pine Family Farm produces sod that is rolled up from the fields at the right and delivered for new lawns. Bryan Pine says his most interesting delivery was made to the Kansas Motor Speedway to create the lawn areas around the grandstand and track. Sue Pine tells about the golf courses and soccer fields for which the farm has supplied new grass surfaces. From these sod production fields they can provide a home owner with one square yard of replacement lawn or make instant lawn for a major office complex. Sod is delivered to locations up to two hours away, from Kansas City to Manhattan.

The Pine family has been farming in the Kaw River valley since Will Pine moved here in 1868. The sixth generation of the family now operates the farm. They also raise the traditional crops for this area—corn, soybeans, and potatoes. The total farm operation encompasses 4,000 acres, not all in the valley. Sod growing is a recent niche opportunity. In the early 1970s the first sod was sold as a way to stretch out the harvest season and to hedge against the weathersensitive potato crop. Sod is now grown on 80 irrigated acres that

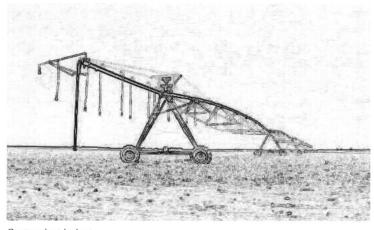

Center-pivot irrigator

can be seen from I-70. You'll see much more irrigated agriculture as you continue west (see 69W; page II2), and there is more about center-pivot irrigation machines like those you see here watering the sod.

203 The Kaw

The Kansas River, also known as the "Kaw," begins in Junction City (ahead near mile 298) at the confluence of the Republican and Smoky Hill Rivers. Its mouth is at the Missouri River in Kansas City. The Kansas River was an important means of transport for pioneers moving equipment and supplies into frontier Kansas. The river's water depth fluctuates wildly, and the many sandbars and other hazards make navigation difficult. Boat traffic declined with the development of the railroads and overland trails, and today, only canoes and small fishing boats ply the waters of the Kaw. A small hydroelectric dam downstream in Lawrence is the only one in the state.

202 Lawrence

Lawrence traces its roots back to Eli Thayer of Worcester, Massachusetts, who organized the New England Emigrant Aid Company to resist pro-slavery powers. Soon after the pioneers arrived in 1854, they adopted the name of Lawrence in honor of Amos Lawrence, a Massachusetts financier of the New England Company. Interestingly, Lawrence deplored having the Kansas town named after him. He feared that it would give the appearance of self-promotion and that it would lessen his influence for the good of the "free-state" cause. Indeed, bloody conflicts were soon sparked when pro-slavery forces from Missouri attacked Lawrence. Read details of Quantrill's raid at 198E (page 221).

200 Deer Crossing

Watch out for deer, which were eliminated from the state in the 1930s but have again become numerous. Deer have adapted to agriculture, and even city life. In fact, now many people believe we have too many deer, which annoy farmers and gardeners by eating crops. More serious problems are caused when deer try to cross highways and tragic accidents result. About 10,000 deer-car accidents occur each year in Kansas!

You can see two different kinds of deer as you drive across the state. White-tailed deer are found throughout Kansas, whereas

mule deer are found only in the western two-thirds of the state. Mule deer are generally larger and have large ears (hence the name). They have a white rump with short, black-tipped tail. White-tailed deer are more reddish, with a white tail that is especially noticeable when raised as a sign of warning or when the animals are running away from danger. Male mule deer antlers are distinguished by the Y-shaped forks, whereas white-tailed deer have a large, curving antler beam with smaller unforked tines branching off of it.

198 Lecompton: "Bald Eagle, KS"

At Exit 197 is Lecompton, founded in 1855. The town was originally named Bald Eagle for the eagles that roosted in the trees along the river. "The great metropolis of Kansas" was the founder's optimistic forecast for the town located halfway between Topeka and Lawrence on the Kansas River.

Judge Samuel Lecompte presided over the town company that surveyed the 600-acre site. The town was later named Lecompton, for the judge. For three years it fulfilled the expectations of its founders. Pro-slavery leaders made it their territorial capital, and workers began building the state capitol, as well as the governor's house. Soon Lecompton had almost 5,000 residents. However, the victory of the free-state forces in Kansas caused the booming town to go bust, and the capital was moved to Topeka. Along with the capital went the businesses of Lecompton.

During the 1850s a ferry operated to carry goods and people across the river. The ferry was a large dug-out cottonwood trunk, not unlike the crude boats still used by indigenous people in Africa and South America. *The WPA Guide to 1930s Kansas* quotes William Simmons, the ferry operator, as saying to a hesitant traveler, "Don't feel skeery, mister, for she's as dry as a Missourian's throat and as safe as the American flag."

Lecompton is where President Dwight Eisenhower's parents met and were married while attending the now-defunct Lane University. Today, Lecompton is a small farming community with 600 residents. The eagles still roost along the Kansas River during winter, and they nest at Clinton Lake just south of here. Watch for them soaring overhead, especially during winter.

196 Woodland Wildlife

Woodlands interspersed with farm fields and pastures provide ideal habitats for many kinds of wildlife. Deer and eastern turkey are especially easy to see from the interstate because they stand out in the fields. Bobcat and badger populations are increasing in the area. Red-tailed hawks are among the most conspicuous birds along I-70. Look for a white object in the trees, and it will undoubtedly be the white breast of a red-tailed hawk.

You may spot coyotes in the fields along the interstate. Coyotes are most active at night, but you may be lucky and see one during the day, especially in the morning or evening. They are rather gangly, doglike animals, usually seen trotting alone across a field. They eat almost anything—plant or animal—and this versatility is one reason their numbers are increasing in Kansas and throughout the United States. Now they can even be found in cities, howling at streetlights rather than the full moon!

195 The Oregon Trail

The ridge route that parallels I-70 for the next several miles was one route used by early traders and pioneers as they headed west. The wagon trains picked routes that minimized stream crossings and hills that had to be climbed. When highways were constructed for horseless carriages, it was natural for this route to be used. It became part of U.S. 40, the first federally funded coast-to-coast highway.

If the pioneers were headed for Oregon, they called this the Oregon Trail. Those headed to California considered it the California Trail. All who reached this point would have probably assembled their company in Independence, Missouri, the westernmost county seat town in the United States at that time. Then the trek to the northwest began, following ridges to watering stops like Big Springs just ahead.

By 1849, spurred on by California's gold rush, more than 90,000 people had headed west on Kansas wagon trails. Today the trails continue to provide a route across Kansas as the I-70 "trail." Tollway traffic records at this location count an average of more than 30,000 vehicles every day.

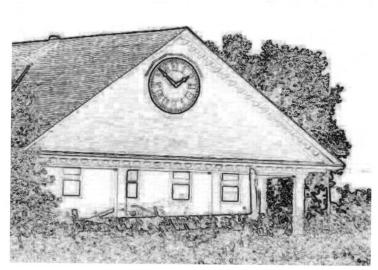

Award-winning Clock House

193 Clock House

The clock over the front porch of the house on the left was taken from a courthouse and is a recent addition to the structure. The house itself, which was selected as the National Farmhouse of the Year in 1908, was built from a kit ordered from Sears, Roebuck. Learn more about the clock and the house at 192E (page 219).

192 Numbered Signs

At the left of the interstate along the fence row, you may have noticed yellow signs with three-digit black numbers on them. These signs, which are angled so they can be seen from an airplane, are used by utility companies, especially oil and natural gas companies, to check for leaks, vegetation in need of removal, and other problems as they fly over buried pipelines or cables. Problems are reported to ground crews, which are then dispatched to make repairs. The orange signs on the white posts indicate a buried telephone communications line.

191 Big Springs

Two miles south of the interstate is the small farming community of Big Springs, the oldest settlement in Douglas County. When

William Harper and John Chamberlain established Big Springs in the fall of 1854, it was already known as an excellent watering place along the Oregon Trail. As travelers emigrated west, the town became an important trading post.

Two noteworthy events occurred in the early history of Big Springs. One of the first blows against slavery in the Kansas Territory was struck at a "free-state" convention of settlers from all over Kansas on September 5, 1855. This meeting began the attempt to seize political power from pro-slavery sympathizers in the territory. The old stone stable where the meeting was held is now the Oregon Trail Museum.

The other event was a strike against liquor. A Dr. Carter, the local physician, prescribed drugs and medicinal alcohol to the people of Big Springs. However, his operation came under scrutiny when a Missouri man delivered three barrels of whiskey to Carter's office, which the doctor used to start his own tavern. After the doctor's first night in business, thirty residents sent him a notice protesting his operation. The doctor ignored the notice and kept the tavern open. The next night forty angry residents marched into the bar, opened a barrel of whiskey, set a pile of wood shavings on fire, and burned down the tavern. After the fire, the citizens signed a temperance pledge abolishing alcohol. This is one of the first recorded temperance meetings in Kansas, and it was the beginning of a crusade that led to prohibition laws.

189 Shawnee County

In 1830, pioneers began to settle in the Shawnee County area along Mission Creek, which you will cross west of Topeka (mile 351). The county, which was not established until 1855, was named for the Shawnee Indians.

188 The Oregon Trail

Here your modern interstate trail crosses the historic Oregon Trail. The Oregon Trail continues toward the northwest, generally along ridge tops, to Topeka, where a ferry carried wagons across the Kansas River. The trail continued along the north side of the Kansas and Blue Rivers toward the Platte Valley and Fort Kearney in Nebraska Territory.

187 Roadside Gardens

Ralph Waldo Emerson said, "The earth laughs in flowers." Over the next several miles and inside the cloverleaf at the next interchange (Exit 366, just past the tollbooths), notice how during summer the land laughs in wildflowers. Some areas are not mowed frequently so that you may enjoy the beauty of this wild garden of flowers. Because a variety of flowers grow here and because their blooming periods are short and varied, it is impossible to know what will be blooming when you drive by, but some possibilities are pink prairie phlox, purple coneflower, prairie coneflower, black-eyed Susan, white and purple prairie clover, white and yellow evening primrose, chicory, gayfeather, mullein, goldenrod, milkweed, spiderwort, wild indigo, leadplant, verbena, aster, coreopsis, and, of course, sunflower.

186 Woodlawn Farm and the Toll Plaza

When the toll plaza just ahead was constructed in 2001, much of the land came from Woodlawn Farm, which you will see on the right.

Woodlawn Farm is readily recognized by the white board fences that can be identified well before the buildings come into view. Gary Gilbert, the current owner, explains that even with reduced acreage he is challenged to maintain the farm "to preserve the history of the dairy farm and keep the land in productive agriculture." You may see Hereford cattle in the pastures adjacent to the

Woodlawn Dairy Farm

interstate. Beyond the pastures and farm buildings is cropland that produces corn, soybeans, and hay for the animals. These fields contain the first soil conservation terraces in the region, built during a farm field day demonstration in the 1930s.

The barn was built in the 1920s based on plans from the magazine *Hoard's Dairyman* that encouraged a two-row arrangement of stanchions for the cows. It was argued that it would be cheaper to build and more convenient to have a wider barn than a longer one with a single-row arrangement. But then the dairymen debated whether to face the cows away from or in toward a center aisle. In this barn the cows face a center feeding alley, making it more practical to distribute silage from the silo at the end of the barn.

The Tolbert family, who operated the dairy from 1926 through 1975, went to Wisconsin and brought back a rail carload of Guernsey milk cows to get started. At first, Woodlawn sold cans of fresh milk in town. Then the family started bottling the milk and delivering it door-to-door using the slogan "From Moo to You." The Tolberts continued to upgrade the barns with coolers, a bottling room, and a pasteurizer (required by a Topeka ordinance passed after World War II).

The dairy was named after Woodlawn, Maryland, the birth-place of the first owner, John V. Abrahams. He and Tolbert had agreed to a farming arrangement in which they split profits and expenses fifty-fifty. Abrahams was responsible for materials to keep up the farm, while Tolbert supplied the labor. Cattle were owned fifty-fifty. Tolbert did the field work to produce all the feed for the cattle, and Abrahams provided the seed for planting. By 1975, milk with a high cream content was no longer in demand, and Woodlawn ceased operations.

Over the past twenty years, Gary Gilbert has meticulously restored the farm buildings here to their working condition. In 1983 he built a new home, and a tenant house has been restored. New field terraces and other erosion control measures have been installed, along with the white board fences.

At mile 183 you leave the Kansas Turnpike. Beyond the tollbooths, I-70 mileage is once again measured from the farthest west point, the Colorado state line. Thus, Woodlawn Farm is 366 miles from Colorado and 183 miles from Oklahoma.

TOPEKA, THE STATE CAPITAL

364 Topeka: A "Capital" Place to Dig Potatoes

Just ahead is Topeka, the state capital and the fourth-largest city in the state. On December 5, 1854, nine antislavery men met on the banks of the Kansas River at what is now Kansas Avenue and Crane Street and drew up plans for establishing Topeka. A ferry service had started here more than ten years earlier to take Oregon Trail wagons across the river. Colonel Cyrus K. Holliday, a Pennsylvania native who would become Topeka's first mayor and the founder of the Atchison, Topeka and Santa Fe Railroad, wanted to name the town Webster, after Daniel Webster. However, others wanted a more colorful local name. The name Topeka comes from three Indian words that have the same meaning among the Otoes, Omahas, Iowas, and Kaws. "To" means wild potato (or other edible root), "pe" means good, and "okae" means to dig. Thus, "Topeka" means "a good place to dig potatoes."

Topeka was incorporated in 1857 and became the state capital in November 1861. Railroad offices were established in Topeka, spawning growth as an important railroad town.

363 The Capitol

The green copper dome rising 286 feet above downtown Topeka is part of the Kansas state capitol. The capitol was constructed over a period of thirty-seven years, from 1866 to 1903. It was initially modeled after the Capitol in Washington, D.C., but wings were added to the rotunda section in the shape of a cross, reflecting the strong role religion played in the state.

The capitol's rotunda features a series of murals illustrating the story of Kansas by the native Kansan artist John Steuart Curry. One mural that depicts famed abolitionist John Brown is particularly impressive. Curry also painted the murals at the Wisconsin state capitol.

On top of the capitol dome is a twenty-two-foot-tall statue of a Kansa Indian warrior with his arrow aimed at the stars. The statue, called *Ad astra* (to the stars), honors Kansas's Native American heritage and is based on the state motto. Because of funding problems, it took sculptor Richard Bergen fourteen years to complete the statue after winning a contest sponsored by the Kansas Arts

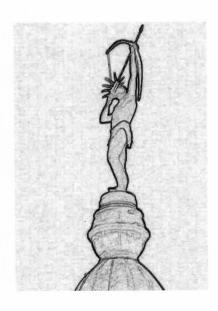

Richard Bergen's Ad astra statue stands atop the Kansas State capitol dome

Commission in 1988. The two-ton sculpture was placed on the dome on October 10, 2002, and on November 4, 2002, Indians from five tribes took part in the dedication ceremony by singing prayers and blessings for the statue.

362 Twin Spires

You will see a prominent Topeka church as you come around the elevated ninety-degree curve. The two spires adorn St. Joseph's German Catholic Church, a Romanesque-style church that was built in 1899 to serve the large German community. For many years the notably long sermons were preached in German. Travelers have commented that from a certain angle the spires of the church appear to contain the faces of owls, with the clocks forming the eyes.

361 The River of Commerce

The Kansas River has played an important role in the commercial life of Topeka as it brought people and goods to this location. Among the first Europeans and first businessmen in the Topeka area were the French-Canadian Pappan brothers, who married three Kanza Indian sisters and settled near the Kansas River. After they established a ferry over the river in 1842, wagon trains headed

along the Oregon Trail made this the regular crossing. As a result, several ferryboat services were established here.

Grain elevators along the river and railroad tracks will be familiar sights in the miles ahead. They store wheat and other grains to support the food processing industries here, and the trains allow shipment east and overseas.

Today's industries include food companies such as Frito-Lay, Hill's Pet Products, Quaker Oats, and Reser's Fine Foods' taco and tortilla bakery. Other industrial employers include Goodyear Rubber and Tire and Hallmark Cards.

359 Menninger and the Mansion

If the spire rising above the trees ahead looks familiar, it is because it is a replica of Independence Hall in Philadelphia. For many years the building here was the home of the Menninger Foundation, a world-famous center for the study of psychological disorders founded by author and psychologist Karl Menninger.

To the right of Exit 357, back on top of that hill, is Cedar Crest, the Kansas governor's mansion. The land around the stately mansion is open as a public park and includes nature trails, exercise trails, and ponds for fishing and ice skating.

The turrets at the top of the white barns on the right are ventila-

Menninger spire

tors designed with flues to supply fresh air to the dairy cows. These dairy barns are of similar construction to the Woodlawn Farms dairy barn you read about on the other side of town.

357 Kansas Museum of History

The Kansas History Center, which includes the Kansas Museum of History and the Center for Historical Research, can be reached by taking Wanamaker Road, Exit 356. You'll see the building on the right in about a mile. The museum, which is located on a branch of the Oregon Trail, offers information and artifacts from the Indian era to the present. You can view many objects related to the history found in this book. The past is told through exhibits and objects that make living in a log house or traveling in a covered wagon come to life.

Among the archives are documents that report the actions of the territorial legislature, personal logs of the territorial governors, and original reports about the vast, rich history of Kansas. A nature trail provides an opportunity to stretch your legs in a relaxing and educational setting.

355 Symbols of the State of Kansas

As you leave the capital of Kansas, you might reflect on the official state symbols. Sunflowers were chosen as the state flower in 1903 because "the open frankness of the sunflower is indicative of the fearlessness with which Kansas meets her problems and solves them." The cottonwood was named the state tree in 1937. The buffalo, more correctly called "bison," was adopted as the state animal in 1955. The western meadowlark is the state bird, the ornate box turtle is the state reptile, the state amphibian is the barred tiger salamander, and the state insect is the honeybee. See if you can locate them all during the remainder of your trip.

354 A Historic Highway

You are entering a historic stretch of highway—the very first section of the U.S. interstate system to be completed. The eight-mile stretch of I-70 from the Topeka city limits to the Wabaunsee County line was opened on November 14, 1956, less than four months after President Eisenhower signed the Interstate Highway Act of 1956. This is the beginning of the nation's interstate system, the largest public works project in world history.

The interstate system was originally designed as military highways to efficiently transport military equipment and personnel across the country and move thousands of people out of urban areas. Experiences in Europe during World War II, particularly his observations of Hitler's autobahn, had impressed upon President Eisenhower the importance of having highways to move military personnel and equipment. In fact, one of the goals of the Interstate Highway Act was to link all cities having a population greater than 50,000 to make quick evacuation possible in the event of attack. The highways were born out of the fear of nuclear war, not with family vacations in mind. President Eisenhower apparently envisioned the ultimate "rush hour," but he probably never imagined motorists dealing with daily morning and evening rush hours or today's intercity traffic. More details about this historic highway are found at 346E.

352 Kansas Forests

You can see substantial forests along the banks of Blacksmith and Mission Creeks. Only 3 percent of Kansas is forested, but those 1.5 million acres of forests are important ecologically and economically. Most of the forests are here in the eastern third of the state, with 83 percent of them adjacent to rivers or streams. These riparian forests not only harbor wildlife, including endangered species, but also protect water quality in the streams by stabilizing the banks and filtering water running off from adjacent fields.

Kansas forests produce significant commercial wood products. The state has more than fifty sawmills that harvest over 30 million board feet of timber annually. Although 85 percent of the trees cut in the state are processed at Kansas sawmills, 95 percent of the veneer logs (the highest-quality logs) are exported overseas, with the remainder shipped to mills in Missouri. Wood and lumber manufacturers employ more than 3,500 Kansans and have a combined payroll of \$93.3 million. Kansas forest products contribute more than \$208 million to the economy. Much of the walnut harvested in eastern Kansas goes into making gun stocks, establishing Kansas as a leading supplier for this industry.

About 94 percent of the forests in Kansas are on private land, mostly in tracts of less than fifty acres. Each year Kansas grows enough wood to construct about 27,000 homes, but only a third of this growth is actually harvested. A considerable amount of fire-

wood is burned in Kansas; in fact, one-fourth of all homes in the state use firewood for heating purposes. Although forests are scarce, they make an important contribution to the quality of life in Kansas. As you drive west from here, you will see fewer and fewer trees.

349 Tall Tower

The tall tower on the left belongs to KTKA-TV. It is 1,440 feet tall and supported by twenty-seven guy wires. Towers such as this take a toll on migrating birds. Between 4 and 10 million birds are killed by flying into communication towers each year. The tower warning lights, especially red ones, seem to confuse the birds on nights with low ceiling and poor visibility. Birds often circle the tower and end up hitting the guy wires. Scientists studied this tower and found that about 1,000 birds representing fifty-eight species were killed here between 1998 and 2000. The worst night was October 8, 1999, when 478 individuals of thirty-five species died. Scientists are studying the possibility that strobe lights or some combination of lights will reduce this mortality.

348 Wide Horizons

Ahead on the horizon you can see Sleeping Buffalo Mound. You will drive over this hill at mile 339, about nine miles ahead.

Speaking of seeing things on the horizon, over the next few miles you can see three smokestacks on the horizon to the right. They are part of the Jeffrey Energy Center, the largest power plant in Kansas. This plant, more than twenty miles north of I-70, can produce 2,250 megawatts of electricity. It burns relatively clean coal brought in by rail from eastern Wyoming. Thousands of acres of land and lakes around the power plant have been designated as a wildlife refuge and the Oregon Trail Nature Park.

347 Rossville and Willard

Willard was once the site of Uniontown, a trading post for the Potawatomi Indians. Following two outbreaks of cholera, Uniontown was burned and abandoned in 1859. Rossville, just across the river from Willard, was named for William Ross, who came from Wisconsin in 1855 and later served as a Potawatomi Indian agent. William's brother Edmund G. Ross became a U.S. senator in the 1860s and cast the deciding vote against convicting President

Andrew Johnson after he had been impeached by the House of Representatives.

346 Wabaunsee County

This is one of the few Kansas counties whose name was taken from a Native American tribe or chief. It was originally named Richardson County in honor of the man who introduced the Kansas-Nebraska Bill in the House of Representatives that created the territory. The name was changed to Wabaunsee in 1859.

Wabaunsee was a warrior chief of the Potawatomi tribe. He never lived in Kansas but was born in Indiana in 1760 and died there in 1845. The Potawatomi name "Wah-bahn-se" means "dawn of day" or "causer of paleness." Wabaunsee said that when he killed, an enemy would know him and call him Wae, then would turn pale and resemble the first light of day.

The first white settlers in the county were a band of outlaws known as the McDaniel Gang. Supposedly, they built a cabin near Harveyville, about twenty miles south of here near the Santa Fe Trail, where they preyed on wagon trains. The gang was said to have buried a box containing \$75,000 worth of gold under the cabin floor. Legend says that a "preacher-fisherman" came to the area, dug up the gold from beneath the ruins of the cabin, and left as mysteriously as he came.

FLINT HILLS REGION

345 The Flint Hills

You have entered the Flint Hills, the second landscape region of Kansas along I-70. The Flint Hills are characterized by flat tops and prominent valleys that in some places are 300 feet deep. It might be more accurate to call these the Flint Valleys, because erosion has cut ever more deeply over the centuries, creating these "hills" from the flat terrain. The "flint" in the name comes from the chert or flint rock that underlays the slopes.

The Flint Hills stretch north and south from Nebraska to Oklahoma across the entire width of Kansas. They create a picturesque landscape for I-70 travelers and indeed one of the most pleasant landscapes in the United States. The Flint Hills also provide un-

excelled pastureland for cattle. Prairie grasses flourish during a growing season that averages from 160 to 180 days. The region averages about twenty-eight inches of precipitation annually. You will read more about prairie grasses and the creatures that live on the prairie as you travel ahead.

344 Hudson Ranch

The abundant grasses and hilly terrain are ideal for the cattle raised on the Hudson Ranch. This ranch is more than 10,000 acres and extends for miles along the interstate. It is just one of the large ranches owned by the Hudson family in Kansas. Members of this family also owned the Hudson Oil Company. The family home is perched high on a hill to the left of the interstate at mile 343. Read more about this ranch's operation at 341E (page 209).

343 Gullies

The effects of erosion are visible in some pastures you see along I-70. The ongoing process of gullies cutting away at the dips and depressions in the pastures is a reminder of how the larger valleys have developed. When cattle remove the grass by eating and trampling it, the field becomes more susceptible to soil erosion. Banks form as water flows through depressions where plant roots had held soil in place. As cattle concentrate near water, they walk on these unstable banks, causing more soil to crumble and fall to the bottom of the gully. The next rain will then wash away this soil, and the process continues unless the banks and bottoms of these depressions are again stabilized with vegetation.

342 St. Marys

The town of St. Marys is located about twelve miles north of I-70 on what was the Oregon Trail. St. Marys was established as a Jesuit mission to the Potawatomi Indians. The mission evolved into a training school for the Indians, then later became a school for Catholic children and a Jesuit seminary. The mission closed in the 1960s, and the grounds eventually were sold to a group of traditional Catholics who still conduct masses in Latin. During the time the Jesuits ministered to the Potawatomi, the Native Americans received their allotments from a stone cabin built by the government in the 1850s. It still stands and now serves as the Pay Station Museum.

341 Sleeping Buffalo Mound

As noted several miles back, the hill ahead is referred to as Sleeping Buffalo Mound. As you go up the hill, notice the difference in vegetation on the north and south sides. Compare the area where vegetation is predominantly grass with the north side that is mostly shrubs. The rancher on the south side burns the prairie annually to promote lush grass growth for grazing. Less frequent burning on the north side has allowed undesirable shrubs and trees to invade the grassland.

During the spring you may see across the hills the prairies ablaze or blackened fields still smoldering. Or you may see hills that have become a bright "pool table green" with new growth after being burned. The lush green grass contrasts sharply with the brown vegetation in areas yet to be burned.

In 1867, a travel writer from Philadelphia witnessed the prairie fires in these Kansas Flint Hills and wrote, with at least a touch of hyperbole, "I have seen the ancient light of Vesuvius by night, as it rose and fell in marvelous glory, but it did not impress me more deeply than did the long, wild sweep of the prairie fires of the West." You, too, may witness the glory of prairie fires if you travel through the Flint Hills in spring.

339 Rest Stop

The next rest stop features modern picnic shelters, a historical marker telling about the settlement and development of this region, and a memorial to highway workers killed on the job. It also offers native wildflower plantings and a woodland trail that leads to the top of the hill and provides panoramic views of the Flint Hills.

338 Guard of the Plains

Notice the sculpture ahead, on top of the hill. Many local people believe that this work, titled *Guard of the Plains*, represents a howling coyote. From any angle, and to a viewer who has a bit of imagination, it does resemble a coyote with its head thrown back, howling skyward. However, the sculptor, James Kirby Johnson, created the piece to symbolize a windmill and honor the important role windmills played in harnessing the wind for the good of humans on the plains. You can hike the trail at the rest stop to get an up-close look at the sculpture.

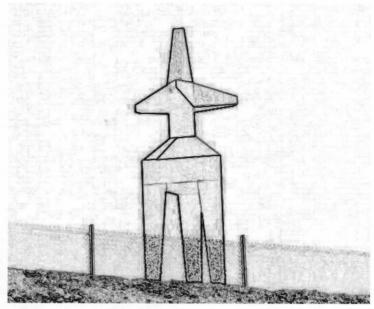

Guard of the Plains sculpture

337 Rails to Riches

To the right are the Union Pacific Railroad tracks, which veer off here but will be back alongside I-70 many times as both head west. After all, both the tracks and the highway, in their time, were built to move people, goods, and resources through this corridor across Kansas.

It's impossible to overstate the importance and lasting impact railroads have had in Kansas. Railroads determined land values and locations of towns. The steam engines' need for water determined the spacing of towns along the route. Maintenance and equipping of the railroads determined which towns would survive. In the late 1800s the railroad provided a means of transportation for people and freight traveling west. People then took stagecoaches north or south to settlements not serviced by rail. Goods would be either stored in towns along the tracks or loaded into ox-drawn wagons to continue their journey, usually no more than a couple of hours drive from a town. In trains heading back east, railroads transported

wool, hides, cattle, and ore to eastern markets. Today it is mostly grain that is shipped out to eastern states and ports.

Besides the geographic and economic impacts, railroads had a profound effect on the psyche of American society. Belching, noisy, and powerful steam engines traveling thousands of miles of tracks symbolized progress and caused Americans to view themselves for the first time as the world's technological and industrial leaders. Walt Whitman, traveling across Kansas by train in the fall of 1879, remarked that the railroad was America's furthest "advance beyond primitive barbarism." The railroad expansion in the late 1800s was met with an enthusiasm that rivaled our response to the expansion of space travel a century later.

335 Paxico

The charming town of Paxico (Exit 333 or 335) thrives on antiques. When Hollywood came to Paxico to film movies and television shows, the town's antique stores and florists supplied props and flowers. Scenes for the soap opera *Sunset Beach* were filmed here, as was the movie *Cross of Fire*, starring Patty Duke. The television miniseries *Sara Plain and Tall*, filmed in eastern Kansas, used antiques found here. Pottery made in Paxico has been featured in the magazines *Country Living, Midwest Living*, and *Country Sampler*.

Paxico got its name from a Potawatomi Indian medicine man, Pashqua. The land in this area was part of the Potawatomi Indian Reservation. In 1868 the federal government sold some of the land to the Atchison, Topeka and Santa Fe Railroad. Read at mile 332E (page 208) about the impact of the Rock Island Line after the company bought the land in 1886.

334 Wine Country

At Exit 333 north of the interstate you will see the Fields of Fair Winery, the first licensed winery in Kansas. The company's vine-yards were planted in the early 1980s, and the first wine was ready for market in the spring of 1989. The Fields of Fair continues a long tradition of growing grapes and making wine in Kansas.

The Kansa Indians were growing grapes in the area at least as early as 1794. In 1865, the community of Doniphan started vine-yards along the Missouri River and made wines to offset the loss of trade with river boaters. However, this business was cut short

when the state enacted a prohibition law in 1880. Kansas now is home to seven wineries.

333 Mill Creek

For the next two miles you will be passing through flat bottomlands surrounded by hills. This is the floodplain for one of fourteen Mill Creeks in Kansas! This name indicates that the stream provided waterpower to a grist mill. Water, diverted to flow over a power wheel, was connected to turn a grinding stone that crushed the grain to grist. A coarse grind was used for animal feed; finer grinding produced flour for home cooking. Until the mill was built, this stream had been known as Beaver Creek.

Deep, rich soil has been deposited over these creek bottomlands from thousands of years of Mill Creek flooding. Farmers take advantage of these rich bottomland soils for crop production. During the remainder of your trip west, be aware of how cultivated crops such as corn and soybeans are grown in the flat bottomlands, whereas the steeper rocky hills remain as native grasslands and are used for grazing cattle.

332 Silos

Tall silos are part of the skyline throughout cattle country. The tall, cylindrical structures at a farmstead store feed for cattle at both beef and dairy farms. They vary from 30 to 100 feet in height and from 20 to 40 feet in diameter. Two prominent types of silo construction may be seen along I-70: gray concrete silos with silver-colored aluminum dome tops, like the one here, and the deep blue steel silos popularly called by their trade name, Harvestore.

Silos are filled in late summer and fall with feed for cattle to eat during the winter and dry late summer months. Chopped grass crops are cut from fields; when packed in airtight silos, the grass cures somewhat like sauerkraut to become haylage, a delectable cattle feed.

In early fall, corn or a grain sorghum that has partially dried stalks may be chopped into fodder (a coarse feed). When placed in a silo, this fodder ensiles or cures into traditional silage. Silos may also be filled with high-moisture corn that has been harvested by combines early in the fall.

Concrete silos are unloaded from a mechanism at the top that throws the feed down a chute along the side of the silo to wagons

Concrete silo

or conveyors. The domed top covers the unloader. The first feed this type of unloader takes out is the very last that was put in. Harvestores, which have nearly flat roofs, are unloaded from the bottom, so that the first feed put in is also the first taken out.

330 Truckin' Through

Trucks must stop and check for weight distribution of their loads at a weigh station like the one at mile 330. On Kansas interstate highways the legal gross weight limit is 80,000 pounds, with no more than 20,000 pounds on a single axle or 34,000 pounds on a tandem axle. The legal limits for a truck are 8.5 feet for its width, 14 feet for height, and 65 feet for the length of a truck-trailer combination. Trailers pulled in tandem can be only 28.5 feet long each. Oversized loads must have a special permit. These rules help protect the pavement, bridges, and overpasses from damage. A five-dollar permit can be obtained to haul bales of hay during daylight hours if the load does not exceed 12 feet in width, and from May 1 to November 15 combine operators can get a permit to move equipment for ten dollars. The importance of agriculture in Kansas is reflected in these easy-to-obtain special-use permits.

329 Wamego

Exit 328 ahead leads to the town of Wamego. A Dutch windmill rises above the quaint city park. It was built on a nearby farm in 1879 by a Dutch settler so wind power could be used to grind grain.

The windmill was moved to the park, stone by stone, and reassembled in 1923. Wamego is the birthplace of Walter Chrysler of automotive manufacturing fame. Read about Wamego's historic Columbian Theater at 326E (page 206).

328 Wings over the Prairies

More than 450 kinds of birds can be seen in Kansas. If you are traveling across the Flint Hills during the summer months, you will see many interesting species that are rare in other parts of the country. Summer birds include upland sandpipers, a long-legged, long-necked pale brown bird that you might see standing alertly on fence posts or flying with quivering wings over the grass.

Another conspicuous prairie bird of summer is the nighthawk;

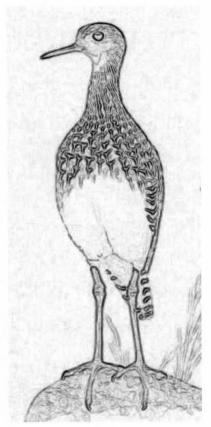

Upland sandpiper

this is not a real hawk but a member of the "goatsucker" family. The name goatsucker comes from a legend that the birds suck milk from goats at night. During the summer you will see nighthawks flying erratically, fluttering and flopping over the prairie as they catch insects in midair. Although overall the nighthawk will appear as a sleek brown bird with long, slender, pointed wings, you may notice the bold white patch near the wing tips.

Throughout the year the fences along I-70 are adorned with western meadowlarks, the state bird of Kansas and five other states. If the meadowlark is facing the road, you may see its yellow breast marked with a black V-shaped band; when it is facing away, the meadowlark appears to be a chunky brown bird. In flight the meadowlark uses rapid wing beats, then glides, and you may see the white outer tail feathers on its short, stubby tail.

326 Tree Islands in a Sea of Grass

As you drive through the Flint Hills, you may notice that there are few trees and bushes except in the draws or valleys. The area is dominated by a sea of grass, with islands of trees growing in the valleys, where they get the moisture they need. Rainfall from the surrounding hilltops collects and runs off into valleys. The depressions and valleys also provide a more protected environment for plants than on the grassy hills.

325 Grandma Hoerner's Gourmet

At the red building seen on the right at Exit 324, you can watch from a visitor's gallery to see the applesauce canning process. The big-slice apple applesauce for which Grandma Hoerner is famous goes back a century ago to when she grew up on a Kansas farm. She learned from her grandmother how to use the apples that were picked fresh from trees to make apple butter and extra-chunky applesauce. Grandma Hoerner loved to cook and became known for her mastery in the kitchen.

Now Grandma Hoerner's whole-fruit products are again available through the efforts of her grandson, who started producing them in 1987. Apples are combined with other fruits to create eight different flavors of applesauce and a dozen spreads and toppings, all available fresh from the processing line at the factory store.

Just past Exit 324, the wooden tower on the hill is a skeet tower. Read about this shooting sport at 323E (page 204).

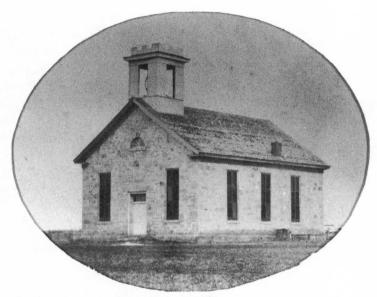

Beecher Bible and Rifle Church (Kansas State Historical Society)

324 Beecher Bible and Rifle Church

Wabaunsee Road leads north six miles from Exit 324 to the Beecher Bible and Rifle Church. The church's story began in the spring of 1856, when a group of sixty people from New Haven, Connecticut, prepared to move to Kansas to cast their votes with the free-staters. Henry Ward Beecher addressed them with an eloquent antislavery speech and promised to donate twenty-five rifles and some Bibles if the audience would provide twenty-five more. When the group left Connecticut, the rifles were packed in boxes labeled "Bibles" in an effort to smuggle them past pro-slavery settlers and into Kansas. The group set up camp at Wabaunsee. Some formed the Prairie Guard to fight against pro-slavery forces using the "Bible rifles," as explained at 324E (page 205).

323 Riley County

Just ahead you will enter Riley County. This county was established in 1855 and took its name from the military post that you will be passing in about twenty miles.

322 An OK Corral

At the crest of the hill, the fencing and structures on the right side of the interstate make up a corral. Corrals were made famous in cowboy movies and are still an important part of ranching. This is where cattle are herded together to be treated if they are sick or loaded onto trucks to be moved. The newest corrals can be identified by curving alleys and solid panels that help calm the cattle. Designs are created to direct the livestock into different pens and sort them safely and efficiently. Attention is given to providing smooth surfaces and control gates that protect animals from injury. The corrals include features that make it practical for one cowboy to manage a herd alone when necessary.

321 Growing Beef

The tallgrass prairie that remains here in the Flint Hills supports thousands of cattle. The soil is too shallow and rocky to be plowed up, and it is not adaptable for conversion to cropland as was done in Illinois, Iowa, and other prairie states. The many thousands of buffalo that originally roamed here have been replaced by cattle, but the tall grasses remain.

The region is covered with big bluestem, one of the best grasses for grazing whether the animal happens to be a buffalo or a cow; it is even more nutritious than Kentucky bluegrass. Cattle are shipped into the Flint Hills each year from Oklahoma and Texas to graze upon the rich grasses as they are grown for market. During some periods, the grass eaten by a single cow is converted into two pounds of beef per day. If you multiply that by the hundreds of thousands of head of cattle in the region, each day the Flint Hills produces many tons of hamburgers and steaks.

320 Distant Views

You might be able to make out a sign and buildings on the horizon. Those structures are six miles ahead at mile 314. That hill on the horizon is I-70's highest point as it crosses the Flint Hills region—clearly this region of Kansas is not flat!

319 St. George

North of here is the Kansas River valley. On the Kansas River east of Manhattan lies the town of St. George. The founding of St. George was accidental. In April 1855, a group of immigrants—George W.

Gillespie and family, J. George Gillespie, and George Chapman and family—headed west from St. Joseph, Missouri. The families planned to go to California to look for gold. After several hard days on the road, Mrs. Gillespie said that she had traveled far enough and refused to go any farther. The group decided to camp there on the banks of the Kansas River, and the next day they decided to homestead in Kansas Territory instead of going on to California. According to Daniel Fitzgerald in *Ghost Towns of Kansas*, because all three men in the group were named George, and acknowledging that Mr. Chapman was a saint for tolerating his bossy wife, they chose the name St. George.

318 Flint Hills Streams

North of the interstate is a stream that runs parallel to the road. You may be able to see the clear, silt-free water. The bed of this river, like that of many Flint Hill streams and rivers, is covered with limestone. Because the water drains off of grassy pastures, which hold the soil in place, rather than cultivated fields, these streams tend to run very clear.

317 Camels in Kansas

"The Great American Desert" was how, in 1820, a U.S. Army explorer referred to the area that now makes up Kansas. But it's safe to say even he wouldn't expect to see camels here, grazing as they do today in the Deep Creek valley just before Exit 316. Camels are most often seen in the valley on the left side of the interstate, but sometimes they are visible on the right.

These camels are owned by the Hudson Ranch, seen back at mile 344. The rancher brought them in to diversify his livestock operation. Camels have proved to be a profitable livestock enterprise. Because they browse on undesirable shrubs, they do not compete with cattle for food when grazing.

Typically the herd numbers about fourteen adults and eight young. Camels born here on the ranch are sold at public exotic animal auctions, which occur almost monthly in the region for much of the year. Ranchers typically get \$2,700 to \$2,800 for a thirty-day-old camel, but some animals have sold for as much as \$5,900, depending on their color and health.

Raising exotic animals as a profitable "crop" is not unusual on

Kansas ranches. Ranchers raise and sell all sorts of creatures, including bison, llamas, emus, and even mountain lions and tigers.

The camels are sometimes not visible from I-70. If you don't see them on your first trip through Kansas, don't worry; you may be able to see them on your next "desert" crossing!

315 Council Grove

The historic town of Council Grove is about thirty miles south of Exit 313 along the Santa Fe Trail. This route was used by Native Americans, fur traders, and explorers when Santa Fe was the capital of Spain's province of Nuevo Mexico.

William Becknell took the first wagons down the trail to Santa Fe in 1821, the same year that Mexico won its independence. Council Grove became an important stop along the trail. It was on the Neosho River, surrounded by abundant forests and grasslands where horses, cattle, and oxen could be fattened on lush grasses and allowed to rest and drink before heading out on the long journey to Santa Fe. Since large trees of any kind were scarce west of Council Grove, timber for replacement axles was gathered and carried on wagons headed west. Read details about Becknell's journeys and famous Council Grove settlers at 312E (page 202).

314 The Little Apple

Exit 313 north leads to Manhattan. The town calls itself "The Little Apple" to avoid confusion with the *other* Manhattan. This Manhattan was formed in 1856 when a riverboat chartered by a group known as the Cincinnati Kansas Association got stuck on a sandbar in the Kansas River. The stranded travelers were twenty miles short of their destination, the junction of the Republican and Smoky Hill Rivers (mile 300 ahead). They were welcomed by a group of New Englanders who had already settled here as part of the effort to make Kansas a free state in the battle over slavery. A clause in the Ohio Company's constitution required the new town to be named Manhattan.

Manhattan is the home of Kansas State University, with more than 20,000 students from all over the world. Radio commentator Paul Harvey called the university the "student scholar capital of America." Since 1986, KSU has been number one among the nation's 500 public universities in having students receive na-

tionally prestigious scholarships. Its students have won ninety such scholarships, compared with fifty-eight for the second-place public university. KSU's agricultural teaching and research programs are internationally recognized; its student livestock and crop judging teams have won numerous national championships and are consistently among the best in the nation; and in 2002 the university was selected as the site for the Food Safety and Security Research Center to combat bioterrorist threats on our agricultural systems. KSU's speech and debate teams have won several national championships in recent years. The College of Veterinary Science performs more rabies testing than any other lab in the world.

KSU is the home of Colbert Hills Golf Course. Developed by KSU alum and PGA golfer Jim Colbert, it successfully integrates nature conservation with economic development and university education. In 2002 it was one of only six golf courses in the world that met requirements to be designated an Audubon International Silver Signature Sanctuary.

312 Sea Bottom

On both sides of I-70 you continue to see limestone layers exposed during construction of the highway. Cutting into the hills to level out some of the ups and downs of the terrain has revealed rocky limestone layers.

Limestone is a sedimentary rock, composed of sediments that settle to the bottom of bodies of water. The layers here are mostly remains of sea animals such as mollusks and corals that died and fell to the bottom of an ancient sea that covered this part of North America. At the top of the cuts you also will see that the soil is very shallow. It is no wonder that these prairies have never been converted to cropland.

311 Konza Prairie

The Konza Prairie is located on the right side of the interstate. Scientists from Kansas State University and around the world come here to conduct studies on this 8,616-acre ecological research site.

The name Konza comes from one of the more than 100 variations of the name of the Kansa Indian tribe; this is also the source of the name Kansas. Much of this land was a ranch owned by Chicagoan John Dewey, who acquired wealth by buying up real

estate after the Great Chicago Fire. Between 1971 and 1979 tracts were purchased by The Nature Conservancy, a national organization dedicated to preserving important natural areas. They lease the land to Kansas State University.

The Konza Prairie is part of the tallgrass prairie that once extended from Texas to Canada and from the Dakotas through Iowa to Illinois and Indiana. Enormous herds of grazing animals such as bison, elk, and pronghorn antelope were an important part of the vast tallgrass ecosystem before European settlement. Today cattle have replaced these native grazers.

About eighteen species of native grasses grow here. Typical grasses are big bluestem, switchgrass, Indiangrass, and prairie cordgrass. Several types reach more than six feet tall, and two species, prairie cordgrass and Indiangrass, have been known to grow eight feet tall. About 200 kinds of birds have been seen on the Konza. Bison have been reintroduced and live alongside almost 50 other kinds of mammals, 8 kinds of lizards, and 4 kinds of snakes!

The prairie ecosystem involves complicated interactions between plants, animals, soil, climate, and fire. If any of these things change, the entire prairie system changes. Kansas State University scientists study the plants and animals that live here, as well as the effects of cattle and bison grazing, prairie fires, and watershed pollution on the prairie ecosystem. Even the National Aeronautics and Space Administration has been involved in research here. NASA scientists take satellite readings to monitor radiation and reflection of energy from the earth, as well as to observe vegetative growth and moisture conditions. Visitors can hike nature trails to experience the prairie firsthand (Exit 307).

308 Prairie Chickens

Prairie chickens thrive here in the Kansas Flint Hills prairie. The destruction of prairies throughout the United States eliminated prairie chickens from most of their former range. In fact, one type of prairie chicken, the heath hen, is now extinct.

Prairie chickens were an important food for Native Americans and especially for the settlers who came along later, who had fewer options and less knowledge about eating off the land. Kansas hunters still hunt prairie chickens for their meat, which William A. Quayle described as tasting "as wild as its prairie flight. Its tang is

Prairie chicken

caught from the wayward prairies, a wild flavor as strange as bison flesh, the prairies become sapid."

People who spend time on the prairies receive benefits from prairie chickens beyond their culinary value. Prairie chickens add animation and sound to the prairie landscape. Along I-70 you may see these fast-flying brown birds as they zoom across the landscape like feathered cannonballs shot low across the fields. During the spring, groups of males perform amazing dances—jumping up and down, stomping their feet, spinning around, and inflating bright yellow sacks on the sides of their necks—all to attract a female mate. While dancing they make unearthly hoots and "booms," some of which resemble the sound made by blowing across the top of a soda bottle. One or more females typically stand off to the side of the lek, or booming ground (the avian equivalent of a dance floor) and watch the males perform, seemingly unimpressed and aloof—all in all, not much different from what happens with humans in bars and dance halls across the country.

People come from all over the world to see and photograph this incredible creature from blinds set up on booming grounds. Kansans are indeed fortunate to share the grasslands with these extraordinary birds.

305 Hawks

As you drive along, you will see large hawks sitting on fences or trees near the highway. Most will be red-tailed hawks, which are common year-round wherever there are trees. Red-tails are attracted to the interstate because the grassy medians and right-of-ways provide ideal habitat for their favorite food—mice and other

small mammals. Although some people call them "chicken hawks," they do not bother chickens. In fact, red-tailed hawks are valuable to farmers because they eat rodents that otherwise would eat the farmer's grain. Look for a mostly white breast and short, fanshaped tail, which may be brown or rusty-red depending on the age of the bird.

Between April and September you may also see Swainson's hawks, particularly as you go farther west. These hawks have a dark upper breast, like a bib, and a distinct dark and light pattern under the wings when they soar. Sometimes they migrate in huge flocks from their winter grounds in Argentina, and you may see them following tractors to eat the rodents and insects stirred up in the fields. In the winter, while the Swainson's hawks are in South America, rough-legged hawks come down from the Arctic. They have varying degrees of black and white, with some forms being almost all black. Usually you can see a wide black band across the belly, and when they are flying you might notice the black patches on the underside of the wing where it bends. Their tails are usually whitish, with a large black band. You may see these rough-legs hovering—beating their wings rapidly in place—as they look for prey on the ground below.

303 Marshall Field

Over the next hill are the runways at Fort Riley's Marshall Airfield. Many vehicles and helicopters stored here were used in the Persian Gulf War. The vehicles were painted tan, rather than the usual army green, to blend in with the desert sands. Soldiers from Fort Riley advanced across the desert and were bearing down on Baghdad when the war ended. The fort museum has artifacts from Desert Storm. Hap Arnold, the first commander of the U.S. Air Force, got his start in aviation by flying biplanes from this field in 1912.

At Exit 301 a small park called Freedom Park has cannons on display. A trail leads up to the ridge (on the left), where you can see one of only three atomic cannons in the world. This cannon, visible on the hilltop, was designed during the cold war to shoot a nuclear warhead. It could hit a target more than twenty miles away.

302 First Capitol

Exit 301 also takes you to the first territorial capital of Kansas. Work began on the capitol building in the spring of 1855. The legislature

convened on July 2 as planned in spite of the shortcomings of the hastily built structure. Just days later, legislators passed a bill transferring the seat of government from this location to Shawnee Mission, near Kansas City, to be closer to their homes. The governor vetoed the bill, but his veto was overridden. Read about Pawnee's five hectic days as the capital of Kansas at 298E (page 198).

301 Fort Riley

Built in 1853, Fort Riley encompasses 157 square miles. Its name honors Major General Bennett C. Riley, who led the first military escort along the Santa Fe Trail in 1827. Soldiers from Fort Riley provided protection for travelers on the Santa Fe and Oregon Trails, as well as for railroad builders and passengers. They also "policed" the territory during clashes between pro-slavery and antislavery factions.

Fort Riley's cavalry school, which trained horse soldiers until 1950, was the only one in the United States. You can visit the Cavalry Museum on the base to see the progression of equipment and uniforms of our cavalry through time, original artworks of Frederick Remington, and memorabilia from military heroes. Military leaders who have served at Fort Riley include George Custer, Philip Sherman, Jeb Stuart, Robert E. Lee, and George Patton. Read more about Fort Riley at 295E (page 197).

JUNCTION CITY-FORT RILEY

300 Head of the Kaw

Just ahead, the interstate crosses the Smoky Hill River. At this point the river has flowed all the way from Colorado through valleys you will see to the left of I-70 as you drive west. About two miles to the right it joins the Republican River. Together they form the Kansas River, which you have followed from its mouth in Kansas City to its source here.

The explorer Captain John C. Fremont camped near this spot on a trip west in 1843. "The Pathfinder," as Fremont was called, reported great numbers of elk, antelope, and friendly Indians here. Elk are once again roaming the area. A herd has been reestablished at Fort Riley.

Several attempts were made to create a town where the Republican and Smoky Hill Rivers join. In 1855, settlers tried to reach this spot by steamboat traveling up the Kansas River, but as mentioned back at the description of Manhattan, they got stuck and decided they had traveled far enough. Another failed attempt to create a town was made by Captain Millard, a steamboat captain on the Kansas River. Junction City was finally established in 1858. Today, looking at the shallow, silty, sandbar-strewn river, it is hard to imagine that steamboats would even attempt the trip from Kansas City. Early residents here called the area the "Garden of Eden" because the Smoky Hill, Saline, Solomon, and Republican Rivers all come together near here, and the area matched the description of the garden in the Book of Genesis.

Junction City is the county seat of Geary County, which originally was named Davis County after Jefferson Davis, secretary of war from 1853 to 1857. During the Civil War, residents of Davis County became outraged that while Kansas men were fighting and dying for the North, their county was named after the Confederate president. Twice during the war, legislators tried to get the county name changed but failed. In 1889, long after the war was over, the legislature finally changed the county's name to honor Kansas's third territorial governor, John W. Geary. Geary went on to be mayor of San Francisco, where the famous Geary Street is also named for him.

297 Kansas's Largest Lake

Exit 295 will lead you north to Milford Lake, where you'll find more than 16,000 acres of water surface and 163 miles of shoreline for recreation. The lake was created by damming the Republican River. The primary purpose of the dam is to control flooding downstream on the Republican and Kansas Rivers. Although Kansas is not often thought of as a water recreation state, about twenty-five large reservoirs and dozens of smaller lakes make it one of the top states for sailing, waterskiing, fishing, and other water-based activities.

Below the dam are an interesting nature center and a modern fish hatchery operated by the Kansas Department of Wildlife and Parks. These facilities are open to the public and offer nature trails, exhibits, and educational tours.

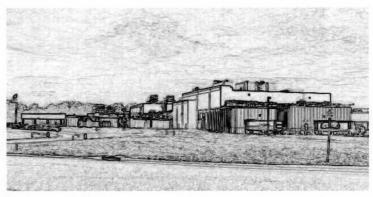

Sausage factory

296 Sausage Factory

The Armour Swift–Eckrich (AS-E) factory, visible on the right, produces smoked sausage products. A groundbreaking ceremony in December 1995 launched this 183,000-square-foot facility that employs about 400 people. This site was selected after an extensive search, which evaluated locations in more than 1,300 counties across the Midwest. Key factors in selecting Junction City included the local population's strong work ethic and the availability of capable workers.

The three names of AS-E have long been associated with the meat industry. The Armour company began packing hogs in Chicago in 1867. Gus Swift became a cattle dealer in 1872 and soon formed a partnership to sell dressed meat; he moved from Massachusetts to Chicago in 1875. Peter Eckrich opened a meat market in Fort Wayne, Indiana, in 1894. Today Armour Swift–Eckrich is an independent operating company of ConAgra. It is a leading manufacturer of prepared meat products such as smoked sausage, brown-and-serve sausage, dry and semidry sausage, salami, pepperoni, hot dogs, cold cuts, ham, bacon, and deli products for retail and food service markets.

294 Rest Area

A historical marker introduces the Abilene area located just ahead.

292 Redcedars

The evergreen trees you see along the highway and scattered in the grasslands are eastern redcedar, the same trees that are used in

western Kansas windbreaks because of their heat and drought tolerance and because their dense foliage blocks the wind and snow. Redcedars are not really cedars but instead a member of the juniper family. They grow in open and sunny places, often encroaching into grasslands unless they are burned. Although ranchers do not like them because they compete with the grass, redcedars have many positive attributes. Because of its color, fragrance, and presumed ability to repel moths, redcedar wood is used for chests, wardrobes, and closet linings. Cedarwood oil is used for making many other fragrances. Woodenware and many of the wooden novelties sold at tourist attractions are made from redcedar. At one time most wooden pencils also were made from redcedar, and the tree was known as "pencil cedar," but now only about 10 percent of pencils are made from this tree. Redcedars are in the top five trees used for Christmas trees.

Redcedars benefit wildlife by providing year-round shelter from enemies and the elements. Birds use them for nest sites, and the trees' berries are eaten by many kinds of birds, as well as raccoons, skunks, foxes, rabbits, and other mammals. Although most redcedars in Kansas eventually fall victim to fire or cutting, one tree on an undisturbed rocky bluff in Missouri has been estimated to be well over 1,000 years old!

290 Dickinson County

This county was created by an act of the Kansas territorial legislature and signed into law by Governor John W. Geary on February 20, 1857. It was named after Daniel S. Dickinson, a U.S. senator from New York, who introduced legislation that helped create the Kansas Territory.

288 Icy Roads

Just before the overpass on the right is a remote-sensing weather station. A small solar panel powers batteries that run the devices. The Kansas Department of Transportation monitors road and weather conditions from this location. Gauges read wind speed, air temperature, and precipitation. Sensors buried in the concrete report road conditions. Data from this location are transmitted to a central office in Topeka. It is particularly useful to obtain the temperature of the road surface and learn when icing or snow conditions may be developing. Information from this

Weather station

weather station is helpful in determining when to call out snowplows and salt trucks.

287 Chapman

Chapman, located on the north bank of the Smoky Hill River, was called "Little Ireland" because it was settled by Irish immigrants in the 1880s. Chapman is home to the first county high school in the United States.

One of our nation's premier pilots and astronauts is from Chapman. Joe Engle has spent more than 10,000 hours aloft, while piloting more than 130 types of aircraft. His test flight on the X-15 to a height of 280,000 feet made him the youngest U.S. Air Force officer to wear astronaut wings. He was part of the support crew for *Apollo 10* and the backup lunar module pilot for *Apollo 14*. In 1981 he was the commander of the second flight of the space shuttle *Columbia*. Astronaut Engle maintains close ties with family and friends in Chapman.

285 Serious Skies

As noted back at the weather station, weather can affect Kansas travel, especially in winter. Kansas playwright William Inge noted that people on the prairie are "more dependent upon and influenced by the sky and its constant maneuverings than in other re-

gions. Men here look at the sky each morning as soon as they get out of bed, to see what kind of a day is indicated. Life and prosperity depend upon the sky, which can destroy a season's crops in a few hours, by hail or blizzards or tornados or a relentless burning sun that can desiccate the land like an Old Testament curse." As you travel across Kansas, you, too, need to be aware of the sky. Regardless of the season, if skies look threatening, listen for weather reports. Nature can express her majesty and power not only in ways that can destroy crops but also in ways that can take their deadly toll on travelers.

283 Enterprise

Enterprising settlers founded the town of Enterprise in 1873 along the south bank of the Smoky Hill River about two miles south of here. The town quickly became a milling center for locally grown wheat. By the 1880s several flour mills had been established there.

In the early 1900s, famed ax-wielding prohibitionist Carrie Nation came to town and demolished a saloon with her famous ax. She had some women supporters, but according to an account in *The WPA Guide to 1930s Kansas*, her female opponents thought her behavior was "unladylike" and, in true ladylike fashion, ran her out of town under a barrage of rotten eggs.

282 Four Seasons Trail Riders

The I-70 trail brings a different type of traveler than those who first rode trails west through Kansas. A truly four-season traveler will pull off the trail and set up for the night at the Four Seasons RV Acres, a campground that has a fishing pond and miniature golf for relaxing after a hard day "on the trail," as well as a convenience store and service and parts departments. A Conestoga-like shelter adds to the contrast between the wagon train traveler and those "roughing it" today. Imagine how far we have come from having to carefully ration supplies or being stuck because of a broken wagon axle with no tree in sight.

Like a camp for the cow herders you'll read about ahead, this campground is sometimes home to construction workers passing through the area. They ride out to their construction sites each morning, and like cowboys at the end of the trail, when their job is finished, they move on.

281 Power Highways

Along I-70 we have crossed trails used by Native Americans and settlers, railroads that carry farm products to market, and roads for trucks and cars. Other "trails" transport electricity.

Power lines that will cross the interstate at miles 280 and 276 are constructed to carry different amounts of electricity. One determination of the amount of power is voltage, or pressure that moves current through the lines. To move electricity through your home takes 115 or 230 volts. About 6,900 volts are used to move power through lines along the city streets or out to the farms. To send power between eastern and western Kansas, much bigger lines are required. The electric line here can carry 345,000 volts. It brings electricity from the Jeffrey Energy Center (see 320E; page 204) to Salina and then continues south to Hutchinson.

You can tell the line carries high voltage because the cables are spaced far apart and long insulators are used to attach the cables to the tower frames. Those insulators are a string of ceramic bells hooked together to assure that the high voltage will not cause the

Electric power lines

current to jump across. In your home wiring, this can be accomplished with a layer of insulating tape. As the voltage increases, it requires a greater and greater separation. So when you see an electric line, notice how long the insulators suspending the cables are; the longer they are, the higher the voltage. Along with longer, heavier insulators it takes bigger cables to carry more power. This heavier construction creates more wind resistance and thus demands more rugged and better-braced towers to support the lines.

279 Historic Abilene

Approaching Abilene you will see a grain elevator rising 143 feet to signal the city ahead. There are seventy-two bins here that store wheat for processing to produce bulgur. Read at 273E (page 192) about the importance of bulgur wheat for emergency food.

Abilene was founded by Timothy F. Hersey in 1858. Mrs. Hersey chose the name by allowing her Bible to fall open and picking a name from that page. Her Bible opened to the third chapter of the Book of Luke, which includes the name Abilene in the first verse. Appropriately enough, Abilene means "city of the plains."

Abilene was one of the first cattle boom towns, receiving herds of longhorn cattle driven up the Chisholm Trail from Texas. James Butler "Wild Bill" Hickok made a brief appearance as the town marshal in the early days of Abilene.

Abilene was also the boyhood home of General Dwight D. Eisenhower, president of the United States from 1953 to 1961. His presidential library, the Eisenhower Museum, and Ike's boyhood home are all open to the public. President Eisenhower, his wife, Mamie, and one son are buried in a chapel on the museum grounds.

Abilene is known as the greyhound capital of the world (dogs, not buses!). The Greyhound Association Headquarters and Greyhound Hall of Fame are located here, and many kennels for the sleek racing dogs can be found in the area (see 86E; page 152). The Hall of Fame bills itself as "offering a tribute to Man's Best and Fastest Friend." The museum honors racing dogs (some clocked at forty-five miles per hour) and offers stories about the 4,000-year history of greyhounds and greyhound racing.

The Museum of Independent Telephony, a museum of unique telephones, also is in Abilene. It has on display a silver-dollar pay phone, candlestick phones, a little pink Princess, and even a

Brookville Hotel

"mother-in-law" phone. You can be a "Hello Girl" at the manual switchboard and touch many pieces of telecommunications gear. Abilene was home to the founder of the independent Brown Telephone Company of Abilene, which later became Sprint.

The story of C. W. Parker, who became known as the "Amusement King," began in Abilene in the 1880s when he built a shooting gallery. He went on to build his first carousels in Abilene, along with all kinds of carnival and amusement devices. You can ride one of his early carousels operated by its original steam engine at the Dickinson County Historical Society Museum. It is a track-operated machine with twenty-four horses mounted on a rocking mechanism instead of on a pole as in later designs. Parker horses have become highly collectible and valuable.

At Exit 275 on the right, the historic Brookville Hotel is recreated. It is open evenings for the famous chicken dinners described at mile 240 ahead.

274 Chocolate Factory

You can see the Russell Stover candy factory ahead on the left. Russell Stover was born in a sod house in western Kansas in 1888. His wife, Clara Stover, started making candy in Denver in 1923 in a small bungalow. By the end of the first year, five stores selling "Mrs. Stover's Bungalow Candies" had opened in Denver, and in 1924 Mrs. Stover opened stores in Omaha, Lincoln, Kansas City, and St.

Louis. In 1945 the name was changed to Russell Stover. Clara Stover died in 1975 at the age of ninety-three. Today, Russell Stover, Inc., is the world's largest producer of hand-dipped chocolate. At this plant, employees working around the clock in three shifts make and package 125,000 pounds of candy each day! Mostly these are boxes of assorted chocolates, pecan delight, or creamy cordials. Exit at 272 to take a tour and see the candy being made. Free samples are offered!

273 End of the Chisholm Trail

Read about rail shipment of Texas cattle from Abilene to Chicago, about Abilene's reputation as the wildest town in the West, and about the town's famous sheriff, Wild Bill Hickok, at 275E (page 193).

270 Sand Dunes

You may have noticed over the last several miles that the landscape here is sculptured differently from the land you have been seeing. Those are sand dunes under the blanket of grass. These dunes formed over many thousands of years as sand blew up from the Smoky Hill River valley. The coarse sand particles piled up, leaving these uneven surfaces on which grass took root.

As you would expect in this open country, the wind moves a lot of soil. Soils are classified by textures that range from very fine clay to loam to coarse sand. The finer soils are deposited in more rolling patterns than sand. The general region is loess plains. Loess (rhymes with "fuss") soil is a loamy, windblown deposit that leaves a productive topsoil. Soil texture plays a significant role in the soil's ability to hold water and support plant growth.

269 Solomon

The next exit (Exit 266) takes you to the town of Solomon, which sits along the Solomon River and was named after it in 1894. Solomon had large salt deposits, and by the 1870s salt producers were producing about 10,000 barrels a year.

268 Hedgerows

Exactly to the right of marker 267 is a hedgerow. To the right and throughout this area you will see fields bordered by hedgerows—a single row of rather short, rounded trees. The trees are Osage

orange, often called "hedge" or "hedge apple." Before the days of barbed wire fences, hedgerows were planted to serve as natural fences. Osage orange is a dense, bushy tree with thorns on the branches. When planted close together, these trees make an impenetrable fence touted as being "horse-high, bull-strong, and pig-tight." Although native only to Texas, hedgerows were already a common sight as far away as New England even before the Civil War.

The wood of the Osage orange is so hard and strong that it was used to make wagon wheels. Now it is used to make fence posts, cross ties, and archery bows. The "hedge apple" or "hedgeball" is a nonedible, softball-sized yellow-green fruit that is lumpy and contains a sticky, milky juice. Hedgeballs are sold at farmer's markets to people who believe they repel insects and spiders from homes and other buildings.

266 Solomon River

Ahead along the Solomon River the rest area provides a modern oasis in a setting like those the wagon trains must have searched out as they headed west. It would have had trees for firewood and wagon repairs, and grassy areas to feed the animals. A historical marker at the rest area introduces the story of wheat in Kansas.

You cross the Solomon River near mile 264. Explorers witnessed this stream being drunk dry by an enormous herd of buffalo. The river flows into the Smoky Hill River two miles south of the bridge.

The Solomon River was not named for the Old Testament biblical king; rather, French fur trappers called it "Salmon," for a leader of the Louisiana Territory. Explorer Zebulon Pike crossed this river in 1806 on his way to what is now Pikes Peak and modified the name to Solomon's Fork.

264 Saline County—Salt Water in Kansas

The first European to visit the Saline County area was Coronado, the Spanish explorer. In 1541 he led the expedition searching for the Seven Cities of Gold, but instead he must have found salty water. When explorer Zebulon Pike camped near here in 1806, he tasted the stream water. It was salty or "saline." He reported to the government that the region was "The Saline River Country." Hence the name Saline County was adopted when the county was organized in 1859.

263 Winter Wheat

You are in the area where winter wheat was first planted in Kansas. T. C. Henry, mayor of Abilene in 1870, secretly planted a five-acre patch of winter wheat. He proved that if seeds were planted in the fall, the young plants would be protected by winter snows and would then produce grain for harvest before the hot, dry summer scorched the plants. He unveiled his success in 1871 and transformed the high, dry plains of western Kansas into the nation's breadbasket.

262 Iron Mound

To the left of the interstate, in the far distance, you can see Iron Mound, which has an elevation of 1,497 feet. Iron Mound is a clay and gravel hill capped with Dakota sandstone. The mound is the result of erosion caused by heavy rains. Because the sandstone is less prone to erosion, the mound area has remained while the surrounding soil eroded.

261 New Cambria

New Cambria is located at Exit 261. S. P. Donmyer, a settler born in Cambria County, Pennsylvania, founded this town in 1872. The name honors his Pennsylvania birthplace and his Welsh heritage.

260 Alfalfa

Alfalfa was first introduced to Kansas here in Saline County. *The WPA Guide* explains how Dr. E. R. Switzer planted alfalfa seed here in 1874. That year a grasshopper plague and drought seemed to destroy the new crop, but September rains brought it back to life. Switzer thought that the crop would be just the thing for a place like Kansas.

Alfalfa is important for its ability to restore nitrogen to the soil as well as its ability to grow back every year even after a cold winter. You'll see the purple to bluish blossoms on alfalfa fields in the spring. Throughout the summer and fall there will be fields where the crop is being cut, dried, and baled. It grows back after cutting and can be cut again. Depending on the amount of rain, farmers can take three or four cuttings of alfalfa from a single field each year. There's more about this important Kansas crop at 261E (page 189).

258 Motherly Love

Mary Ann "Mother" Bickerdyke, the famous Civil War field nurse, lived in Saline County. Many Civil War veterans settled in Kansas. In fact, Kansas had more Grand Army of the Republic members per capita than any other state, leading it to be called "the Soldier State." Mother Bickerdyke alone was responsible for bringing over 300 families into Saline County after the Civil War. She provided care for veterans and their families during Kansas's days as the Soldier State. Forty-six Kansas counties are named for Civil War soldiers, most of whom died in battle.

SALINA: CROSSING THE CENTER OF THE STATE

257 Salina

Ahead you see the buildings of Salina. Salina was founded by William Phillips, a lawyer and writer for the *New York Tribune* who wrote articles about the slavery issue in Kansas. He was a colonel in the Civil War and later became a Kansas congressman. In 1858, Phillips and several other men established the town site of Salina near the confluence of the Saline and Smoky Hill Rivers. One of the men, A. C. Spillman, is given credit for picking the name. The name was first pronounced "Sa lē na," but because the group feared the name would suggest salty stock water, they changed the pronunciation to "Sa lī na."

The Union Pacific Railroad tracks extended to Salina in 1867. J. G. McCoy, a livestock dealer from Illinois, visited Salina and proposed that it be the end of the Chisholm Trail. Fearing the violence and vices of a cowtown, the people rejected McCoy's offer. Abilene gained the distinction of being the end of the Chisholm Trail and became the cowtown that Salina feared and rejected.

Native Americans believed Salina was safe from tornados because it was at the confluence of two rivers. This is just one of many Indian legends about tornados. As Kansas towns go, Salina has been relatively fortunate in not being in the path of killer tornados.

255 Bottomlands and Uplands

As you drive along the Saline River just ahead, you will again notice how the flat bottomlands are planted in wheat, whereas the

hilly uplands are covered with grass (as also seen at mile 333). Besides the obvious difference in terrain, the bottomlands have deep, rich soil from the silt deposited when the river floods. This soil yields good crops. The hills have relatively poor, shallow soils not suited for cropland, and so the protective blanket of native grasses still exists and is used for grazing cattle.

254 Aviators

Several famous people related to aviation have come from the Salina area. These include Glen Martin, who in 1908 flew the first aircraft flight that took off under its own power, and who also invented the first parachute and the first bomber and founded Martin Aircraft in California; Tom Braniff, the founder of the now defunct Braniff Airlines; and Steve Hawley, a NASA astronaut who flew on the maiden voyage of the space shuttle *Discovery*.

253 Blue Beacon

The very first Blue Beacon truck wash is on the right. The concept was started here with a single wash bay in May 1973. There were other truck washes at that time, but drivers commonly had to wait in long lines, and the wash could take forty-five minutes. Blue Beacon introduced high-pressure sprays that make possible a tenminute truck wash and also emphasized attentive care of customers. The company now has a nationwide network of about 100 locations, many with three bays to maintain the short-line, fastwash reputation.

252 The Wheat State

The first railroad car full of wheat was shipped from Saline County to New York City in 1870. By 1880 Salina had three flour mills and six grain elevators. More than 120 years later, wheat still plays a major role in Salina's economy, as evidenced by the enormous Cargill-Salina grain elevator seen on the left. This elevator has a 32-million-bushel capacity. The 140 bins are 150 feet tall and from 25 to 35 feet in diameter. Not as visible are six flat storage buildings, each one big enough to house two football fields.

An "elevator" is a cluster of bins with a single mechanism to take the grain to the top. It receives its name because grain is "elevated" to the top of the tall storage bins. In one type of elevator, buckets attached to a moving belt scoop the grain and carry it to the top. From there, grain is discharged to one of several chutes, where it flows by gravity down into one of numerous storage bins. Most Kansas towns have elevators to store grain from the surrounding area. The size of elevators and the huge number of them are indications of the tremendous volume of food resources that come from our farms year after year.

Grain purchased at the Cargill-Salina elevator is brought by truck from farms within a thirty-mile radius. Sixty percent of the storage is used for hard red winter wheat. Bins are also filled with sorghum, corn, and soybeans. Grain is shipped out in hundred-car trains, with 85 percent of the wheat destined for export. Trains go to Texas and Louisiana seaports to load ships that take grain to other parts of the world.

As much as 50 percent of the U.S. wheat production is exported. Some top customers have been China, the former Soviet Union, Japan, Korea, and Egypt. According to the Wheat Foods Council, the average American consumes about 150 pounds of wheat flour products every year. But while China is traditionally thought of as a rice-eating nation, the Chinese consume 180 pounds, mostly in the form of noodles. The high-consumption nations include France (241 pounds), Egypt (384 pounds), and Algeria (441 pounds).

Among the six classes of wheat, there are differences in the color of the kernels and the hardness of the grain. But the only difference in nutrients is the protein content, which is nutritionally insignificant but makes a big difference for baking. Hard red winter wheat like that grown here has 10 to 15 percent protein, which is good for breads and all-purpose flour. The soft red winter wheats range from 8 to 11 percent protein and are used in cakes, cookies, pastries, and crackers. Hard spring wheat with 12 to 18 percent protein is used for yeast breads. Durum, the hardest wheat, averages 14 to 16 percent protein and is used for pastas.

That's a lot about wheat! In the miles ahead, it will become even more evident why Kansas is called "the Wheat State."

248 Bombs Away!

The small, flat hill seen on the far left horizon, first appearing to the left of the white elevator, is called Soldier Cap. From this distance the landscape seems pastoral and peaceful, but looks are deceiving. That hill is located on the Smoky Hill Air National Guard Range, where jets from McConnell Air Force Base in Wichita and

other bases conduct target practice. This practice range was particularly important during World War II, when it was a training base for B-29 bomber crews.

Can you estimate the distance to where those bomb runs were made at Soldier Cap? That particular hill is eleven miles away. You can see a long way here on the plains.

247 Rhinos on the Plains

A section of Kansas prairie has been transformed south of Exit 244 into a beautifully landscaped zoological park. The Rolling Hills Zoo, a ninety-five-acre nonprofit prairie oasis that opened in October 1999, is dedicated to conserving and propagating rare and endangered wildlife. You can see two rare white rhinos and more than eighty other kinds of animals. In the first eighteen months after the zoo opened, it was visited by more than 110,000 people, including thousands of school children on class field trips.

246 Farm Ponds

Farm ponds such as you will see on the right and over the next fifty miles provide great fishing. State records for eight kinds of fish have come from farm ponds, including the state record largemouth bass, weighing in at eleven pounds, twelve ounces. The Kansas Department of Wildlife and Parks will stock ponds with channel catfish and largemouth bass at no cost if the landowner agrees to allow public access.

Farm ponds store water for livestock but are most frequently constructed as water and sediment control basins near the top of a watershed. Such ponds are created by constructing a compacted earth embankment, forming a small dam to hold back the water. According to agricultural engineering design standards, a pond should be able to "control runoff from a 10-year frequency, 24-hour storm without overtopping."

244 Sunflowers

Fields in this area are sometimes planted to sunflowers. During the summer you'll see many different varieties of these yellow flowers, but they all have one thing in common. When sunflowers are blooming, notice how all their heads are looking in the same direction. Throughout the day, they follow the sun across the sky as if commanded to look up to it in unison.

You may have already observed large sunflower fields along

I-70. This is wild sunflower country, but farmers grow a commercial variety of sunflower, which is becoming an important crop in Kansas. Sunflowers are used to make oils, bird seed, and of course the sunflower seeds you can buy at convenience stores to munch on during your travels. There are commercial sunflower operations at miles 57 and 13 ahead. You will read more about this crop at those locations and also at 241E (page 185).

240 Brookville

Brookville, about five miles south of the interstate, once bustled with 2,000 residents. This is the same town famous for the Brookville Hotel and its chicken dinners that you read about at 279W (page 51). Business flourished after the arrival of the Union Pacific Railroad in the 1870s. There were two lumber yards, a general merchandise store, flour and feed stores, and a second hotel. Because this was a division point for the railroad, train crews lived here and took the trains a specified distance in either direction, where they would turn the train over to the next crew. They would then work on another train for the return trip to Brookville.

Brookville's economy suffered a blow when, around the turn of the century, the Union Pacific moved its division farther west. Businesses left town and moved to Ellsworth and Salina. Brookville residents went off to find jobs in larger towns, and Brookville became a quiet country community.

The Brookville Hotel remained, and its reputation grew. During World War II the military personnel at the nearby Smoky Hill Army Air Base patronized the hotel by the hundreds. People came from miles around for dinner, and notable guests came to stay. Originally known as the Cowtown Café and then the Central Hotel, the Brookville Hotel has had notable guests such as Buffalo Bill Cody, J. C. Penney, and Henry Chrysler, whose son Walter founded Chrysler motors.

SMOKY HILLS REGION

238 The Smoky Hills

The Smoky Hills, so named because in the summer the hills are obscured by a smoky-looking heat haze when viewed from a distance, are the third region through which I-70 passes.

You have climbed to over 1,500 feet from the 760-foot low point at Kansas City. The elevation will change another 1,000 feet as you travel the next sixty miles to the western edge of the Smoky Hills region. Considerable ruggedness is evident over short distances, particularly where rivers have eroded their channel. Along the Saline River, just north of the interstate, the river has cut canyons 300 feet deep in places. You will notice interesting rock formations exposed on eroded slopes. There is not much precipitation here, averaging only twenty-four inches annually.

You will continue to see trees along the streams—cottonwoods and willows, with green ash and hackberry sometimes present. The predominant upland vegetation is prairie grass: buffalo and grama grass interspersed with taller grasses such as bluestems. You will also see sunflowers and wildflowers such as plains indigo and prairie primrose. You will cross Elkhorn Creek ahead, which reminds us that elk once roamed these lands along with herds of buffalo, grizzly bears, and wolves. Today watch for coyotes, wild turkey, and deer.

The Smoky Hills are rich with natural resources and contribute much to Kansas's prosperity. This region is the heart of the state's oil production. Natural gas and salt are taken from underground. On the surface, rich soils produce sorghum, wheat, soybeans, hay, and new varieties of drought-resistant corn.

236 A Land of Lincoln

You will be passing through Lincoln County, established on February 26, 1867, and named after Abraham Lincoln, who had been killed only two years earlier. President Lincoln was a hero here because Kansas was an antislavery state and remained with the Union. After George Washington's name, Lincoln's is the most popular choice among political place-names in the United States. Altogether there are twenty-two Lincoln Counties in the United States!

235 Bison

Just to the left is a ranch that sometimes has buffalo, more accurately called bison. Bison numbered in the millions in this region. However, the coming of the white settlers and the railroad quickly eliminated them from Kansas. At first, the white men killed the bison only for their meat and hides, but soon after the railroads

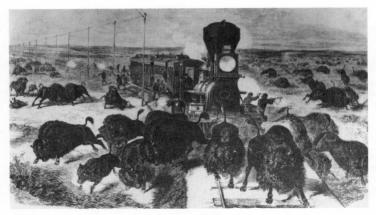

Shooting buffalo on the line of the Kansas Pacific Railroad in 1871 (Kansas State Historical Society)

arrived, the animals were killed from trains by sport hunters and often left to rot. Within a few years, the bison were gone. This mindless slaughter not only eliminated a fuel and food source for settlers but also helped to seal the fate of the Plains Indians, who depended on bison herds for survival; in fact, this was the motivation of some "buffalo" hunters. Bison also can be seen across from Fort Hays State Historic Site (Exit 159).

233 Post Rock

Over the next fifty miles or so you'll see many stone fence posts being used with barbed wire to section off farm fields. You are entering the heart of "Post Rock Country." Stone fence posts created from limestone have been used so extensively in this area that they are an identifying feature of the landscape. The Post Rock Country is from ten to forty miles wide and stretches about 200 miles from the Nebraska border south to Dodge City.

Limestone is unique in that while the stone is covered with earth and protected from the air, it remains soft enough to be cut with a hand saw, although most post rock was split off using hammers and wedges. Upon exposure to the air, however, chemical changes take place that turn the stone hard. The limestone here is in thin, six- to eight-inch layers and near the surface for convenient excavation. Horses were used to drag the 400-pound cut rock posts to their final locations.

This area's development is strongly tied to this limestone. Details about the history of post rock use are provided ahead at mile 190W (page 75). The next rest area (mile 224) is a good stop to get an up-close look at examples of post rock fences.

230 Spite Fence

On both sides of the road you will see two post rock fences running parallel, just a few feet apart. These "spite fences" have been built where there was a dispute or at least some confusion between landowners about the exact location of the property line. More commonly, there were disagreements about fair and equal maintenance of fences placed directly on a property line, so landowners built the fence well inside their own boundary. The space between the fences, called the "devil's lane," often is grown up in woody vegetation because livestock cannot graze between the fences.

229 Living Snow Fence

The redcedars planted in dense rows form a living snow fence. They block the wind and blowing snow before they reach the highway. Other snow fences can be seen along I-70, including a large one at mile 15. Ahead you will begin seeing such windbreaks around farmsteads.

228 Cheyenne Bottoms

About thirty miles south of Exit 225 lies Cheyenne Bottoms, the "Jewel of the Prairie." Cheyenne Bottoms is an important wetland ecosystem, a critical migration point for shorebirds in North America, and a world-class bird-watching destination. During migration, it attracts almost half of the entire northward-migrating population of North American shorebirds. Large numbers of ducks and geese frequent the bottoms, as well as the endangered whooping crane. A recent fall waterfowl count on the bottoms put the number of ducks at 225,000 and geese at 25,000.

The Cheyenne Bottoms is a threatened ecosystem plagued by water problems, sometimes too much, but usually too little. The damming of the Arkansas River and increased irrigation in eastern Colorado and western Kansas have drastically reduced the water inflow to the bottoms except during heavy rain periods. Siltation problems caused by rainfall runoff from the surrounding land threaten the aging marsh. Even in its tenuous condition, this is a

wonder-filled wetland to visit, as birdwatchers who visit from around the world will attest.

226 Fort Harker

Fort Harker provided a safe haven for settlers headed to western Kansas. The fort, named to honor Captain Charles Harker, who had been killed during the Civil War at the Battle of Kenesaw Mountain, could accommodate about 700 soldiers and 1,400 civilians. Distinguished generals who visited the fort included Grant, Sheridan, Sherman, and the infamous General Custer.

Fort Harker provided protection for the Butterfield Overland Despatch during its short eighteen-month history. The fort was called Home and Eating Station Number 6. After Fort Harker was abandoned in 1880, families headed out along the river, and some dug homes into sides of bluffs and lived in caverns like cave dwellers. Carvings and petroglyphs created by Native Americans and early settlers can be seen on the walls of caves in this area. The Fort Harker Museum in Kanopolis contains artifacts and war memorabilia displayed in one of the fort's original buildings.

The small town of Kanopolis was once going to be "the Capital Metropolis" or "Kansas Metropolis." The town was designed for 150,000 people! Four city blocks were even set aside for the state capitol building. *The WPA Guide* called it "one of the most extensive 'paper' towns ever conceived." These ambitious plans never came to pass. But the town has survived, in part because in 1887 rock salt was discovered by people drilling for gas and oil just east of town. The Independent Salt Company continues as the oldest continually operating salt mine in the United States.

224 Ellsworth

You entered Ellsworth County a few miles back. Both the county and the town of Ellsworth are named after Second Lieutenant Allen Ellsworth, of Company H, Seventh Iowa Cavalry. He established the small fort in 1864 along the Smoky Hill River. Two years later it was moved a mile or so and became Fort Harker, which you just read about at 226W (above). During its short history, Fort Ellsworth was attacked twice by Indians; on one occasion a raiding party drove off fifty horses and five mules. No deaths were reported from these attacks.

South of Exit 219 is the town of Ellsworth. Ellsworth prospered

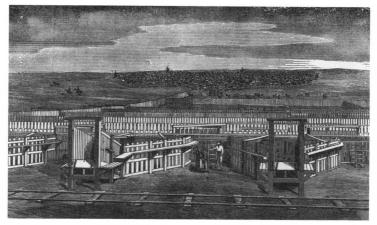

Ellsworth stockyards (Kansas State Historical Society)

from the cattle trade. It was the end of one branch of the Chisholm Trail, which split into two branches just south of the Kansas border with the Oklahoma Territory. The other branch ran to Abilene, as you read at 279W (page 51).

Rumors that Ellsworth would be the end of the line for the Union Pacific Railroad helped it thrive by attracting speculators. The first railroad cars arrived in Ellsworth on July 5, 1867, bringing merchants, lawyers, doctors, gamblers, gunmen, laborers, and thieves. They all played different roles in shaping the "newest" important cowtown on the Texas cattle trail.

Along with these people came drinking, gambling, prostitution, and all sorts of trouble. Gunfights occurred regularly, including the killing of Sheriff Chauncey B. Whitney. Another dispute resulted in a vigilante group hanging two men. A local newspaper reported the situation: "As we go to press, hell is in session in Ellsworth."

Ellsworth's role in the cattle industry was over almost as soon as it started. By 1875, the cattle business left Ellsworth as the railroad extended west and people moved on with it.

222 Pioneer Problems

Kansas farmers still face hardships, but they are much less harsh than the ones faced by the original pioneers. See the description of the challenges presented by the harsh environment, conflicts with local Indians, and especially the grasshopper invasion of 1874 at 230E (page 181).

Helvey Farms

220 So This Is a Farmstead?

The cluster of buildings back of the service station at Exit 219 looks like a business center. It is. It's the center of the Helvey Farm's 2,000-acre operation. Forget the image of a self-contained farm-stead complete with home and garden, livestock barns and barnyard. Such a farmstead of the 1900s has given way to this machinery repair and parking center with fuel and chemical supply tanks.

The farm originally was on the eighty acres near the exit. The first Helveys moved here from Illinois. For five generations the Helveys have produced food, mostly wheat, on this land. But to keep up with farming trends and costs, it is necessary to grow more crops and market new varieties. The family's land is spread from Ellsworth to Lincoln and Mitchell Counties as insurance against damage from extreme weather. David Helvey explains, "With the cheap food policy of the United States, farmers are forced to continually produce more for less." When he started farming in the 1950s, you could sell a bushel of wheat for three dollars. Today you still get about the same price for a bushel of wheat, but the cost of seed, fuel, and fertilizer has gone up 300 percent.

So we asked him, why do you stay? "To meet the challenge," Helvey says. He now grows corn, sorghum, and sunflowers in addition to wheat. Crop rotations conserve soil and moisture. New techniques fight insects. Machines ease the heavy labor. "This is a great place to live. We can trust people," he says. "Here a person's word is a person's bond. We're staying."

218 Terraces

To grow crops successfully in the same field on a sustained basis, water and topsoil must be saved. Notice here how farmers not only are using contour plowing (plowing and planting rows of crops across the slope) but also are using "terraces" to slow the runoff from rain and melting snow. Mounds or ridges of soil are plowed to curve along a slope, making level areas to hold the moisture so it will soak into the soil for crop production. When water runoff is slowed, less soil is carried away, preserving the topsoil and reducing erosion. You will see more of this widespread and valuable farming practice on steeper slopes as you travel across Kansas.

Standards for terrace design have been established by the American Society of Agricultural Engineers. It encourages the use of parallel terraces so that an equal number of crop rows can be planted, thus making it easier to operate tractors, combines, and tillage tools. The design standard suggests that terraces be spaced nine meters (thirty feet) apart to accommodate the rows for most crops. Long, gentle curves aid in making terraces farmable using commercial farm equipment.

Several types of terraces channel water into grass waterway outlets. The design engineer calculates water runoff from weather and soil data. An outlet is then constructed at a slope so no erosion will occur. You will see many terraces ahead. At mile 121 you will see terraces with concrete channels directing water into the roadway ditch.

Just building the terrace does not assure erosion control. Every year farmers must maintain the terrace shape and restore ridge height. Other conservation practices are recommended along with terrace management, such as strip-cropping, minimum tillage, and crop rotations. These practices will be pointed out as we travel across western Kansas.

215 Dog Soldiers

During Indian raids in this region, the most feared of all roving war parties were the "Dog Soldiers." These Kiowa and Cheyenne warriors were driven by the single purpose of killing white settlers encroaching on their traditional lands. What made the Dog Soldiers so dangerous was their independence. They were a blood brotherhood who chose their own leaders and did not submit to the tribal chiefs established through family lineage. They did not

Lighted Cross Church

honor peace treaties made by other Indian leaders and continued to attack settlers even in times of truce.

214 The Lighted Cross Church

The quaint white Excelsior Lutheran Church on the left is known as the "Lighted Cross Church." The cornerstone for this church was laid in 1908. The adjacent cemetery has markers for people with birth dates in the early to mid-1800s, pioneers who came to farm these hills and now rest in them.

The church's cross is sixty-five feet tall. It is lined with forty-eight lights that are lit from dusk to dawn, making it conspicuous from the interstate in an otherwise dark stretch of road. The cross arm is a circle of lights sixteen feet in diameter, arranged so that it appears in perfect proportion from any direction. A fund has been established so the lights will continue even if the continually diminishing congregation no longer exists. The landmark is so prominent that gifts from travelers have been delivered when only a Wilson, Kansas 67490 address is used.

213 The Big Bales

The big, round bales you see rolled up in the fields or stacked near a feed yard are likely to be alfalfa hay that will be used to feed cattle

in the winter. Some may be straw that was baled after wheat harvest, waiting to be used as livestock bedding. These bales often weigh at least 2,000 pounds.

These big bales have their roots here in Kansas. When Wes Buchele grew up on a Kansas farm, hay was gathered loose and pitched to the cattle with a fork. In high school he ran a crew that went from farm to farm to compact hay into sixty-pound bales, thus making it easier to stack and transport. But handling those bales required a lot of backbreaking labor, and the compacting plunger injured many farmers.

After receiving engineering degrees at Kansas State University, Buchele continued to think about ways to mechanize the handling of hay. In 1968, by now a teacher at Iowa State University, Professor Buchele suggested to one of his graduate students a project to design an economical hay package that would reduce the number of bales to be handled and be safer to operate. They created the machine to make big, round, rolled-up bales, completely eliminating hand labor by substitution of a reasonable investment in equipment and twine. The result of the agricultural engineers' design has been the creation of a new industry to manufacture the balers and related handling equipment that reduce the drudgery of farming. Their work made it possible for fewer workers to supply our food at lower cost.

211 Pioneer Immigrants

Another cemetery is just to the right of the interstate amid the cluster of redcedar and elm trees. Grave markers here include those of people who were among the first settlers of the region and who died in the 1880s. Family names include Peterka, Hanzlicek, and Dolezal, reminiscent of the Czech influence in this area. See 207W (page 70) ahead.

210 Black Wolf

The town of Black Wolf, five miles south, was named after an Indian Chief who was well liked in the area. For many years this spot was famous for the following sign south of town:

Black Wolf, Kansas
Population 41
Speed Limit, 101 Miles Per Hour
Fords, Do Your Damnedest

209 The Post Rock Scenic Byway

At Exit 206 you can take the Post Rock Scenic Byway north to the Garden of Eden. The byway traverses beautiful rolling hills covered with lush grasses and dotted with lines of post rock fence. Lucas is home to the Grassroots Art Center, devoted to exhibiting folk art. In Lucas you also will see an unforgettable example of folk art—the Garden of Eden. This site, which is listed on the National Register of Historic Places, was built by Civil War veteran Samuel Perry Dinsmoor and includes an eleven-room limestone and concrete "log" cabin and 150 amazing concrete sculptures depicting Bible stories and making Populist political statements. An interesting side note to the Garden of Eden story is that at the age of eightyone. Dinsmoor married a twenty-year-old woman and fathered a son and daughter who, as of 2002, were the only living children of a Civil War veteran. Dinsmoor died in 1932, and his body is visible in a glass casket in the concrete mausoleum he built to display his remains.

208 Wilson Lake

Wilson Lake, about five miles north of here, was created in 1964 when the Army Corps of Engineers dammed the Saline River as a flood control measure. Grasslands above the lake hold the soil in place when it rains, making this one of the clearest lakes in Kansas and thus a popular fishing lake. The lake is noted for its walleye, striped bass, and smallmouth bass. With over 9,000 surface acres of water and more than 100 miles of shoreline, Wilson Lake attracts people to water-ski, windsurf, hang-glide, picnic, camp, and hike nature trails.

207 Czech Capital

Exit 206 leads to Wilson, also known as the Czech capital of Kansas, and the Kansas Originals Market. The market displays the works and products of 1,200 Kansas artists, craftsmen, and cooks. This cooperative association has been featured in the magazine *Midwest Living* and has sold Kansas products to people in all fifty states and more than 100 countries, bringing in more than \$2 million to the artists and craftsmen.

In 1865, Wilson Creek was a watering stop for horses on the Butterfield Overland Despatch stagecoach line. An early settlement name was Bosland, as cows were envisioned to be an important

part of the settlement. The settlers used "Bos," from the Latin for "cow" or "oxen." But few cows were shipped from the town, and in 1874 the name was changed to Wilson. The town was promoted by a Czechoslovakian named Francis Swehla. Wilson still reflects Czech culture. Traditional foods and handicrafts are available, and during special events, descendants wear authentic Czech costumes.

The Midland Hotel was used in the movie *Paper Moon*. Alaska's first governor, Walter Eli Clark, married Neva McKittrick, a Wilson resident. So the very first First Lady of Alaska was from here.

205 Russell County

This county and the town of Russell (mile 187) were named after Avra P. Russell, a captain in Company K, Second Kansas Cavalry, who fought in the Civil War and died of battle wounds in 1862. The county was established on February 26, 1867.

Russell County's economy is largely supported by oil. Ahead you will see many oil wells and storage tanks along the interstate.

204 Abandoned Homes

Over the last twenty miles, you may have noticed the many abandoned home sites. These vacant, ramshackle dwellings signify the end of efforts to make a living from this land. Each house once held a family and tells a story of their struggles. The dust bowl years drove many residents to California. Others left because of harsh winters, unreliable water, or homesickness for places back East. Sometimes all that remains of a family's dream home is a shade tree that they had planted and nurtured. In fact, in western Kansas, where trees are naturally scarce, a good way to locate an old homestead is to look for a tree out in the middle of a field. Often it provides shade to only a crumbling foundation, the remains of what was once someone's pride and joy.

The abandoned square, yellowish limestone farm house on the right side of the interstate near marker 202 was built sometime before 1910 and abandoned in the late 1950s when the last residents moved to Wichita. The house is a reminder of what Ian Frazier noted in his book *Great Plains*: "You can find all kinds of ruins on the Great Plains; in dry regions things last a long time. When an enterprise fails on the plains, people usually just walk away and leave it. With empty land all around, there is not much reason to tear down and rebuild on the same site. In the rest of

America, you are usually within the range of the sound of hammers. A building comes down, another goes up, and soon it is hard to remember what used to be there."

201 Dorrance

Home of the hoops! National Basketball Association basketball rims and backboards are made here in Dorrance. Read at 197E (page 174) about how backboard designs were changed because of a Dorrance firm's influence. Like many Kansas towns, Dorrance is named after a railroad man. In this case, O. B. Dorrance was the Union Pacific Railroad superintendent at the time of the town's founding.

198 Wind Power

Windmills, such as the one on the right, have been used by Kansas farmers and ranchers since the late 1800s. Windmills harness an ever-present Kansas resource, the wind. Windmills attached to pumps are a natural way to lift water from wells for livestock, for crop irrigation, and, when combined with an elevated storage tank, for household needs.

In the Smoky Hills the average wind speed is thirteen miles per hour, with gusts of forty to sixty miles per hour. New kinds of farms are popping up around Kansas—wind farms! Around some hills,

Windmill

tunneling effects produce higher constant speeds, making those areas opportune spots for wind turbine energy farms. Several wind farms, each with dozens of tall wind turbines, have been proposed for the state. Energy experts believe Kansas has a tremendous untapped potential for generating electricity by capturing the wind.

196 Why Are Barns Red?

Ahead you will see red barns. Red was the color of choice for painting barns for many years, probably because the ingredients for red paint were inexpensive and easy to mix. Iron oxide powder was often used to give a deep red color. Mixed in linseed oil, it could be spread easily on the barn boards. When a little casein (as in white glue) was added, the protective coating had a longer life. Casein adhesive is a constituent of skimmed milk, which was always available on the farm. To produce a more red-orange color, lead oxide powder was used. With today's technology for formulating ready-to-use paint, white and other colors have become popular for painting barns.

194 Bunker Hill

The next town is Bunker Hill. A stagecoach station on the Butter-field Overland Despatch was located here in 1865, and the Union Pacific Railroad went through in 1867. A colony from Ohio arrived in Bunker Hill in May 1871. The settlers named the town after a town in Ohio having the same name.

193 Chief Spotted Horse

At the east end of the Bunker Hill Cemetery is the grave of a young Pawnee chief named Spotted Horse who died of typhoid fever in 1874 near Bunker Hill. His father was a Pawnee chief who had converted to Christianity, and he requested a Christian burial in the white man's cemetery. The grave of Spotted Horse lies among graves of Civil War veterans and early settlers.

192 Tower No. 4

That slim tower off to the left is 110 feet tall but only 10 feet in diameter. It holds 60,000 gallons of water and provides water pressure for the Post Rock Rural Water District. Water is distributed to small towns and farms through rural water districts such as this one. In this district, water for the system is pumped from Kanopo-

Chief Spotted Horse's grave

lis Lake, downstream from Fort Harker on the Smoky Hill River (226W; page 64). After purification treatment it is pumped to a series of towers stretching across much of the area through which you have been traveling. This Tower No. 4 provides pressure to serve customers ahead in Ellis County, as far as fifteen miles away in Walker.

This rural water district started signing up subscribers in 1974. Ten years later, enough users had agreed to support the system, and Tower No. 4 was erected. The water purity has never been a concern, but customers can detect seasonal changes in flavor that result from lake water changes. Today, nearly 1,200 customers in eight counties are assured of a reliable supply of healthful water, something that was not always possible when they depended on individual wells.

Throughout history, the quality and quantity of water have been determining factors in where communities are located and the type of commerce that develops. Managing water is complicated here where there is a limited supply. In Kansas over twenty governmental agencies address water-related issues. This tangled web requires vigilance and cooperative efforts to optimize the value of the water resource.

Post rocks and fence

190 Still More Post Rocks

You will see more post rock fences ahead. When pioneers arrived, few trees grew here, so there was no wood for fence posts, corrals, or homes. The early settlers were British, Scandinavian, German, and Czech, and some were skilled in masonry and stonecutting. As the saying goes, "Necessity is the mother of invention." These folks saw the potential of the area's limestone and used it in place of wood for fence posts and buildings.

The original idea of using stone for fence posts supposedly was conceived by C. F. Sawyer, who lived near here. Mr. Sawyer was a stoneworker in Illinois before coming to Kansas and recognized the possibility of using limestone for posts. According to one of his sons, Sawyer built the first stone post fence in December 1878. Today more than 40,000 miles of stone post fences remain in this region of Kansas!

Each group of people that inhabited the Post Rock Country used the easily accessible limestone. Native Americans used broken pieces for burial mounds and crude weapons. Explorers and trappers used the stone as markers. Surveyors made stone pillars for landmarks. Early horse traders and cattlemen placed upended slabs side by side along ravine walls to form corrals. Settlers built churches, schools, bridges, water towers, and even silos from this amazing stone. Some of it was shipped by rail for building construction as far east as New York. Grace Muilenburg and Ada Swineford, in *Land of the Post Rock*, show how important limestone was to settlers in this region: "Throughout the area, remains of old self-sufficient homesteads may include a stone dwelling, a cave or cellar with a stone entrance, a stone barn, two or three other stone outbuildings, a stone corral, stone clothesline poles, stone gate posts, a stone hitching post or two, flagstones for walks between buildings, stone well curbs, stone feeding floors and hollowed-out slabs for watering or feeding farm animals."

The rest area ahead highlights the commercial importance of post rock. While more cost-effective types of construction are used today, limestone is still available and specified when a particular architectural effect is desired.

187 Bob Dole Country

A group of seventy German settlers from Ripon, Wisconsin, established the town of Russell in the winter of 1871. Early accounts state that they were "good, sober, industrious people" who prohibited gambling and saloons. When *The WPA Guide* was written in the 1930s, the authors noted that the German-Russian population was still made up of "good, sober, industrious people." Russell is now known for being the hometown of two influential U.S. senators. Longtime Kansas senator and presidential candidate Bob Dole and Senator Arlen Spector of Pennsylvania both have their good, sober, industrious roots here. Russell was once known as Fossil Station because of the rich fossil beds in the area.

186 The Coyote and the Doodlebug

The oil boom here has been credited, oddly enough, to a coyote and a "doodlebug." In the early 1920s, representatives from the firm of Sterns and Streeter were searching for oil when a coyote ran in front of their car. One of the men claimed they would find oil where the coyote had been. A contraption called a "doodlebug," which supposedly indicated the presence of oil, "doodled" at the spot where the coyote had stood. Sure enough, there was oil. A wooden derrick, Carrie Oswald No. 1, named after the landowner, was erected at that spot in June 1923.

The Oil Patch Museum in Russell tells the story of the area's oil industry. At Exit 184 you can see derricks and an outdoor collection of rotary drilling rigs, pulling units, pump jacks, steam engine power units, and an actual oil storage tank that you can walk through.

184 Wonderful Wetlands

Wetlands such as the marsh areas seen on the left are more valuable than most people realize. Wetlands can take many forms, from damp meadows to forested swamps. Regardless of their appearance, they serve us all by providing a natural sponge to soak up floodwaters and are nature's filter, removing pollutants. Wetlands also allow water to replenish the groundwater rather than run off. an important function out here on the Plains where people rely on the groundwater for nearly all their water needs. Wetland vegetation can protect shorelines from wave erosion. In some places, wetlands are important for fisheries because they serve as nurseries for the young fish. Wetlands provide important habitat for hundreds of kinds of wildlife, including waterfowl that migrate across North America, as well as several endangered species. They also provide recreation opportunities such as bird-watching, fishing, hunting, photography, and canoeing, as well as enhancing the scenic beauty of an area. Wetlands certainly are not wastelands.

182 Tanking the Crude

Notice the oil storage tanks scattered in the fields. Where does the crude go after it is lifted from the ground? A network of pipes connects the oil wells with those storage tanks. It is then picked up by tanker trucks and transported to refineries. In some cases it is piped directly to refineries near Wichita or as far away as Texas. There are both oil and gas wells in the fields by which you pass. You can see the "rocking horse–style" pump on oil wells. Gas accumulates under its own pressure, so no pump is needed on a gas well.

Something you will not see are tall oil derricks. At one time, every well had a derrick. But in the 1950s a team of men from Texas came to Ellis County and quickly removed all of them. Witnesses said it was quite a sight to watch, as the men by hand "flipped" the derrick up into the air so it would land on its top rather than just tipping it over. This prevented joints and beams from being bent on

impact with the ground. Then, like a NASCAR pit crew, they feverishly dismantled the derrick and loaded it for shipment to Texas, where much of it was used for scrap metal.

180 Sinkhole

The pond on the left side just before the overpass is the result of a "sinkhole." Note the dip in the road here. Over the next couple of miles you will notice several such dips, which are also the result of sinkholes beneath the roadway. According to Rex Buchanan and James McCauley in their book, *Roadside Kansas*, I-70 was originally flat here. As they explain, these sinkholes form when water dissolves or washes out cavities in salt beds 1,300 to 1,600 feet below the surface. Some sinkholes here are caused by water dissolving the salt around abandoned oil wells. Occasionally, sinkholes form suddenly when a salt cavern is formed and, subsequently, the overlaying rocks cannot support the weight above and come crashing down. Everything above collapses, forming the sinkhole at the surface. Buchanan and McCauley reported that I-70 near the sinkhole was still slowly dropping and putting stress on the overpass that you drove under.

177 Water-Loving Willows

Ahead at mile 175, notice the willows growing along the stream. Willows and water go together. Old Testament prophets, Shakespeare, and a multitude of writers and artists for centuries have linked willows and water. Unlike some other literary linkages, this association is biologically accurate. Willows require an abundance of water and can survive long periods of flooding, attributes that make them the perfect shoreline tree. Willows serve an important function in preventing erosion of banks in ponds and streams; their roots form dense mats that hold the soil particles in place instead of being washed away by waves or flowing water.

Native Americans used willow wood and limber willow sprouts to make traps, tent poles and stakes, mats, baskets, drums, meatdrying racks, and many other objects. Today willow wood is sometimes used for boxes, crates, and furniture parts. A specialty use of willow wood is for artificial limbs for amputees.

Willows were a living pharmacy for both Native Americans and European settlers. Virtually every potential health problem was treated with teas or pastes made from parts of the willow tree by some group of people on the Plains. Even "chew sticks," the precursor to toothbrushes, often were willow twigs. These sticks may have provided other dental health benefits from the chemicals in the wood. Salicin, a painkiller used in modern pharmaceuticals, is found in willow bark and leaves.

175 Ellis County

Ellis County is named for George Ellis, a Pennsylvania man who came to Kansas and enlisted in the Twelfth Kansas Infantry. He fought Quantrill's raiders at Lawrence in 1863 (see 198E; page 221). He died at Jenkins Ferry, Arkansas, in 1864. Kansas legislators honored Lieutenant Ellis by naming a county for him.

Ellis County has consistently been the best oil-producing county in Kansas. The Ellis Oil Field was discovered in 1943. By 1986, Ellis County wells had produced more than 450 million barrels of oil.

174 St. Ann's Church

On the right, St. Ann's Church in Walker, with its towering steeple, is a prominent landmark. It was constructed using local limestone in 1904. This is a small parish that benefits from being close to a major cathedral so that a priest is always available to the congregation and to conduct services. One parishioner explained, "It is smaller, but it is friendlier to worship here."

St. Ann's Church

173 An Avenue Exit

In the more than 400 miles of I-70 across Kansas, there are only two exits for avenues, the one for Walker Avenue, which you have just passed, and an exit for First Avenue in downtown Topeka, about 200 miles east of here. Having only two exits for avenues in more than 400 miles illustrates the rural character of your trip across Kansas.

172 Abandoned Air Base

The hangars, aircraft control tower, and smokestacks of the abandoned Walker Army Airfield can be seen rising among the trees on the horizon to the right. The base was built by the Army Air Corps in 1942 and served as a training center until 1946. There are no operations today. Because of the proximity of aircraft industry near Wichita, the wide-open spaces, and generally clear weather, during World War II Kansas was home to sixteen army air fields and even two naval air stations! The primary mission of these bases was to train air combat crews. A large percentage of all such World War II crews received at least part of their training in Kansas.

171 Cathedral of the Plains

On the left, the twin steeples that dominate the landscape identify St. Fidelis Church, known as the Cathedral of the Plains. Catholic Volga-German settlers built three churches before constructing the current cathedral. The first church in Victoria was merely a forty-by-twenty-four-foot lean-to attached to the south side of a nearby house. It held only half of the congregation. A sixty-by-thirty-foot stone church was completed one year later, in 1878, with funds raised by the Honorable Walter C. Maxwell, a Catholic Englishman. The contributions he obtained included one for 100 pounds from the duke of Norfolk in England.

However, the community quickly outgrew this church, too. In 1878, Capuchin-Franciscans came here from Pennsylvania. Father Hyacinth Epp, superior of the Capuchins, visited Victoria and convinced the Kansas Pacific Railway to donate ten acres for a larger church. Parishioners contributed money and labor and spent four years building the church, completing it in 1884. It seated 600 people. The name of the third church was changed from Mother of Sorrows to St. Fidelis, in honor of a martyred priest of the Capuchin order.

Cathedral of the Plains

By the turn of the century, the people again found themselves in need of a larger church. The present church was completed in 1911 using native fence post limestone quarried south of Victoria. The stone was cut by hand and hauled to the building site, where masons dressed the stone blocks and placed them by hand. Each stone weighed between 50 and 100 pounds. The settlers hauled and dressed more than 125,000 cubic feet of rock to complete the church.

William Jennings Bryan visited Victoria in 1912 while campaigning as the Democratic Party nominee for president. He thought the church was a beautiful symbol of faith and called it the "Cathedral of the Plains." The church seats 1,700 people, and its spires rise 141 feet toward the heavens.

169 A British Colony

The town of Victoria was founded by Sir George Grant, who wanted to form an aristocratic British colony in the United States. In 1871, he bought land from the Union Pacific Railroad and named the settlement after Queen Victoria. In 1873, he arrived with a group of wealthy young men who would be supported from home while the colony was being established. Read about their escapades with a riverboat on the Plains at 167E.

Volga-Germans also formed a colony adjacent to Victoria. They

were well trained for conditions on the Plains and, unlike the young British men, were skilled in agriculture. They prospered and eventually absorbed Victoria when the British abandoned it.

168 Fort Fletcher

About five miles off to the left is Fort Fletcher. The Smoky Hill Trail parallels I-70 along the Smoky Hill River to the south. The fort was built to protect travelers on the trail and the freight being carried by the Butterfield Overland Despatch. In 1867 a tragic flood killed several soldiers and a civilian at the fort. General George Custer's wife, Elizabeth, barely escaped drowning. The flood, the bankruptcy of the Butterfield Overland Despatch, and the coming of the railroad here, five miles north of the fort, contributed to the fort relocating to Hays. This fort then became Fort Hays.

HAYS

166 Fort Hays

As railroads moved west through this part of Kansas, so did the settlers. This encroachment into "Indian" territory sparked conflicts between settlers and Native Americans. To protect the settlers traveling along the rails and trails, the I-70s of the 1800s, the federal government built military posts along the way, including Fort Fletcher on the Smoky Hill Trail. Forts provided some peace of mind for settlers and encouraged settlement. In 1867, when Fort Fletcher was relocated, it was renamed Fort Hays to honor General Alexander Hays, a hero at Gettysburg who was killed at the Battle of the Wilderness.

Fort Hays was the headquarters for military campaigns into all of western Kansas and parts of Colorado. The fort also served as a supply depot for all military activity in the area, as well as for military operations farther west and southwest. It was never attacked. In its heyday, Fort Hays was home to about 210 soldiers. Notable military figures, including George A. Custer and Philip H. Sheridan, passed through the fort. Custer led many expeditions against the Indians, taking supplies and military support from Fort Hays.

Fort Hays headquarters

As the railroad expanded farther west and more people settled in the area, the need for the fort dwindled. By the mid-1870s, commanders were recommending that the fort be abandoned. On November 8, 1889, the last garrison of troops left. The government donated the land to the State of Kansas to be used for a college, an agricultural experiment station, and a park. The college, now called Fort Hays State University, offers degrees in education, business and leadership, arts and sciences, and health and life sciences. It occupies 4,160 acres of land that was part of the fort. The agricultural research station comprises 6,100 acres of former fort property. As part of Kansas State University, there are field plots, pastureland, and general farmland. Frontier Park is maintained by the Hays parks department across the road from the entrance to the fort. A small buffalo herd includes the main bull, Max, and a harem of cows.

Four of the original buildings remain at the site of Fort Hays, including the stone blockhouse that served as post headquarters. The fort was featured in the movie *Dances with Wolves*. You can get to the fort from Exits 157 or 159.

163 Hays City

In 1867, soon after the new fort was constructed to protect travelers along the trails, Hays City was staked out one mile east. When the

railroad arrived in the fall of the same year, Hays City and Fort Hays, in essence, became one. Hays grew quickly and became another wild frontier town filled with saloons and dance halls. There was enough excitement to entice Wild Bill Hickok to serve as special marshal for four months in 1869. Hickok left Hays after a brawl with some troopers from the fort.

Rome wasn't built in a day, but Buffalo Bill Cody built Rome, Kansas, very quickly. Read about the boom and bust of this settlement at 154E (page 166).

162 Sternberg Museum of Natural History

Ahead on the left is the domed roof of Fort Hays State University's Sternberg Museum of Natural History. Here you can see the famous "fish-within-a-fish" fossil, along with life-size models of a *Tyran-nosaurus rex* and other amazing prehistoric creatures. The museum's collections include 3.7 million specimens. The museum has the third-best collection of flying reptiles in the world and some of the most complete dinosaur fossils found anywhere. Children and adults get hands-on experiences with specimens in the Discovery Room, and you can walk through a land and sea diorama depicting what the area would have looked like during the Cretaceous period. Follow the signs from Exit 159 to visit this fine museum.

160 Boot Hill

Hays is the home of the original Boot Hill Cemetery, where men were buried with their boots on. It was the final resting place of many an overzealous cowboy or unwary pioneer in Hays. Some people think Dodge City had the first Boot Hill, but when Dodge City was founded in 1872, the Hays City Boot Hill was already filling up. Hays's brief status as a lawless frontier town helped create the need for such a monument to violence. Estimates of the number of people buried at Boot Hill vary from thirty-seven to over a hundred, but the most reliable estimate is that there were about eighty graves. When homes were built at the site, some bodies were moved to Mount Allen Cemetery, but records on those moved to the new cemetery were incomplete, and the whereabouts of those buried and moved are lost for all time.

158 Big Batteries

The 425 workers at the EnerSys Inc. plant just past the overpass on the left make batteries—big stationary batteries. Batteries are

Roth stone blockhouse

manufactured to provide uninterrupted power backup for the telecommunications industry, medical instrumentation, utilities, and a host of other industries. Batteries from this plant are shipped to customers in fifty-five countries.

The Roth house near the highway in front of the EnerSys Inc. plant is a good example of one of the first structures built from limestone blocks. A plaque at the door explains that it was built in 1866 by Joseph and Mary Roth. The Roths, along with their six sons and two daughters, migrated to Hays by way of Brazil after previously leaving Germany and living for a time in Russia. They were wheat farmers and probably lived on the land for many years before claiming ownership. The first records at the Register of Deeds office show that Joseph Roth filed a homestead claim for the farm in 1897. He purchased an adjacent 320 acres in 1904. This land continued to be used as a farm until it was sold for the battery plant to be constructed.

EnerSys Inc. keeps the little two-room house on the buffalo grass prairie to share with visitors, a reminder of how early settlers lived. The house was restored in 1975 by a previous company, using the original stone blocks and relying on early photographs. At that time a daughter of the Roths who had lived in the house for her

first fifteen years explained that a kitchen had been attached to the stone house. She said her brothers slept in a loft just under the roof.

156 Yocemento

Behind the grain elevator at Yocemento on the left, notice the bluff called the "hog back." This town got its name from the words "Yost" and "cement." In 1906, I. M. Yost and Professor Erasmus Haworth met in Hays and decided to build a cement plant at the "hog back." You can still see where the quarries operated along the ridge, now much reduced by the mining activity.

Haworth, a professor in the Department of Geology at the University of Kansas and director of the Kansas Geological Survey, was revising geologic maps and spoke to Ike Yost, a longtime Hays resident and mill owner, about the area's topography. After Haworth outlined the kind of information he needed, Yost drove him to an outcrop of rock along Big Creek. After climbing the steep bank and looking at the site, Haworth commented that cement could be made there more cheaply than anywhere else in Kansas because of the availability of limestone and water in the area.

Yost was excited about such an enterprise, and the men began plans to start a mill. Yost thought they should set up a town and start selling lots to builders, as well as selling stock in the mill. With the Union Pacific tracks being close by, passengers and freight would come and go from the town, along with the cement. The men sold stock to people in both the eastern and western United States, and construction began in July 1906.

By 1908, cement was being made at the U.S. Portland Cement Company. Yocemento became a thriving town of 350 people, with a train depot, post office, hotel, company store, restaurant, town newspaper, and office building. Two hundred men were on the plant payroll. For several years the mill made a small profit. Some of the cement was used in building Union Station in Kansas City in 1910–1911. Today part of that station houses a science museum.

But the good times were short-lived. By 1912, the cost of getting coal from Wyoming to run the huge furnaces dug too deeply into profits. At the same time, competitors in southeast Kansas and Colorado started expanding their operations, thereby cutting further into the profits of the Yocemento plant. The company declared bankruptcy, and a Colorado competitor, the Boettcher Cement

Company, bought and dismantled the plant. Yocemento slipped into obscurity as the people moved to Hays to find work. However, the lives of the ambitious founders of Yocemento were not ruined by this failure. Yost went back to his thriving flour mill, and Haworth continued to serve as state geologist until 1915.

Today, the owner of the plant's foundations and ruins has built his home in the old plant office building. The Yocemento elevator, built in 1956, collects corn from up to ten miles south and twenty miles north. About 60 percent of the corn is ground into feed and returned to local farms.

150 White Roads

Notice how white the county roads are here. They are surfaced with crushed limestone, a particularly white rock in this area. Along the interstate there are road cuts that clearly reveal the limestone layers similar to those that provide the road surfacing rock. You may recall that these layers were formed at the bottom of a warm, ancient sea.

149 The High Plains

You have entered the High Plains region, the largest, highest, and driest region in Kansas, covering the western third of the state. Elevation ranges from about 4,000 feet along the Colorado-Kansas border to 2,000 feet above sea level here on the eastern edge of the region. The climate is becoming drier as you travel west. This region receives less than twenty inches of precipitation per year. The High Plains have a reputation for having high winds and extreme temperatures (both hot and cold), which can fluctuate wildly, sometimes changing fifty degrees in twenty-four hours.

148 Ellis: Museums and Antiques

Ellis, ahead on the left, boasts having three museums and several antique stores. Ellis has a railroad museum focusing on Union Pacific Railroad history and offering a 2.5-mile miniature train ride. The Bukovina Society of America Museum honors the immigrants and culture from the province that was once part of the Austrian Empire and now is divided between Ukraine and Romania.

The Walter P. Chrysler Boyhood Home and Museum marks Ellis as the town where inventor and automobile manufacturer Walter Chrysler grew up during the 1880s as the son of a railroad worker.

Chrysler home

Chrysler's boyhood home contains his personal memorabilia. The museum also displays a Chrysler car from 1924, the first year they were made. Maybe you are driving a car that bears his name. Every day many Chryslers pass Chrysler's hometown.

Other notables who spent time in Ellis include Wyatt Earp and Buffalo Bill Cody. Walt Disney's grandfather and father both lived in Ellis.

144 Field Windbreaks

On the right you may notice rows of trees along a field. These "field windbreaks" prevent the wind from blowing the soil from fields; they help crops conserve moisture by reducing evaporation; they protect livestock, birds, and other wildlife from winter winds; and they are used as snow fences to prevent snow from drifting across roads (see 16W; page 130). Research has shown them to be an important recreational resource, especially for hunters, and an aesthetically pleasing visual addition to the landscape.

Many field windbreaks were planted after the dust bowl disaster, which is described vividly at 50W (page 119). With the United States reeling from the dust bowl and the Great Depression, the U.S. Department of Agriculture developed an ambitious plan to plant trees in 100-foot-wide strips not more than a mile apart in a

band from Canada to the Gulf of Mexico. During this project, 18,599 miles of windbreaks containing more than 223 million trees were planted.

According to the Kansas Forest Service (KFS), today Kansas has over 78,000 windbreaks covering 114,000 acres. However, the KFS also reports that about half of these are in fair or poor condition because of a lack of care as the trees age. The KFS concludes, "Not enough field windbreaks are planted or maintained to protect our soil and crops."

143 Trego County

This county was established in February 1867 and named in honor of Captain Edward P. Trego of Company H of the Eighth Infantry. Captain Trego was killed in September 1863 at the Battle of Chickamauga.

Several Trego County residents died during the "dirty thirties" from "dust pneumonia" caused by blowing soil. Herman Elriches, a prominent Collyer Township farmer, suffocated during a dust storm on February 21, 1935. The storm hit at about 3:30 in the afternoon and darkened the sky so that people had to turn on lights in homes and businesses. The fine silt swirling in the air made breathing difficult. Herman attempted to drive home from Collyer in near-total darkness at the peak of the dust storm, but he ran off the road and into a ditch. He tried to walk home, but his body was found about a mile from his car. Read more about the dust bowl days ahead at mile 50W (page 119).

142 Riga Road

The town on the left was named by the Volga-Germans. "Riga" means "ridge of sand." The town's grain elevator, like many others in western Kansas, is located along the Union Pacific Railroad tracks to facilitate shipping grain.

141 Kansas Skies

Montana officially calls itself "Big Sky Country," but its state motto would apply to Kansas as well. Kansas has impressive skies. Kansas playwright William Inge wrote, "One is always aware of the sky in these states, because one sees so much more of it than in the mountainous regions where the horizons are blocked and the heavens are trimmed down like a painting, to fit a smaller frame." Other

states may claim more spectacular land forms, but Kansas has spectacularly spacious skies. Kansas skies are usually clear. Typically for 300 days each year, the sun shines brightly, and the night sky teems with brilliant stars. But clouds, too, add beauty, interest, and inspiration. In summer, majestic, anvil-shaped thunderheads (some containing as much energy as a nuclear bomb) build before your eyes. Sweeping across the horizon, they often drag a curtain of blue-gray rain beneath them. Slivers of lightning tear through the dark pedestal of the thunderhead. Throughout the year, fair-weather cumuli push their shadows across the landscape, beckoning wayfarers to join them. Sunrises and sunsets hang like a stage backdrop over our subtle and understated landscapes.

Walt Whitman described such sunsets on the Plains in this poem:

A Prairie Sunset
Shot gold, maroon, and violet,
dazzling silver, emerald, fawn,
The earth's whole amplitude and
Nature's multiform power consign'd
for once to colors;
The light, the general air possess'd by
them—colors till now
unknown,
No limit, confine—not the Western
sky alone—the high meridian—
North, South all,
Pure luminous color fighting the
silent shadows to the last.
—Walt Whitman, Leaves of Grass

138 Lifeline

As you cross over the Union Pacific Railroad tracks ahead, imagine Buffalo Bill Cody galloping along them. This stretch of railroad was completed in 1868 as part of the line that connected Kansas City to Denver. Buffalo Bill came here to supply the railroad construction workers with buffalo meat during those years. He claimed to have killed 4,280 buffalo near here in only eighteen months!

Consider how the railroad affected every facet of life on the Plains for more than fifty years until roads like U.S. Highway 40

were built across Kansas in the 1920s. All sorts of people came and went on the railroad—poor immigrants, wealthy speculators, soldiers, criminals running from the law—the same range of people that use I-70 today. Food, furniture, fuel, and other freight arrived by train, a lifeline from the East. In return, buffalo skins, grain, cattle, and stories of romance and rowdiness on the range traveled eastward. Today the railroad is still a lifeline as grain is sold and shipped to markets from small towns hugging the tracks.

136 Ogallah

The name Ogallah, originally spelled Oglala, was taken from a tribe called the Oglala Sioux, a division of the Teton Sioux who lived on the Bad River in South Dakota. Experts disagree over the exact meaning of the word "Ogallah." Some say it means "to scatter one's own," whereas others claim it means "she poured out her own." Cedar Bluff Reservoir is about twelve miles south of Ogallah on State Route 147. It provides over twenty miles of shoreline and over twenty-three square miles of land and water for recreation. Read about Ogallah being home to the state's first tree nursery at 138E (page 164).

135 Midwest Coop

To the right are four bins of the Midwest Coop. Cooperatives, called "co-ops" for short and generally spelled "coop," have become a common way of doing business in farming regions. An agriculture coop involves farmers who unite for the purpose of economically purchasing supplies and profitably marketing their crops. At coops like Midwest Coop, farmers pooled their resources to build the elevator where their grain can be stored until it is sold and shipped. A basic coop code specifies democratic control, with each member having one vote. Members receive a distribution of net profits in proportion to the amount of their patronage.

Sitting along the Union Pacific Railroad tracks, this is one of the smaller grain shipping centers. Even so, it is a significant facility, making it possible to move grain to markets all over the world. Wheat and grain sorghum arrive here every working day. Trucks deliver grain from fifty miles west and forty miles east. Grain is received from forty miles south and sixty miles north, where there are other railroads to ship grain.

Trains of 100 cars are loaded every week destined for the export

market. During the busy harvest season, three or four trainloads are shipped weekly. The elevator capacity is 3,300 tons of grain. That is over 110,000 bushels stored in each bin, waiting to be loaded into the railcars that you often see lined up in a row, ready to move under the filling chute.

Midwest Coop has affiliate storage elevators in eleven surrounding towns, including Quinter, ahead at mile 109. They cooperate, with each one specializing in storage and marketing of different grains.

133 Rest Area

Most of these trees are Austrian pine, a species native to Europe. Kansas has the distinction of being the only state other than Hawaii that has no native species of pine. In other words, until settlers planted them, there had been no pines growing in Kansas for at least the past several thousand years. All the pines you see here today are native to other lands.

132 Corn

As you travel across the High Plains, you will be driving past miles and miles of cornfields. Whether it is used to make corn dogs, corn oil, corn-based biodegradable plastics, or is merely eaten straight off the cob, corn is America's number one crop. The U.S. Department of Agriculture reports that corn leads all other crops in acreage planted, bushels harvested, and dollar value. Corn is an important component of the Kansas agricultural economy. The 1997 USDA Census of Agriculture ranked Kansas eighth among the states in volume of corn production. In recent years more than 10,000 Kansas farms planted a total of 2.5 million acres to corn. In good-weather years, nearly a half billion bushels are grown. Most Kansas corn is "field corn," used for feed and other products rather than for roasting ears.

About 60 percent of the U.S. corn crop is fed to livestock. A bushel of corn fed to livestock produces 5.6 pounds of retail beef, 13 pounds of pork, 19.6 pounds of chicken, or 28 pounds of catfish. Export markets and other uses are vital to the corn industry. Over 3,500 supermarket products contain corn or corn by-products. The average American consumes 3 pounds of corn every day through food and nonfood uses.

A bushel of corn can yield 32 pounds of cornstarch, 2.5 gallons of

ethanol auto fuel, or 33 pounds of corn sweetener, enough to sweeten more than 400 cans of soda. After extracting one of these products, that bushel will also produce 1.6 pounds of corn oil, 11.4 pounds of 21 percent protein gluten feed, and 3 pounds of 60 percent gluten meal.

Corn is a North American grain. Fossilized pollen from corn plants found in Mexico is believed to be 60,000 years old. Europe knew nothing about corn before Columbus took back samples. Native Americans from Canada through South America raised corn with red, blue, pink, and black kernels, as well as the familiar yellow kernels.

129 WaKeeney

You are welcomed to WaKeeney at Exit 128 by the 100-foot-tall flag pole flying a 25-by-40-foot United States flag above an Iwo Jima memorial. A local travel and tourism council member explains, "It's a patriotism thing with us." The town is proud to have been selected as the location of one of the nation's newest veterans' cemeteries, dedicated September 11, 2002.

Iwo Jima sculpture

"Beautiful location and surrounded for scores of miles by the most fertile agricultural land in the world." This is how some settlers saw WaKeeney, Kansas, which was named after John F. Keeney, a Chicago real estate developer, and his friend Albert Warren. The men chose this spot along the route of the Union Pacific Railroad, halfway between Kansas City and Denver. A stone post at the downtown railroad underpass points on one side to Kansas City, 322 miles, and on the other to Denver, 322 miles.

128 Merry Christmas

Over the last forty years, WaKeeney has gained a reputation as being the "Christmas City of the High Plains." It claims to have the largest Christmas tree and lighting display between Kansas City and Denver. Each year, prior to Thanksgiving, the residents build a 40-foot Christmas tree made up of 2,300 pounds of fresh evergreen branches, 1,100 yards of hand-tied green roping, and over 6,000 lightbulbs.

WaKeeney has been a town since 1878. That same year, people from throughout Trego County fled to WaKeeney for protection from a group of Cheyenne Indians. The next year it was chosen as the county seat.

127 Plows

As you drive through western Kansas, you will observe many kinds of farm implements. Before these machines were developed, the settlers had to cultivate the land using horse- and oxen-drawn plows. The original tilling of Kansas soil was tough work because the ground had a dense network of roots that resisted usual techniques and equipment. Special plows had to be created that were up to the task. Oxen were the favored animals for plowing up this tough sod because they could maintain their energy by eating range grass, whereas horses needed supplemental feed. The pioneers rarely had extra feed for horses, so they used oxen. Now farmers pull plows with powerful tractors complete with air-conditioned cabs and guidance from computers, lasers, and even satellite positioning data to ensure straight rows that are precisely spaced without overlap.

126 "A Dry and Thirsty Land"

Most of the cropland between here and Colorado is irrigated (see 69W [page 112] and 21E [page 139]). Great civilizations such as the Babylonians, Assyrians, Sumerians, and others throughout history

failed because their food production took place in dry regions requiring irrigation, and eventually their irrigation systems became inefficient. These collapses in agricultural production led to scarce commodities, poverty, and even wars between nations. Many believe that the wars of the twenty-first century will be fought over water. This has already begun at the state level with legal wars between Colorado, Nebraska, and Kansas. Water is the lifeblood of the Great Plains.

Precipitation is scarce in the High Plains; therefore, farming benefits from irrigation water found in the Ogallala Aquifer, an enormous underground water source the size of Lake Huron. The aquifer extends at varying depths from north Texas into southern South Dakota. It allows farmers to raise crops, especially corn, that otherwise would be impossible to grow in this dry region. These crops are sold to grain markets and to feedlots to grow cattle that in turn also consume water. Packing plants have moved to the area to be close to these feedlots. They, too, depend on the grain and also consume large amounts of water.

Irrigation alone accounts for 84 percent of all water used in Kansas, and 92 percent of all groundwater used is for irrigation. In some areas the aquifer is being depleted fourteen times faster than it is being recharged from rains. This "mining" of groundwater has caused some wells to go dry, necessitating wells being dug deeper at great expense or irrigation being turned off. Because the region's economy is based on a foundation of irrigated crops, many fear that when it becomes infeasible to continue mining this groundwater, the economic consequences will be disastrous. The High Plains could face the same fate as those ancient civilizations.

123 Farms in the Forest

Notice how the farmsteads in this region are hidden among dense stands of trees. Ever since the first settlers arrived, trees have been precious commodities on the Plains. In fact, when settlers first arrived, a single tree was almost an oddity. Shade was scarce, but so was wood for building or burning. Often any tree encountered was cut for wood. Settlers planted trees for shade, for windbreaks, and just because the treeless Plains seemed empty. Then, too, they missed the forests of their eastern homes and so planted trees around their buildings.

Today people plant and maintain these shelterbelts for protec-

tion from the brutal winter winds and for shade during the harsh summers. Not only do they make life around the farm more comfortable, but by reducing the wind, they reduce energy costs for heating and cooling. Shelterbelts also lower maintenance costs because the farm house and buildings need to be painted less frequently and generally hold up better in less severe conditions. These shelterbelts can reduce stress on livestock and prevent snow from piling up in the farmyard or on the long driveways. For all these reasons, planting and watering trees is a wise investment out here on the Plains. Eastern redcedar is the most common tree planted in these windbreaks because it is one of the few trees that thrives in the abundant sunlight and dry conditions of western Kansas. Its dense foliage, which it keeps year-round, is an effective barrier to the winter winds.

Because of these tree planting efforts and because wildfires are kept under control, many more trees grow in western Kansas now than during settlement days. Over the next fifty miles, you will see that most farmsteads are located in the heart of their own small forests.

121 Rocks on Their Way

Here you can see the concrete outlets of terraces, which direct water runoff into the roadside ditch. Because soil is made up of particles that have been weathered and worn from rocks and because erosion by wind and water is a universal natural phenomenon, it has been said that "soil is rocks on their way to the sea." Although the movement of soil into the sea is inevitable, farmers try to slow the trip down. Farmers are using more environmentally friendly techniques that conserve topsoil, moisture, and nutrients such as leaving residue plant material from previous planting seasons, contour plowing (making furrows across the slope), and, as you saw back at mile 218, using raised "terraces" that catch rainwater and allow it to soak into the soil rather than run off and carry soil with it. All these strategies help hold soil particles in place and prevent them from moving toward the sea.

120 Homes on the Range

Cattle ranches are common throughout the High Plains. Most ranches are large compared with those farther east. It takes more acres to support each cow out here where grass is short and sparse.

A herd that could live on a few acres in Missouri would need hundreds of acres to survive on the High Plains. The only plants that survive here are those that tolerate dry conditions, like cactus or yucca, and buffalo grass and blue grama that survive long, hot periods. These grasses are important for holding the soil and for grazing livestock.

Ranches here grow more than beef. Grama grass is a good source of food for jackrabbits and prairie dogs, which in turn are good food for hawks and coyotes. Finches, longspurs, and other birds eat the grama seeds. North America's closest relative to the antelope, the pronghorn, graze these grasslands of western Kansas.

119 Volga-Germans

Most original settlers here were Volga-Germans, descendants of Germans who migrated to the Volga River region of Russia in the 1700s. Catherine the Great had enticed Germans to come to Russia by guaranteeing the colonists and their descendants free land, exemption from military service, freedom of religion, and local self-government. Catherine made these promises because she wanted to strengthen her empire by having southern Russia and the Ukraine settled. Catherine's invitation appealed to the people of the southern provinces in Germany who had recently suffered great economic hardship as a result of the Seven Years' War. Although they lived in Russia, they maintained their German language and customs.

Unfortunately, the resident Russians resented the special treatment Catherine the Great had given to the new immigrants, and this caused conflict. Catherine's promises lasted for about 100 years. However, in 1874 the Russian government passed a law requiring Germans living in Russia to serve in the armed forces or leave the country within ten years. Soon after this ultimatum, the Germans sent scouts to America to find a new home. Railroad land agents, town site developers, and state government lured them here with promotional efforts, some of which were less than honest in their portrayals of the climate and living conditions. However, the Germans discovered the landscape and climate here to be similar to those in Russia and suitable for their people.

The Germans adapted well here, having been hardened by living in the Ukraine. They learned to use what nature provided,

perhaps better than any other immigrant group. While many other European pioneers moved on as the frontier shifted westward, the Volga-Germans stayed to raise their families and crops. They persevered against the difficulties presented by the harsh High Plains environment.

117 Collyer

Ahead on the right is a town named for the Reverend Robert Collyer, who was president of an organization from Chicago that formed a soldiers and sailors colony here in 1878. This group was joined by a colony of Irish settlers and a Czech colony. Read more about Collyer and his colony at 114E (page 158).

116 The Lipp Farmstead

The red barn on the Lipp farm, left, has been at the center of the farm operation for nearly a century. When Phillip Lipp arrived from Russia in 1907, the family settled on 160 acres surrounding the farmstead; he had only thirty dollars with which to start farming. The first house built here was made of sod. A two-story farm home added much later was replaced by a modern ranch home.

Ten years after his arrival, Lipp built this traditional barn to house fifteen milk cows and the horses needed to do the field work. The barn became his factory, where grain produced in the fields was converted into milk and cream, eggs and meat. It was the warehouse for animal feed, with grain in bins on the ground floor and a high center loft to store hay.

You have seen many barns of this type across Kansas. As with many others, no animals live here now. Little grain or hay is stored on the farm, which has increased in size to 1,500 acres. The winter wheat goes from the fields directly to one of the grain elevators along the railroad track and starts on its way to distant domestic or international markets.

114 Capturing an Iron Horse

In 1868, on the railroad track that parallels I-70 to the right, Indians tried to capture a locomotive "alive" by taking telegraph wire, doubling it back and forth several times, and stretching it across the track, with an Indian or two holding each end. Needless to say, the "iron horse," running at full steam, tore through the snare like a rampaging buffalo through a spiderweb.

113 Gove County

You have just entered Gove County, which was created in 1868 and named in honor of Captain Grenville L. Gove, who had died four years earlier. The soldiers of Company G under Captain Gove's command had been so famous for being the best drilled that when they marched, people came to watch. The first settlers did not arrive in Gove County until 1871. Immigration to the county began in 1878 as Pennsylvania and Holland-Dutch people arrived in the area. Before Gove County was settled, many people traveled through it and kept right on going. The discovery of gold near Pikes Peak in 1858 led to the development of the well-used Smoky Hill Trail along the Smoky Hill River. Like many westbound travelers on I-70, those travelers had their sights set on the mountains of Colorado.

112 Skyscrapers

Fred Atchison, a forester and poet, wrote this about the High Plains landscape.

Security
The vastness of the prairie would be overwhelming
Were it not for a canopy of blue sky pinned neatly along the horizon by grain elevators.

As you drive along, note these rural white skyscrapers pinning the horizon—some visible from as far as twenty miles away. Plains people call them "prairie cathedrals."

110 A Gambrel Roof

That barn on the right has a gambrel roof. You can recognize it by the two ridges added parallel to the peak ridge, making a steep slope down below the flatter upper slope. The design includes a truss-type bracing that strengthens the roof, but the primary advantage is that it provides a high open loft with a lot of room to stack loose hay. Of course, with the availability of big, round bales and tractors to move them, no longer is anyone seen putting loose hay into a hayloft.

You will see other types of roofs at farmsteads, including simple one-slope lean-tos, simple gable roofs, and two-slope roofs. There

will be roofs that slope up from all four sides, called a hip roof if there is a single slope or a mansard if there is a double slope similar to a gambrel on four sides.

Two blue Harvestore silos beside the barn store chopped alfalfa or stalk corn, an indication that feeding cattle has been an important part of this farm operation.

109 A Million Bushels

Ahead on the left, just past the exit, you might see unusual long, flat bunkers with plastic covers. They provide supplemental onground storage for the Midwest Coop, which owns the tall storage bins in Quinter and, in 1998, needed to create additional "temporary storage." That was a particularly good year for corn production, but the bunkers seem to have found a use each succeeding year. Each bunker holds I million bushels of corn.

While the railroad was important for the development of a grain handling and shipping business, today all the grain at this Midwest Coop elevator arrives by truck and leaves by truck. Some corn is fed at cattle feedlots in the area. Mostly, however, it is trucked to grain millers for processing into corn products such as starch and sweetener.

108 Quinter

This town was founded by a group of Dunkards, also known as Baptist Brethren, in 1886. They named the town after Pennsylvania immigrant and church elder Reverend James Quinter. The town is home to Scott Huffman, a U.S. pole vault record holder.

107 Two Pounds a Day

That's correct, calves can gain about two pounds every day. That's the goal of Reinecker Feedlot on the right. Calves come into this feedlot when they weigh 400 to 500 pounds. Some calves are purchased at local auction barns, but most are from Kentucky farms. New animals are added monthly. They stay to eat and grow to about 800 pounds. It takes about five or six months to gain enough weight to be sold as market beef.

As many as 1,200 cattle may be in the Reinecker Feedlot at one time. This family enterprise started in 1978 and now is a three-generation operation. Corn for feed is grown on the 2,200-acre ranch. The cattle also eat oats and hay. These grains are purchased from neighboring farms that have fields along streams where grass crops

are preferred. The tall blue Harvestore silo could make excellent silage from the oats and hay, but it stores dry grains. Another major crop grown on the ranch is sorghum, which is sold as a cash crop.

Rex Reinecker explains that his most critical challenge in operating the feedlot comes during blizzards. The animals keep warm by huddling together, but it is difficult to get feed out for them. Another challenge in feedlot management is collecting the manure in runoff pits. Here the pens are scraped every thirty days. The pits are emptied, and manure is used as a fertilizer for crops.

106 Llamas, Too

Reinecker llamas can usually be seen in the field just beyond the feedlot. Look for the brown, black, and spotted animals with the long necks. Mrs. Reinecker explains that the llamas are her "retirement" project. After the animals are sheared, she spins the wool to produce a unique yarn. Natural fur colors on the llamas range from reddish brown to grays and white. Mrs. Reinecker also takes llamas to shows around the United States. Reinecker llamas are sold for breeding stock. These imposing animals are a deterrent to coyotes, and males are valued as guards for flocks of sheep.

104 Cottonwoods

Notice the groves of cottonwood trees on both sides of the interstate. On the High Plains, unless trees are watered by landowners,

Cottonwood trees

they grow only in low areas where scarce water can collect over time. The cottonwood, the state tree of Kansas, gets its name from the soft, white, cottonlike hairs attached to its small seeds that allow them to drift gently on the breeze. Cottonwood trees grow quickly, but they produce light, brittle wood. Native Americans made a tea from cottonwood bark and also fed the bark to their horses. Ian Frazier, in *Great Plains*, noted how cottonwoods "lean at odd angles, like flowers in a vase." He also noted how the bison loved to rub against the cottonwood's bark, which is ribbed like a tractor tire. According to Frazier, in areas with cottonwoods, "In the shedding season, the river bottoms would be ankle deep in buffalo hair."

101 Park

The white "prairie cathedrals" and the tall steeple of the beautiful Sacred Heart Church, built in 1898, mark the town of Park. Originally called Buffalo Park, this was a station on the Union Pacific Railroad. The town was named for the great herds of bison that roamed the area. These herds left their mark on the land in the form of buffalo wallows. During the spring calving season, when the weather got warm, the bison would wallow on the ground to try to rid themselves of their heavy winter hair. As a result, depressions formed in the soil, some two or three feet deep and spreading across several acres. These wallows became dust baths or water holes for the bison. If water was present, bison would wallow in the water and carry the mud away, making the wallow deeper. Even now, more than 120 years later, you can see different plants growing in buffalo wallows because of soil changes caused by the wallowing animals.

In the late 1800s, Gove County was a popular place to hunt buffalo. An early resident of Park was allowed to join an Omaha Indian buffalo hunt. The man's journal described how the specific posture of a scout on his horse would indicate buffalo were nearby. The arrows used by the Indians were grooved to indicate the tepee the hunter came from. These grooves also allowed the blood to flow out of the wound. The Indians used all parts of the buffalo: skins for shelter and warmth, meat for food, and sinews for sewing and bow strings. Most of the meat was cut into one-inch strips and dried in the sun.

99 Strong Sorghum

Throughout western Kansas, you will see fields of grain sorghum during the summer growing season. Sorghum, also known as milo, is a short, bushy plant, standing three or four feet tall, with large seed heads on top. It originally came from Africa. Sorghum is a grass, as is corn, but unlike corn it can be grown in dry, windy regions. Its roots go deep into the soil to get moisture, and the seed heads are produced late in the year, generally after the hottest weather. Sorghum's strong, stocky profile resists being toppled over by the wild winds of western Kansas. Anyone who has seen a cornfield after a severe thunderstorm will understand this choice. Farmers feed sorghum to cattle.

98 Rest Area for the Birds

During spring and fall on the High Plains, rest areas such as this one provide a resting place for travelers other than humanis—migrating birds. Rest areas, windbreaks, and the small towns scattered across the Plains are islands of trees in a sea of wheat and corn for these long-distance travelers. Some birds using this rest area may be on their way to or from South America or the Arctic. And you think you have a long trip ahead of you!

During summer at rest areas in western Kansas, you can see iridescent great-tailed grackles, with their huge, wedge-shaped tails, walking on the lawn and hear yellow and gray western kingbirds chattering from the treetops.

97 Grainfield

The next town on the right is Grainfield. In an area with many grainfields, this name was appropriate back in 1879 when a little girl riding down the trail in a wagon commented to a Union Pacific Railroad official, "Oh, what a pretty green field!" The man, who had been sent by the railroad to lay out the town site, recalled the girl's comment and decided to call the new town Grainfield. Now, more than 120 years later, wheat grows right up to the edges of town, making it the most obvious and appropriate town name along I-70.

An ornate opera house built in 1887 is currently being restored. In the early days, stock companies would arrive by rail and put on plays or concerts for three to five nights and then move on to another town. Since local schools did not have auditoriums,

dances, holiday celebrations, and graduations were also held in the opera house.

The Grainfield Grain Elevator Company, visible from I-70, operates as a farm service center. Grain is purchased and shipped. Some grain is processed into feed for cattle at surrounding farms. Fertilizer and herbicide chemicals are sold to the farmers or custom applied directly to crops. Other grain is delivered by farmers and recorded for their accounts. The elevator company functions as a grain bank, making sure there is similar grain to deliver back to the farmers when they request it for feed later in the year.

Eighty percent of the wheat stored in this elevator is shipped to markets in the United States. This elevator specializes in shipping grain of a specific quality. A state grain inspector certifies the grade and quality before the railcar or truck leaves the property.

95 "A Newer Garden of Creation"

You have seen that this land is a bountiful garden of wheat and corn. In his poem "The Prairie States," Walt Whitman called the High Plains "a newer garden of creation." In another piece, while traveling across these High Plains, he wrote the selection that follows. Maybe you, like Whitman, will find this landscape profoundly and positively engaging.

My days and nights, as I travel here—what an exhilaration!— not the air alone, and the sense of vastness, but every local sight and feature. Everywhere something characteristic—the cactuses, pinks, buffalograss, wild sage—the receding perspective, and the far circle-line of the horizon all times of the day, especially forenoon—the clear, pure cool, rarefied nutriment for the lungs, . . . the prairie dogs and the herds of antelope—the curious "dry rivers"—occasionally a dug out or corral . . . ever the herds of cattle and the cowboys ("cowpunchers") to me a strangely interesting class, bright-eyed as hawks, with their swarthy complexions and their broad-brimm'd hats. . . .

Then as to scenery (giving my own thought and feeling), while I know the standard claim is that Yosemite, Niagara Falls, and Upper Yellowstone and the like afford the greatest natural shows, I am not sure that the prairie and plains, while less stunning at first sight, last longer, fill the esthetic sense fuller, precede all the rest, and make North America's characteristic landscape.

Indeed through the whole of this journey, with all its shows and varieties, what impress'd me, and will longest remain with me, are these same prairies. Day after day, and night after night, o my eyes, to all my senses—the esthetic one most of all—they silently and broadly unfolded. Even their simplest statistics are sublime.

92 Don't Fence Me In

Fences have been installed at the side of the I-70 right-of-way to deter livestock and wildlife from wandering onto the roadway. Typically for range fence, three or four strands of barbed wire are attached to posts spaced about a rod (16.5 feet or 5 meters) apart. Barbed wire is made of two strands of steel wire twisted together with thornlike barbs at about 6-inch intervals. The first patent for barbed wire was granted to Joseph F. Glidden of DeKalb, Illinois, in 1873. Once Glidden's fence proved it could restrain cattle, many different styles of barbed wire were developed. In fact, hundreds of patents have been granted for unique ways to make a fence that will more effectively hold animals.

Arguments raged over barbed wire fences. To deter their installation, cattlemen claimed the barbs seriously injured livestock. Those who wanted free access to the prairies did not agree with farmers who fenced off areas to grow crops. Barbed wire hastened the end of open-range grazing and encouraged crop farming by inexpensively controlling livestock and restricting their movements. Some historians say barbed wire is what settled the West.

90 The Dinosaur War

One of the most bitter duels that ever took place in Kansas was held in Gove County. It was not a gunfight in front of the saloon at high noon; instead, it took place between two scientists using pens rather than pistols to attack each other.

According to the book *Heartland History: Stories and Facts from Kansas*, it all started in 1868, when a forty-foot fossil was sent to Edward Drinker Cope of the Philadelphia Academy of Natural Sciences. Cope, a renowned paleontologist educated at Harvard, was asked to identify the fossil. Cope reconstructed the figure but could not determine its identity. He named the long-necked skeleton *Elasmosaurus*, or "ribbon reptile."

However, another famous paleontologist, Othniel Marsh, dis-

agreed with Cope's reconstruction of the *Elasmosaurus*, and as a newly appointed professor at his wealthy Uncle George Peabody's Museum of Natural History at Yale University, he didn't mind pointing it out to the rest of the scientific community. This, of course, made Cope angry, and he directed his anger, bitterness, and resentment at Marsh. This disagreement set the stage for a lifelong feud, which was not merely a scholarly competition between professors; at times it resembled a full-fledged, knock-down, drag-out fight.

After reviewing the specimen, the men wondered how many more unidentified and unique fossils were in Kansas. Because Cope received the first skeleton from western Kansas and had other workers sending him fossils, he claimed western Kansas as his own research grounds. However, Marsh was tenacious, and he knew the chalk beds in Gove County were in the public domain and could be a gold mine of fossils.

Instead of a gold rush, this was a fossil rush, as both men raced to Kansas to unearth, reconstruct, and name as many of the fossilized skeletons as they could. They extracted the largest collections of dinosaur fossils ever amassed at the time.

In 1870, Marsh, accompanied by Buffalo Bill Cody, trekked back across Kansas to uncover more fossils. As luck would have it, he discovered a previously unknown flying reptile with wings over twenty feet long. He named it a *Pterosaur*.

The rift between Cope and Marsh continued to widen as they gathered fossils from the same area. Each scientist sent spies to the other's camps in Kansas, which often resulted in brawls. The scientists verbally attacked one another at professional meetings and in scientific journals. They even diverted shipments of each other's fossils.

Marsh returned to the Kansas chalk beds in the Smoky Hill River valley in 1871 and claimed to find a fossil of a huge flightless bird and other fossils. Whether he actually discovered them was a matter of great dispute. Nevertheless, he took them back to the Peabody Museum and claimed them as his own.

As soon as Marsh left Kansas to study his new finds, Cope moved back into the state and frantically tried to increase his own collection of important fossils. The autumn and winter of 1871 saw many papers feverishly produced by both men, each claiming new speci-

mens while criticizing the work of the other. Each scientist had sympathizers in the profession and in the newspapers, so their feud expanded into a national conflict.

The two scientists obtained many of the same fossils. The first to have his report printed would be recognized as the person who discovered the fossil. Cope presented a paper to the American Philosophical Society on March 1, 1872, introducing his Kansas discoveries. But the *American Journal of Science*, housed at Marsh's institution, Yale University, announced that although Cope's report was read on March 1, it was not printed for distribution until March 12, five days after Marsh's report. So Marsh got official credit and naming rights.

For the next two years, both men delved deeply into the study of their relics while abusing each other both in print and in person. All this occurred because unique fossils were found near here.

86 Grinnell: Home to Early Jerky

The town on the right was established in 1870 by German farmers. Grinnell was named after Captain Grinnell, an officer stationed at Fort Hays. In 1872, Grinnell had two large sod buildings for drying buffalo meat. The air was so dry here that meat could be stripped off in layers and hung to dry. The dried meat would be preserved and not spoil. This was critical in the days before refrigerators. The people called this meat "jerked" because of the way it was torn from the buffalo's carcass. Today at convenience stores along I-70 you have the opportunity to buy similar jerked meat in the form of beef "jerky."

85 Dryland Farming

When the prairies were first cultivated, irrigation water was not available, so farmers developed techniques for dryland farming. Dryland farming helps conserve precious groundwater. To allow moisture to build up in the soil, dryland farmers often leave some fields unplanted for a year. These fallow fields are plowed to kill weeds and keep the soil loose enough to soak up what little rain they receive. During the second year, the land has accumulated enough moisture for wheat or sorghum to grow successfully. Dryland farming allows two years of rain and snowmelt to accumulate in the soil, which may be just enough to grow one crop. Sometimes farmers can get two crops before having to leave the ground fallow.

Improved varieties of crops developed specifically for dry areas are resulting in dryland yields unheard of just a few years ago. You may notice these cultivated but unplanted fields as you drive through western Kansas.

84 Frozen Cattle Pools

The Smoky Hill Cattle Pool was formed in Gove County in 1883. Ranchers formed cattle pools to allow cattle with different brands to graze and mix together throughout the year. The cattle were rounded up once a year, branded, and sorted. Unfortunately, the pool ended in 1886 after an estimated 10,000 cattle died as a result of a severe blizzard.

It may be hard to believe if you are driving through on a hot summer day, but blizzards still kill cattle on the western Kansas range. Imagine how the winter's winds blow snow across this open landscape and how, without shelter, cattle are exposed to the fierce elements. After some blizzards, hay is airlifted to the cattle and dropped from helicopters and airplanes to prevent the animals from starving. This stretch of I-70 is sometimes closed because of blowing snow. If you are traveling during winter, don't get caught in the open like cattle. Listen for weather reports, and stay close to the shelter of local motels.

82 Hellendale Ranch

At the Hellendale Ranch headquarters on the right you are sure to see Holstein dairy cattle with those familiar black-on-white patches. There could be as many as 1,200 animals in the pens. New heifer calves are added every six to eight weeks. As they grow, they move from small pens to the larger lots.

Farm manager Cheryl Madison produces the majority of the feed for the cattle on the ranch, which extends for about three miles along I-70. A field of alfalfa is produced with the help of a circle irrigation system. Some hay is baled. Haylage (fermented hay used for feed) is produced in the bunkers along the highway on the right. Wheat, hay, and corn also are important feeds.

Only female (heifer) calves are purchased from area dairies. They live in a private individual hutch (like a big dog house) for about eight weeks. Madison explained that the most difficult part of raising calves is preventing them from getting wet and cold.

They may develop pneumonia if exposed to the elements. As they mature, heifers are artificially inseminated and then are ready to join a dairy herd. At one year of age they are sold to one of the Kansas dairies to begin their milk production "career."

Hellendale Ranch was organized in the 1930s. A second generation took over in the 1960s and was asked to maintain the name. Cheryl Madison has been developing this dairy specialty operation since the 1990s.

80 Monument Rocks

The Monument Rocks Natural National Landmark is located twenty-six miles south of Oakley, along the Smoky Hill River valley. They are impressive chalk bluffs and pyramids poking high out of the prairie. Native Americans used them as a lookout perch, and they were a landmark for travelers riding on the Butterfield Overland Despatch on their way to Denver. They are still the source of many fossils.

79 Kansas Sharks

As you sail down the highway in your car, try to imagine you are sailing across a warm tropical sea. Geologists believe that if you had been here 80 million years ago, you would have found yourself at sea. Much of present-day Kansas was part of a large, shallow, shark-infested inland sea that teemed with life ranging from coral to sea turtles. Wind and rain eroded the rocks and carried the eroded material into the water, covering the remains of dead creatures that had settled on the bottom. Over the ages, the winds and rains have again laid bare the ancient ocean bottom, including the animals that died there.

Today, the only fins you'll see along I-70 are on the backs of vintage automobiles from the 1950s and 1960s. But at one time shark fins sliced the surface of the sea here. Shark teeth are still commonly found in the area because the sharks were continually growing new teeth and replacing older ones, similar to people repeatedly losing their "baby" teeth. The Fick Fossil Museum, at Exit 76, contains more than 11,000 shark teeth discovered by Earnest and Vi Fick from the Monument Rocks. The museum also holds fossils found locally by famed paleontologist George F. Sternberg (see 159E; page 167).

Buffalo Bill Cody (Kansas State Historical Society)

77 Eliza, Not Annie

The town of Oakley, ahead, was founded in 1885. People assume that it was named for the famous female sharpshooter Annie Oakley, but it was named for Eliza Oakley Gardner-Hoag, mother of David Hoag, who founded the town. This does not make for quite as good a story, but who can argue with a son honoring his mother?

Annie never made it to Oakley, although some of the West's most famous riders passed through this area. In 1868, William "Buffalo Bill" Cody and William Comstock, both scouts with the U.S. Cavalry and Union Pacific Railroad, competed in a buffalo shooting contest about three miles west of town. It was after he won this contest that Cody began to be called "Buffalo Bill."

Oakley is located at a railroad junction tucked in the northeast corner of Logan County. It was only in 1963 that it finally became the county seat after decades of trying to get the seat moved from the more isolated, but centrally located, Russell Springs.

76 Logan County

You just clip the corner of Logan County, named after General John Alexander Logan, a Civil War veteran and U.S. senator from Illi-

nois during the years 1871–1877 and 1879–1886. The story of this county's name illustrates the rancor and divisiveness of the early politics on the Plains. Read more about it and about Governor St. John at 74E (page 151).

75 Yucca

Right at the marker for mile 74, yucca, or "soapweed," can be seen growing along both sides of I-70. The plants on the right look like shrubs with spikes pointing out in all directions. During spring and early summer, yucca may have a stem going straight up holding large white flowers. The sharp, spiny leaves stay green even in winter. The name soapweed comes from the fact that the plant's roots can be made into soap. When mixed with water, the crushed roots form a shampoo that was used by Native Americans and marketed commercially in the late 1800s. The flower stalk can be cooked and eaten like asparagus, and the flower buds and seed pods were eaten by Native Americans. The leaves have been used to make cord and twine. Yucca is pollinated by a small night-flying moth. Both the moth and the yucca are dependent on one another for their survival—a small piece of the interrelatedness of all of nature.

74 Thomas County

You are now in Thomas County, which was established in 1873 and named in honor of Civil War hero Brigadier General George H. Thomas. General Thomas was known as the "Rock of Chickamauga" because he held his ground during that key Civil War battle while others retreated. Kansas infantrymen served under his command. In Colby (mile 51), streets such as Mission Ridge, Nashville, Franklin, and of course Chickamauga are named after battles fought by General Thomas.

73 Pole Towers

The double-pole construction of the electric transmission line on the right contrasts with the steel towers pointed out earlier (281W; page 50). Electricity is routed along this line at a lower 115 kilovolts. Therefore, shorter and thus lighter-weight insulators are used to separate the cables from the support beams, allowing a somewhat simpler tower construction. This line connects the power plants in Colby ahead with plants in Great Bend to the south. At Colby there

Ring-necked pheasant

are connections with the transmission lines carrying electricity between east and west Kansas. Watch for other lines operating at different voltages as they extend from the Colby plant.

71 Ring-Necked Pheasants

You may see pheasants along the roadside and in the fields. Kansas is consistently one of the top three states for pheasant hunting. As many as 800,000 pheasants have been harvested here during a single hunting season. Hunters from all over North America come to Kansas during the opening week of pheasant season in November.

Pheasants are not a native bird, having been introduced to the United States from China. In 1760, Ben Franklin's son-in-law tried unsuccessfully to introduce pheasants to his farm. However, by the late 1800s, pheasants had been successfully established in several parts of the country.

Because they are so far removed from their current state capitals, some strongly independent citizens from southwestern Kansas, southeastern Colorado, north Texas, and the panhandle of Oklahoma seek to form a fifty-first state called Cimarron. At a recent convention they voted to make the ring-necked pheasant their state bird. No doubt this is in recognition of this bird's tremendous economic impact on the region. In Kansas, pheasant hunting annually contributes well over \$75 million to the state's economy.

69 Super Sprinklers

The irrigation systems you have seen mounted on wheels and stretching out above the crops are center-pivot rigs. These are not your typical lawn sprinklers! The machine slowly sweeps around the field, pivoting from the center, where water enters. Water flows

out through the long arm with sprinkler heads hanging from it. Deep well turbine pumps deliver water from wells, sometimes up to a mile away, to feed the arm. Electric motors drive the wheels very slowly so the arm makes one revolution in twenty-four hours or longer, sprinkling the crop within the circle. Most irrigation arms are a quarter-mile long and cover 130 acres, but some extend for a half mile, thereby watering 568 acres out of the 640 acres in a square-mile field as they sweep above the crops.

Farmers are trying to be more efficient in their water use by switching to center-pivot irrigation from "flood irrigation" systems that allow water to flow in crop rows across the ground. Many farm managers also apply fertilizers, herbicides, insecticides, and fungicides through these irrigation systems. When properly adjusted according to standards established by the American Society of Agricultural Engineers, only the amount that the crop needs is applied, most frequently with nozzles directed at the plant roots so that evaporation loss is minimized. This process of chemigation provides a safer and more effective way to treat the crops.

Center pivots create large green circles of crops on an otherwise brown landscape. It has been said that when you gaze out at western Kansas from an airplane, it looks as if you are flying over a pond with giant lily pads.

66 Pocket Gophers

The mounds of sandy soil seen along the roadway are made by plains pocket gophers. Unlike ground squirrels or prairie dogs, these amazing creatures almost never come above ground, instead remaining in underground tunnels and chambers. Pocket gophers are well designed for their subterranean life. They have small ears and eyes (not really needed in their world), and their front legs are short, thick, and muscular, with long claws for digging tunnels. Gophers do not have to turn around in their tight tunnels. Their tail is highly sensitive and acts as a "feeler" to guide the animal as it backs up through the tunnels. Gopher skin is loose and stretchy, so a gopher can go in reverse almost as fast as it goes forward. Gophers are antisocial, living most of their days alone in their tunnel systems, many of which are hundreds of feet long. The mounds you can see on the surface are made up of the soil that was excavated from the tunnels.

65 Another Power Trail

The power trail that crosses I-70 just before mile 64 is linked to the one described earlier at 73W (page III). Other trails with different construction will cross the interstate just ahead as they converge to exchange power at the two generating plants in Colby, a coal-powered steam generator and an internal combustion plant. These modern power trails vividly contrast our lifestyles with those of past travelers across Kansas trails who never saw a power line and could only imagine the wonders of electricity.

63 Mingo

Mingo, once a thriving railroad town, is named after a branch of the Sioux tribe. The Mingo Co-Ag elevator is a farmers' cooperative grain shipping point.

62 Dirt Poor

Early settlers and farmers had no way of understanding how to care for this land. Grasslands were plowed up to plant crops. Without the thick grass roots tightly holding the soil in place, the land was left exposed and vulnerable to being blown or washed away by wind and water. Inch by inch the topsoil eroded. Crops were planted in rows up and down slopes instead of across them. When thunderstorms hit or the snow melted, water flowed down the furrows, washing away topsoil and leaving behind gullies. Farmers seldom realized they were losing the richest soil and potentially their livelihood.

Today, in many areas the unproductive subsoils that had been covered for many centuries by fertile topsoil are now at the surface. The remaining nutrients in the soil are converted into crops. When crops are harvested, the nutrients leave the fields along with crops by the truckload. Many farmers have had to turn to large inputs of chemical fertilizers, which has caused pollution of groundwater used for drinking in some Kansas counties. Fortunately, farmers are developing better techniques that maintain soil fertility for future generations, while still producing a bountiful crop today. One strategy is to leave the dead plant residue from the previous season on the field to help hold the soil and to partially reestablish the natural cycle of decomposition of plant matter. Look for crop stubble left in the fields.

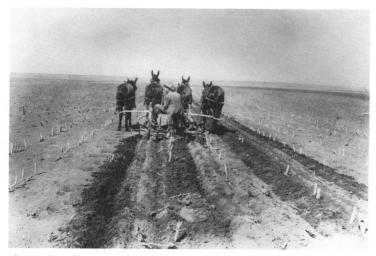

Plowing for soil conservation. It was thought that deep furrows would reduce wind erosion. (Kansas State Historical Society)

People concerned about conserving soil fertility take the longterm view, as stated in a popular conservation slogan: "We do not inherit the land from our fathers, we borrow it from our children." All these efforts are made so that our children will not find themselves "dirt poor."

60 Hill's Cows

Four generations of the Hill family have worked the land around the 7X Cattle Company feedlot on the right. Those grain bins with the spiderweb top store the corn and grain sorghum that is raised on this ranch. The cattle also eat corn silage, ground alfalfa, and rolled corn kernels. Feed is distributed to the cattle bunks that radiate out from the grain center. It's possible you could see 4,000 cattle here when the lots are filled. The livestock waste is useful fertilizer for nearby cropland.

Since this is a feeding operation, no cattle are raised from birth here. They come from nearby farmers who manage grasslands. Cattle are also purchased from the big Oakley livestock auction and from an auction in Burlington, Colorado. Sometimes cattle from as far away as the grassy hills of Pennsylvania are brought here to be fattened on western Kansas grain.

58 Off to China

Wheat collected in the tall elevator at the right is destined for export. Rail grain cars filled here will unload in the Pacific Northwest to ships destined for China and other Pacific Rim markets. Or the trains will head for Houston or Louisiana, where ships will take Kansas wheat to Europe, Africa, and the Mideast. Kansas wheat is one of the important export food products that the United States ships to hungry people all over the world.

The Cornerstone Ag complex here along the Union Pacific tracks was built to load 100-car trains of wheat, and sometimes milo, and transport them to cargo docks. The elevator, with its eight concrete bins and bright yellow legs, receives grain from farmers within a sixty-mile radius, an hour to an hour and a half away. The siding is designed to hold 100 empty hopper cars, which move under the filling chute to each receive 3,300 bushels, or about 100 tons, of grain. With the 10,000 tons loaded, the train takes off to start the trip from Kansas to China.

57 Sunflower Snacks

The silver grain storage elevators you see ahead on the right are the Red River Commodities confection sunflower processing plant. This plant mostly produces seeds for humans to eat. Sunflower seeds are dehulled, producing kernels that have a unique taste. Their rich flavor and crunchy texture add a nutty dimension to

Red River Commodities' sunflower grain elevator

recipes, whether they are used raw, roasted, whole, chopped, ground, or salted. The kernels are rich in protein and high in fiber, iron, and vitamin E.

Sunflower kernels are shipped from here to all parts of the United States and to Mexico and Canada. But the major market is confection food plants in California. Also, about 10 percent of the whole seeds are bagged and sold as bird feed. Often considered waste products, the hulls and damaged seeds are a valuable feed for cattle in nearby feedlots.

The sunflower is an American original. Unlike corn, which came from Central America, and wheat, which came to Kansas from the eastern United States and even as far away as Russia, sunflowers are native to the Great Plains. American Indians are believed to have cultivated and enjoyed the sunflower and used the nutty kernels for a quick energy food. Spanish explorers enjoyed them so much that they sent them back to Europe, and the plants have been cultivated in Europe and around the world ever since. You, too, can enjoy sunflower seeds as you travel because virtually every gas station and convenience store along I-70 sells bags of them for snacking.

55 The Prairie Museum of Art and History

Use Exit 54 to visit the interesting collection of artifacts from people and places on the Plains. The Kuska Collection contains over

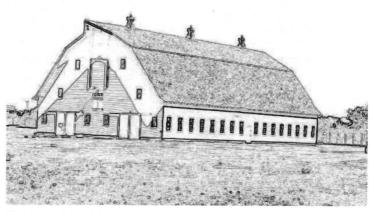

Big barn at the Prairie Museum

28,000 objects collected by Joseph and Nellie Kuska, residents of Colby for over forty years. The collection includes glass, ceramics, dolls, silver, clothing, textiles, and furniture. Since 1997, the museum has been expanding its exhibit space and now includes a 1930 restored farmhouse, a sod house with furnishings from the late 1880s, and a one-room schoolhouse.

The most striking feature on the Prairie Museum of Art and History property is one of the biggest barns in Kansas! It was built by a family named Foster as a barn for showing cattle. As a hobby, the Fosters would take their show cattle to the American Royal Exposition in Kansas City and the Denver Stock Show. The Fosters sold out to a corporation of farmers in the early 1960s. The barn was donated to the museum in 1992 and moved the nineteen miles from the Foster farm to house the museum's current exhibit depicting a 100-year history of agriculture in western Kansas.

54 Colby

This town was named after J. R. Colby, a Civil War hero who dreamed all his life of setting up his own town. On March 10, 1885, the Colby Townsite Company recorded the original plat of the town of Colby. Colby is located in the geographic center of Thomas County and is the county seat. Early settlers of Colby began to arrive in 1879. They remarked how well the land was suited to raising cattle and hunting buffalo because large expanses of buffalo grass extended "as far as the eye can see." In the early 1880s, ranching, catching wild horses, and gathering buffalo bones to sell as fertilizer were the principal means of livelihood. In fact, after the buffalo herds were wiped out, people with no other source of income gathered buffalo bones from the thousands of carcasses that littered the Plains. They received from \$6.25 to \$8.00 per ton of bones, which were then ground up and sold as fertilizer. Carcasses were particularly common along railroad lines, where buffalo had been shot for sport from the railcars and left to rot.

52 The Moser Feedlot

There are trees planted for windbreaks at the feedlot ahead on the left. Ken Moser says that protecting the cattle from winter winds is one of the major challenges in his operations. Read about this feedlot at 49E (page 146).

50 Dust Bowl Days

For four long years beginning in 1933, farmers from Texas to the Dakotas battled hard against drought. Settlers had plowed up the native prairie grass and converted it to row crops during periods of sufficient rainfall. This "sodbusting" removed the protective blanket of grass that would normally hold the soil in dry years. With the grass removed, a conservation time bomb was set to go off during the next drought. When the next round of dry years hit, the crops withered, their roots shriveled, and the soil was left to blow with the incessant Kansas wind. The years 1934 and 1935 were particularly bad. Brown dust clouds two miles high blew across the Plains. Dust storms halted autos and trains, leaving people stranded, often in total darkness. Some Kansas topsoil was carried a thousand miles east, where it settled on New York City. The irony did not go unnoticed when the U.S. Department of Agriculture building was splattered with muddy raindrops. Even a steamship 200 miles offshore in the Atlantic reported falling dust!

On May II, 1934, a storm lifted 300 million tons of topsoil into the atmosphere, roughly equivalent to the amount of earth moved to dig the Panama Canal. On April 10, 1935, a local newspaper reported, "After a brief cessation from yesterday's blow during the morning hours, a new storm swept in . . . and grew steadily worse until it was as dark as night before noon. Bright electric signs could hardly be seen across the street." It rained mud balls as the soil mixed with rain. Near Goodland, snow blew with the dust, making a dust blizzard and leaving drifts so high that a train derailed. Housewives used rugs and towels to seal door and window openings, but nothing kept the dust from entering. The dust aggravated illnesses, and people both indoors and out covered their mouths with wet handkerchiefs. One farmer said that it seemed as if the entire state was being blown away.

Depending on the site, two to twelve inches of topsoil were lost. The heavier sand particles formed dunes, sometimes burying entire farm buildings and farm equipment. Farmers had trouble making payments on their land and equipment. As immortalized in folk songs by Woody Guthrie and in John Steinbeck's classic novel *The Grapes of Wrath*, many people headed for California. Others, virtually penniless, traveled back East to cities, looking for work or

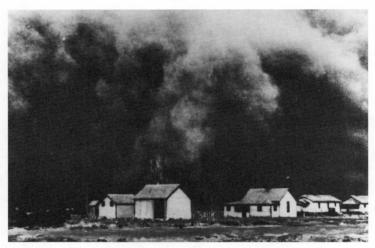

Dust cloud rolling across the plains, 1935 (Kansas State Historical Society)

benevolent relatives. But Kansans were not easily driven off the land. As a western Kansas resident wrote in her journal:

Dust whines against the windows unendingly. Food gets filled with it, clothes weigh heavy and smell chocking, and there is a grittiness about people's skin and hair and mouth that no amount of washing can get rid of. . . . But, like the original colonists, hope filters the atmosphere with a golden glamour for a number. Some yet have a pure, unfounded faith in the benevolence of nature. They know the rains will fall and another boom will again bring new settlers to the county. A regular alternative of booms and droughts is inevitable. Those who stay know the conditions and expect to accumulate sufficient funds in boom times to carry them through dry years, and borrow money only as the next resort to suicide.

Those that stayed did so with a "grin-and-bear-it" attitude, joking about dust so thick that a prairie dog was seen digging a burrow 100 feet in the air or reporting having seen birds flying backward so dust wouldn't get in their eyes. One survivor said that a man was hit by a raindrop, and his friends had to throw a bucket of sand in his face to revive him. These tall tales illustrate the resiliency and determination many people had to possess, and still do possess, to make Kansas their home.

The woman writing in her journal was partially correct. There has always been a natural cycle of wet years and drought. What she and many others still do not recognize, however, is that without topsoil there cannot be boom times when the rain returns. Occasionally, blowing soil on the High Plains still reduces visibility and dangerously impedes traffic along this stretch of I-70.

46 Levant

Nobody knows how this town name came to be. Historians know that Stephen Waters, the founding father, requested the town names of Waterville (after himself) and Fingal (after his hometown in Canada) but was turned down for both. We do know that Waters applied for a post office in 1888 after the Rock Island Line came through here. In those days, the post office often was named first, and the town took its name from that. It may be Waters had planned and platted the town after a visit by a railroad representative in late 1886, but there's no evidence of a proposed town. No other town along I-70 has such a mysterious naming history.

45 Solitary Sentinel

Directly to the right of marker 45 is a lonely tree in a field. Oh, the stories these prairie trees could tell! Not naturally growing here, and growing slowly once they do get started, they often mark the location of a homestead. Thomas Fuller wrote that "he who plants trees loves others besides himself." A tree may have been planted with the hopes that children would climb in it or swing from it, or that hammocks would hang from it and lemonade would be sipped in its shade. The planter may have imagined birds singing in the tree and breezes blowing through its branches. Such lonely trees remain a testimony to a planter who cared about others out here on the plains.

43 Another Historic Trail

That's the early highway U.S. 24 that appears as merely a frontage road along the right side of the interstate. Most of I-70's path across Kansas follows the old U.S. 40 corridor, which back near Oakley headed southwest toward Colorado Springs, as I-70 angled north toward Denver. However, I-70 follows the U.S. 24 route from Colby into Colorado. U.S. 24 connected cities in Colorado with Kansas City and Detroit. When these U.S. highways were built, they at-

tracted travelers who had been using railroads, thereby causing the reduction or even elimination of some railroad passenger service. Likewise, when more efficient interstates were built, they pulled traffic off of these two-lane highways, and roadside businesses suffered. Today the empty shells of abandoned gas stations, diners, and motels along U.S. 24 are reminders of the road's important and prosperous past.

ENTERING THE HIGH PLAINS

41 Kansas Is Not Really Flat

The dips and hills in the road ahead verify the rolling landscape here on the High Plains of Kansas. Although it is said to be flat, it's really just open spaces and wide horizons that give that impression. Although usually dry, the South Fork of Sappa Creek contributes to the topography here by forming a small valley during times when water flows in the creek. Sappa is a Native American word meaning "dark" or "black."

40 How Did They Survive?

This is a land of temperature extremes. It may be 100 degrees above zero or 10 below. There is little precipitation, and as a result there are few trees. When settlers came west, there was not even enough wood to make campfires for cooking and certainly not enough to provide fires for warmth during the long, severe winters. There was no wood to build homes or make corrals.

The land offered grass and little else, so settlers learned to make sod homes for shelter from the heat and cold. They cut dense mats of prairie grass about three inches deep, twelve inches wide, and two feet long. Slowly they would build walls out of sod and then scavenge enough branches to support sod for a roof. These dwellings were warm in the winter and cool in the summer. Some pioneers mixed the abundant native lime with water to plaster the walls of their "soddies."

Settlers gathered buffalo chips for heating and cooking. Dried buffalo chips burn quickly but provide ample heat for cooking. One account from a Kansas pioneer described using the chips—buffalo chips, unless they were dropped by Texas cattle:

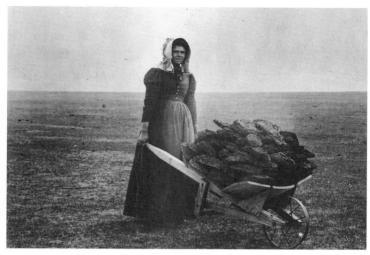

Collecting buffalo chips (Kansas State Historical Society)

Chips make a tolerable fair fire, but of course burn out very rapidly; consequently, to keep up a good fire you must be continually poking chips in and taking the ashes out. Still we feel very thankful for even this fuel. It was comical to see how gingerly our wives handled these chips at first. They commenced by picking them up between two sticks, or with a poker. Soon they used a rag, and then a corner of their apron. Finally, growing hardened, a wash after handling them was sufficient. And now? Now it is out of the bread, into the chips and back again—and not even a dust of the hands!

38 Brewster

The town of Brewster was founded in 1888 and was named after L. D. Brewster of Illinois. He was a director of the Rock Island Line railroad, which passed just south of town. Without the railroad, the town would not have survived.

37 Increasing Crop Yields

As you approach Exit 36, on the left you can check the wind direction with the wind sock at the Berkgren Chemical and Fertilizer Company's headquarters. You may see an airplane taxiing down the landing strip adjacent to the interstate. On days when weeds are to be killed or crops are to be fertilized, planes will be heading out to

the fields from sunup to sundown. About 40 percent of Berkgren's business calls for aerial spraying. On windy days (with winds over about eighteen miles per hour), they must shut down to prevent drift into the wrong places. You may also see big-wheeled, high-clearance ground rigs with spray nozzles on boom arms. These can travel through fields of tall crops, but they also have to come in on windy days. Hot days also interrupt application because the chemicals lose their effectiveness when temperatures exceed 100 degrees. Read more about this company's operations at 35E (page 142).

36 Mountain Time Zone

A sign on the county line road bridge indicates it is time to turn back your car clock and your watch. You have entered Sherman County (named in honor of General William T. Sherman, a prominent general and Civil War hero) and left the central time zone. From this point west you will be on mountain time, one hour earlier than before the bridge.

Like most everything else in western Kansas, the time zone idea is linked to the railroad. In 1883, there were about 100 different railroad times across the United States. Various localities had set their own time, declaring it was 12:00 noon when the sun was directly overhead. When it was noon in New York City, it was only 11:55 in Philadelphia, 11:47 in Washington, D.C., and 11:35 in Pittsburgh. The railroads tried to make their passenger schedules simpler and established their own railroad time for all towns along each route, but even this left confusion. So the railroads agreed to establish four time zones across the United States, each centered on a meridian of longitude, fifteen degrees apart. By 1884 a similar pattern of twenty-four time zones was established worldwide.

34 Jackrabbits

Watch for jackrabbits as you travel on through western Kansas. They are larger and have longer ears and hind legs than the familiar cottontail rabbit. Jackrabbits can quickly accelerate up to forty miles per hour.

In the 1930s, jackrabbits were exported from this area to stock game preserves in Illinois. Fortunately, they failed to survive there. Stocking of game animals was a common practice until recent decades. Modern wildlife managers now know that introducing non-

native animals to an area is costly and almost always fails. When it does succeed, it has devastating effects on the native wildlife. Even stocking native species is often costly, wasteful, and unnecessary. If good habitat is present, the animals usually will be there. If the habitat is poor, all the stocking in the world won't establish the animal, at least for the long term. Habitat is the key!

31 Innovative Agriculture

When I-70 was constructed, fill dirt was frequently required. This was "borrowed" from the adjacent fields such as the one on the right. In many places, a vertical bank was left in the farmer's field. Farmers have been innovative in returning these areas to production or developing new uses such as a feeding center. You will probably see bales of hay stored and trenches cut in the bank as a bunker silo. The openings can be lined with plastic and filled with chopped alfalfa or stalk corn, then covered to seal out the air. Silage develops in the oxygen-reduced bunkers, producing rich cattle feed.

30 Treating Soil Like Dirt!

As you have driven across Kansas, you have read about soil conservation. Agronomists study soil and take soil very seriously. To them, what you see covering the fields is not dirt but soil. They say dirt is what's under your bed or fingernails. To them, dirt is misplaced soil.

Have you wondered what makes up soil? It is a mixture of very small particles worn from rocks, dead and decaying plants and animals (called organic matter), water, air, and billions of living organisms, most of which are microscopic creatures called "decomposers." Decomposers participate in nature's cycle of life and death by converting dead organic matter into forms that can be taken up and used by living things. By making organic nutrients available, they improve the soil's fertility. Good soil is alive and keeps other things, including humans, alive.

Our soil is a national treasure. President Franklin D. Roosevelt correctly said, "The nation that destroys its soil, destroys itself." Our welfare is linked to the soil because nutrient-rich soil grows healthy plants, which in turn support healthy wildlife populations, healthy livestock, and healthy human populations. Good soil grows

plants, animals, and people. Throughout history, civilizations have prospered because of their fertile soil. When they abused their soil and allowed it to wash or blow away, these civilizations crumbled. It's encouraging to note that along I-70 you have seen techniques such as terracing, grass waterways, and field windbreaks being used by farmers to save our soil and protect our nation's prosperity.

28 Ed & Son

Exit 27 marks Edson, population fifty. The town was named because Ed Harris and his son settled here in 1888.

A tragic event occurred just north of what is now Edson in 1867. Because of Indian uprisings, Lieutenant Colonel George Custer and 1,100 soldiers from Fort Hays (see 157E; page 167) were camped along the Republican River north of here. Lieutenant Lyman S. Kidder, along with a ten-man escort and an Indian guide, was sent with a message to Custer declaring, "Beware the hostiles." Unfortunately, Custer had become restless and had decided to travel northwest to Fort Sedgewick. Lieutenant Kidder found Custer's old camp and assumed he had headed south. On July 2, 1867, Sioux and/or Cheyenne Indians attacked Kidder and his party. None of the soldiers survived. Their bodies were found by Custer's men ten days later.

GOODLAND

26 Winning the County Seat

When counties were being formed, towns competed to be the "county seat." These competitions were always bitter and sometimes violent and destructive. You probably take your county seat for granted today, but in this sparsely settled region, having the county government locate in your town was a big deal. Being the county seat "put the town on the map," so to speak, and held the promise of economic development, political clout, and enhanced civic status for the citizens.

Goodland, just ahead, captured the Sherman County seat from several competing towns. According to *The WPA Guide to 1930s Kansas*, here's what happened. Prior to the founding of Goodland, a hard-fought and bitter election resulted in voters choosing the

town of Eustis to be the county seat. At the vote count, people representing the different towns came heavily armed with clubs, Bowie knives, and pistols, but amazingly none of these weapons were used. When Goodland was formed, citizens in the towns that lost the election combined forces with the people in Goodland and held an election to snatch the designation from Eustis. Recalling the weapons brought to the last vote count, Goodland supporters ordered twelve repeating rifles from Pennsylvania to supplement their arms for this election.

Goodland won the 1887 election without incident, but after the courthouse was built, leaders in Eustis refused to surrender the county records. The leaders of Goodland devised a plan to get the records. They secretly hid 300 men in Goodland's empty courthouse and then sent their new sheriff to Eustis to arrest, individually, every man in Eustis! The entire male population was rounded up on false charges, including cattle stealing, wife beating, polygamy, murder, and even harboring a dog without a license. The men went willingly, anxious to clear their names before a judge. The men were taken into a courtroom, where the judge began a mock trial.

Meanwhile, as soon as the trial started, Goodland's 300-man army headed for Eustis to seize the records. An old-time local resident, Colonel George Bradley, saw the men slipping away from the courthouse and figured out what was happening. He got in his buggy and rode to Eustis to confront the Goodland men. When they encountered Bradley, the Goodland group opened fire around his feet, then continued their raid on the Eustis courthouse. They successfully made off with all the records except for the official returns for the 1887 election, which were hidden in a trunk at the county clerk's home. Bradley, knowing this, stole the records from the clerk's home on his way back from Eustis. Later, a local banker who wanted to expedite Goodland's county seat designation then offered to hire—of all people—Colonel Bradley as a detective and pay him \$1,500 if he could solve the crime and produce the stolen election records! But, before Bradley could take advantage of this offer, the Kansas Supreme Court ruled that Goodland was indeed the county seat and the election records were no longer needed. Colonel Bradley then burned them.

Goodland residents experienced all this strife for the honor and,

more important, the financial benefits of having their town as the county seat. Goodland is now a town of 5,700, whereas Eustis is not even on the map.

22 Rainmakers

Rainmakers first appeared in Goodland during the droughts of the 1890s. Frank Melbourne, billing himself as the "Australian Rainmaker," was offered \$1,500 if he could make it rain one inch within a twenty-four-hour time limit. Announcements were posted in railroad stations throughout Kansas and Nebraska. It didn't rain in Goodland, but within twenty-four hours flash floods occurred in Nebraska, causing such damage that towns began telegraphing Goodland, imploring the people there to shut off the rainmaker. Melbourne promised to tell the county his secret and donate a machine so the local people could make their own rain. But, in July 1895, Melbourne admitted his scheme was a hoax, and the people ran him out of town. Melbourne's method was to pour sulfuric acid on zinc to release hydrogen, which would rise and combine with oxygen in the atmosphere to form $\rm H_2O-water!$

Melbourne was just the first of many rainmakers here. A local chemist and a railroad agent had been conducting experiments similar to Melbourne's, and it happened to shower after one of them, so they formed a corporation and sold stock in it. Californians hired them to make rain in several valleys. The Mexican government also sought their services, but the Mexican drought ended before they made Mexican rain.

Dr. L. Morse, a Goodland druggist, operated a rainmaking company for about twenty years. In the summer of 1892, the wheat was burning up in the fields. The postmaster paid Morse fifty dollars to buy chemicals to make it rain. He bought sulfuric acid and began his experiment at ten o'clock in the morning; by two o'clock, according to one report, the wooden sidewalks were afloat, and children were using them for rafts. The railroad even got into the rainmaking action with its own rainmakers and three laboratory train cars, which toured the rails throughout Kansas.

Groundwater management districts here still try to modify weather by "seeding" clouds from airplanes. This modern "rainmaking" is done mostly to diffuse potential hailstorms that would destroy the crops.

20 First in (Helicopter) Flight

If you pass a car from North Carolina, you'll notice that its license plates have the state motto "First in Flight." While North Carolina has the Wright Brothers and their aviation exploits, Goodland is home to America's first helicopter. Two Rock Island railroad machinists, W. J. Purvis and Charles A. Wilson, designed, built, and patented their invention in 1909 and 1910. The machine used two counterrotating rotors to offset engine torque rather than the modern tail rotor. A full-size replica of the original machine can be seen in the High Plains Museum in Goodland.

19 The Big Easel

Yes, that is an easel with a painting way over there on the right. It is eighty feet tall and weighs 40,000 pounds. The "canvas" is twenty-four sheets of standard plywood, providing a twenty-four-by-thirty-two-foot surface on which artist Cameron Cross has reproduced one of Vincent van Gogh's sunflower paintings.

Cross put up his first big easel with a sunflower reproduction in his hometown of Altona, Manitoba. Since van Gogh created seven sunflower paintings, Cross decided to reproduce all of them and install them in different countries. His second is in Queensland, Australia; Goodland, here in the heart of sunflower country, was selected for the third site. The other sunflower paintings will go to areas with a connection to sunflower agriculture or van Gogh himself; places like the Netherlands, Japan, South Africa, and Argentina.

Sunflower painting

The sunflower painting was created with an industrial acrylic urethane enamel, the kind used on ships and farm machinery that is exposed to heat, chemicals, and ultraviolet. Ten layers of enamel were used to assure long life for those big sunflowers. Exit 17 will take you to the sunflower painting and to the High Plains Museum.

18 Good Land

The town was named Goodland not because the founders thought it was particularly "good land" but because a stockholder in the town company was from Goodland, Indiana. However, the name fits, at least for wheat farming.

Today, Goodland is a busy commercial center and one of the largest towns in northwest Kansas. It has adopted the clever motto "Goodland—On the Top Side of Kansas," referring to its position in the northwest corner and the fact that it has the highest elevation of any city in the state.

The bricks in Main Street were laid by Jim Brown in 1921 at the astounding rate of 150 bricks per minute, more than 2 per second. Moreover, even at that great speed he laid them so straight that no adjustments were necessary.

16 Living Snow Fences

The rows of pine trees on the right side of the interstate beyond the overpass serve as living permanent snow fences. The trees will stop the wind, and snow will pile up behind the trees rather than on the roadway. You may recall seeing other living snow fences back at mile 229W.

14 Caruso

Yes, the town at Exit 12 was named after the famous Italian tenor Enrico Caruso. Sometimes called Caruso Station, it is another small railroad town. Although apparently the founders of this town appreciated opera or at least Caruso's talents, "opera houses" found in most of these small towns did not host opera companies. As noted back at Grainfield, they were venues for all sorts of entertainers that the railroad would bring to town, including stock companies and vaudeville acts. Opera houses served as a community gathering place, functioning much as a civic auditorium would today.

13 A Different Kind of Oil

On the right, the elevators at Northern Sun only store sunflower seeds. This division of ADM Corp. ships sunflower oil from the plant you see ahead on the right. Sunflower seeds are trucked to this location from a sixty-mile radius or farther. The oil, similar to that which you purchase at the grocery, is extracted using high-pressure presses, and a protein-rich cake remains after the oil is extracted. The oil is shipped to food operations across the country. The cake is a high-energy concentrate that is sold to local feedlot operators as a valued supplemental cattle feed.

In the summer you will see fields of bright yellow sunflowers in the surrounding farms until they are harvested around the end of July. The sunflower is native to the fertile Great Plains. American Indians are believed to have cultivated and enjoyed the sunflower and used the nutty kernels for a quick energy food.

Spanish explorers enjoyed the Indian kernels so much that they sent them back to Europe. Ever since, they have been cultivated in Europe and around the world. Today in the United States several varieties of sunflowers are grown commercially. There are two primary types of seed. One type is used for oil, like those shipped to the storage elevators here. The other type, confection sunflowers, the kind you buy to shell and eat the kernels, is handled in an entirely different manner, such as described at Red River Commodities (57W; page 116).

10 Ruleton and "the Rock"

At Exit 9 is the town of Ruleton, a small farming community that survived because of the Rock Island Line. As we have mentioned previously, railroads gave life to many Kansas towns like Ruleton and caused the death of others they bypassed. Railroads served as an economic umbilical cord to the outside world. As railroads themselves die off, many towns that were linked with them from birth struggle for survival on their own, many unsuccessfully. The Ruleton Cooperative collects and stores grain from area farmers at the elevator along the railroad to the right. It is part of Frontier Equity Coop in Goodland, whose elevators receive wheat, corn, and sunflowers.

9 Controversial Critters

This is prairie dog terrain, the kind of area where prairie dogs build towns. Prairie dogs are fascinating social creatures that get their name from their doglike "bark." They like areas with short grass, where they can stand on their hind legs and look out over the vegetation to detect danger.

Prairie dog burrows provide homes for many other forms of wildlife, including burrowing owls, snakes, and the endangered black-footed ferret. Before the land was converted to ranches and farms, dog towns stretched for many miles and contained millions of prairie dogs. Today only about 1 percent of the number of prairie dogs that existed before settlement still survive on the Great Plains. Ranchers sometimes poison prairie dogs because they compete with the cattle for grass and because cattle sometimes injure themselves by stepping into prairie dog holes. So, depending on your perspective, prairie dogs are destructive pests, cute and cuddly, or an important part of the prairie ecosystem.

7 Rest Area

Before you leave Kansas, the rest area provides one more setting of rolling hills to assure you the state is not really flat. A historical sign explains that this Dwight D. Eisenhower Highway was designated in August 1973 by the U.S. Congress as "a legacy of safety and mobility that has brought all Americans closer together."

6 The Wayward Wind

If you have been traveling across Kansas, you already know that the wind seems to blow continuously here. The incessant wind aggravates and agitates some people until they cannot take it any more. Over the years, many have left to seek calm days in tree-filled terrains back East or farther west. Some stayed and put the wind to work with windmills to pump water to the surface and wind turbines to produce electricity. Rather than detesting the wind, resilient residents have learned to have fun with it, and some are even inspired by it. The Goodland Chamber of Commerce sponsors Windwagon Races each fall. Contestants hoist sails on homemade wagons and race down a stretch of Highway 24. This wind inspired Fred Atchison to write the following poem:

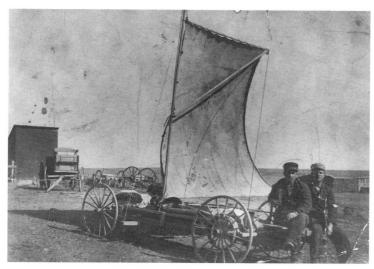

Late nineteenth-century wind wagon (Kansas State Historical Society)

The Prairie Wind I'm thinking of you, prairie wind running free across Kansas plains and see the evidence of our presence billowing seas of golden grain

You etch your mark on sandstone cliffs sculptures carved by a timeless hand and move soft brushes of prairie grass drawing circles across the sand

It is humbling when I realize these soft breezes reaching me now whispered lullabies to the Indian child before the prairie was put to the plow

4 The High Point

You are at the highest point on I-70 in Kansas. At mile 3.7 the elevation of the roadway is 3,910 feet above sea level. Back where the Kansas River empties into the Missouri River, the elevation was 760 feet. It is our hope that you have had many high points in your journey across Kansas.

3 Mountains, Real and Imagined

About twenty miles off to the left, in a pasture on private ranchland, is the highest spot in Kansas, called Mount Sunflower. The U.S. Geological Survey officially plotted the elevation of Mount Sunflower at 4,039 feet above sea level—not exactly ear-popping! However, Mount Sunflower is not considered a true mountain because there isn't a 2,000-foot altitude change within a tento twenty-mile radius of the peak. Even so, many like to conquer Mount Sunflower, just because it's there.

Many first-time travelers to Colorado expect to see real mountains soon after crossing the state line. It is normal to look hard at the horizon with anticipation of seeing the first snow-capped peaks. Travelers have been doing it since the days of the wagon trains. But the landscape and scenery in Colorado will not be much different from that in Kansas for quite a while, since you are still about 150 miles from the front range of the Rockies. That means many more miles of High Plains.

2 Beaver Creek and the Border Town

The name of Beaver Creek reminds us that although it is dry today, Beaver Creek once had enough water to support beavers. Water is becoming more scarce in this region.

There is one more exit in Kansas. Exit I marks the town of Kanorado. This town with the hybridized name of the two bordering states was declared a city in September 1903 and currently has about 200 residents.

HAPPY TRAILS!

You are entering Colorado. We are pleased you chose I-70 for your travels and that you have used this book to add to your adventure. We trust that this guide has been an enjoyable companion, providing you with a greater appreciation for and understanding of the many significant sights along I-70 in Kansas. We hope that as you traveled across our state you were pleasantly surprised by our topography, history, natural beauty, prosperity, and productivity. Most of all, we hope you will return soon to travel more Kansas trails.

Eastbound

1 The High Point

Exit I marks the town of Kanorado. South of Kanorado is the highest point in Kansas, Mount Sunflower, with an elevation of 4,039 feet above sea level. These next few miles will be the high point of your trip along I-70, at least in terms of elevation. From a peak elevation of 3,910 feet at mile 3.7, travel east is all downhill; you will drop more than 3,000 feet by the time you get to Kansas City.

2 The High Plains

Kansas consists of eleven distinct regions, each differing in elevation, vegetation, precipitation, topography, wildlife, and history. You will cross four of these regions if you travel I-70 across the entire state. To the surprise of most people, and in spite of what you may have heard, none of these four regions is flat.

You have entered Kansas in the High Plains region, which covers the western third of the state. This is the largest, highest, and driest region in Kansas. It receives only between sixteen and twenty inches of precipitation per year, and elevation ranges from about 4,000 feet along the Colorado-Kansas border to 2,000 feet above sea level at the eastern edge of the region. The High Plains have a reputation for being windy and for having extreme temperatures (both cold and hot), which can fluctuate wildly, sometimes changing by fifty degrees in twenty-four hours.

3 Sunny Sherman County

Known as the "Mountain Climate Capital of Kansas," Sherman County has an average humidity of only about 27 percent, with 300 days of sunshine per year. This abundant sunshine is the solar energy that is converted by crops into food energy and stored in the grain growing in the bountiful fields you will be driving past. When you eat a piece of bread or corn, you are eating a bit of sunshine, getting your energy from solar energy that traveled 93 million miles to a place like Sherman County, Kansas, and then to your table.

Sherman County receives only about sixteen inches of precipitation annually, so the streams here are usually nothing more than dry gullies, or "washes." As you crossed the Middle Fork of Beaver Creek, you probably noticed that it is dry. But the gullies on both sides of I-70 provide proof that the rivers occasionally run; these gullies were created by water washing away the soil when the area has a "gully washer" of a thunderstorm. The name Beaver Creek indicates that at one time there was a steady supply of water to support beavers.

Sherman County was established in 1869 and named in honor of General William T. Sherman, a Civil War hero and prominent general in the U.S. Army. In the late 1800s, Kansas was called the "Great Soldier State" because so many Civil War veterans settled there. There were more Grand Army of the Republic members per capita than in any other state. No wonder that forty-six Kansas counties are named for Civil War soldiers, most of whom died in battle.

5 Goodland

Just ahead is Goodland, the county seat of Sherman County. Towns would fight to become the county seat. Read the story of how Goodland became the county seat at 26W (page 126).

6 Official Kansas Welcome!

At the Travel Information Center ahead you can receive not only tourism information but also a free cup of coffee, Kansas souvenirs, and a warm welcome. The Kansas flag will be waving in the wind (we can almost guarantee the wind). In the center of the dark blue flag is the state seal, which paints a picture of Kansas history. The thirty-four stars represent the fact that Kansas was the thirtyfourth state admitted to the United States. The rolling hills depict those near historic Fort Riley, hills you will see later in your trip along I-70. Scenes on the seal-Native Americans hunting bison, wagon trains heading west, and steamships carrying supplies up the Kansas River-all represent important activities and eras in Kansas history. The farmer plowing fields near his cabin represents the fact that agriculture has always dominated the economy and landscape of Kansas. The state motto, Ad astra per aspera, meaning "to the stars through difficulties," is included in the state seal. A sunflower, the state flower, is above the seal.

The Kansas flag welcomes you.

8 Ruleton: "The Rock and a Coop"

The Ruleton Cooperative stores grain from area farmers at the elevator along the railroad to your left. Cooperatives (called "coops" for short, and generally spelled "coop") have become a common way of doing business. An ag-cooperative consists of farmers who unite to buy supplies and market their crops more profitably. A basic coop code specifies democratic control, with each member having one vote and receiving a distribution of net profits in proportion to the amount of his or her patronage. This coop is part of Frontier Equity Coop in Goodland (see IoW; page I3I).

For clarity, we will refer to a single tall, round storage structure at an elevator as a "bin" and reserve its other name, "silo," to describe the familiar on-farm cylinder-shaped structure. An "elevator" is a cluster of bins with a single mechanism to take the grain to the top. It is so named because grain is "elevated" to the top of the tall storage bins. In one type of elevator, buckets attached to a moving belt scoop the grain and carry it to the top. At the top, grain is discharged to one of the chutes, where it flows by gravity down into one of many storage bins. Most Kansas towns have large coop elevators like this one, where grain from member farms is stored.

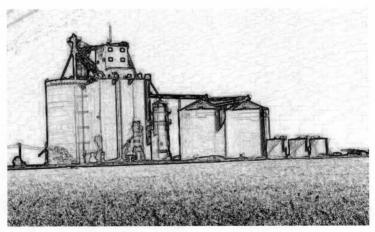

Frontier Equity Coop grain elevator

You will see many grain elevators in the miles ahead and read more about their important economic function.

10 A Different Kind of Oil [13W; page 131]

The Northern Sun elevator that you see on the left stores only sunflower seeds. Sunflower seeds are trucked to this location from fields within a sixty-mile radius, sometimes farther, to be made into sunflower oil.

12 Caruso [14W; page 130]

Most towns along I-70 are named for settlers, soldiers, or places back East, but this town was named for the Italian tenor Enrico Caruso.

13 Controversial Critters [9W; page 132]

On the right side in the corner of the field, you can see the earth mounds of what was once a small prairie dog town.

14 Super Sprinklers [69W; page 112]

The large metal structures in the fields are center-pivot irrigation systems. The long arms move slowly over the crops like the hand of a clock while spraying water pumped from a well.

15 Living Snow Fences

The rows of pines on the left side of the interstate were planted to serve as living snow fences. You will see several living snow fences over the next few miles. Other examples of trees being used to block the wind will be seen at miles 49E and 58E and throughout your trip across the High Plains.

16 Goodland [18W; page 130]

This town is surrounded by good land for growing wheat; however, Goodland was named for Goodland, Indiana. The name was not meant to make a statement about the quality of the local land.

17 The Big Easel [19W; page 129]

Exit 19 will take you to the enormous Vincent van Gogh painting seen off to the left. One of van Gogh's seven sunflower paintings is reproduced here on a giant easel.

18 First in (Helicopter) Flight [20W; page 129]

Use Exit 19 to visit the High Plains Museum and see one of the world's first helicopters.

19 "A Dry and Thirsty Land" [126W; page 94]

People here have been so desperate for rain that they sometimes have turned to "rainmakers." Read the story about the "Australian Rainmaker" at 22W (page 128) and more about irrigation on the Plains at 126W (page 94).

21 Pump Protection

Those small shelters like the one at the right along the fence row, or out in the field, protect motors and pump controls at irrigation

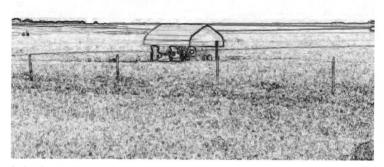

Irrigation pump protector

wells. Each center-pivot irrigation machine has its own well with a deep well turbine pump to lift water from the Ogallala Aquifer. In some places water is more than 300 feet below the surface. Pumps are powered by electricity or by diesel or gas engines. The pump at mile 21 uses a 413-horsepower Chrysler gas engine to deliver 650 gallons of water per minute through a 2.5-inch pipe at 30 pounds per square inch pressure. During the seven days it takes the machine to complete a full circle, the pump will have delivered more than 65 million gallons of water to the cornfield.

Legally, groundwater belongs to the State of Kansas. Farmers can apply for a "water right" permit by demonstrating that they can use groundwater productively. This is called "perfecting" a water right.

22 Spiderweb Bins and Blue Silos

The spiderweb-like towers and chutes radiating from the top of the bins on the right signal on-farm grain processing. At this farm, 2,000 head of cattle may be fed. When trucks arrive, grain is elevated in the tall center shaft by a bucketlike conveyor. It is then directed through one of the tubes connected to the round grain bins.

A half mile down the road, additional grain is stored in the tall,

Bins and silos

blue Harvestore silos. Many of these glass-lined steel silos can be seen across Kansas. The unique design allows storage of hay or grain that is too wet for conventional storage, such as grain that is not completely ripe. It can also store fodder, the whole plant—stalks and seeds. Wet crops are "ensiled" to turn them into a rich feed in the oxygen-controlled Harvestore environment. There is more at 33E about "ensiling" in a silo to slightly ferment the plant material, enhancing its value as feed.

24 "A Newer Garden of Creation"

This is what Walt Whitman called this region in a poem called "The Prairie States." While traveling across these High Plains he also wrote the selection in 95W.

26 Ed & Son [28W; page 126]

The Kidder Massacre site is thirteen miles north of Edson on North Edson Road 27.

The Edson SIGCO grain elevator collects wheat. From this location, about 1.5 million bushels (more than 400 railcars full) of wheat are shipped annually to a flour mill in Utah. Farmers from as far away as Colorado and Nebraska sign annual contracts to bring grain here daily during the harvest season.

28 The Wayward Wind [6W; page 132]

It seems like the wind blows ceaselessly here in the region Ian Frazier called "the airshaft of the continent," but some locals use it and even have fun with wind.

31 Don't Treat Soil Like Dirt! [30W; page 125]

People concerned about conserving soil take the long-term view, as stated in a popular conservation slogan, "We do not inherit the land from our fathers, we borrow it from our children" (see also 62W; page 114).

33 Silos

The tall, cylindrical objects seen near barns are silos. Silos, such as those on the right, are used to make "silage," a succulent feed for livestock, especially on dairy farms. Damp grain, hay, or alfalfa is placed in the sealed cavity of the silo, where it ferments, making a nutritious feed for cattle. The fermentation breaks down the plant material, making it easier to digest. From the early 1900s until the

Harvestore silo

1950s, silos were made of concrete or wood. Then, as mentioned at mile 22, another option became available, the dark blue, glasslined steel Harvestore silos, which make a richer feed. Some farmers dig trenches and put in chopped crops to ferment. You will see several of these trench silos along I-70. A recent innovation is a large, tube-shaped plastic bag that is filled with plant material and sealed. It essentially functions as a silo lying on its side. Before long, an old-fashioned upright silo may be a thing of the past.

34 Thomas County [74W; page III]

Ahead is Thomas County, established in 1873 and named in honor of Civil War hero Brigadier General George H. Thomas.

Exit 36 goes to Brewster, visible on the left. Brewster was named after L. D. Brewster of Illinois, a director of the Rock Island Railroad when the town was founded in 1888.

35 Increasing Crop Yields

As you approach the farm service center on the right at Exit 36, you'll also see an airplane hangar and a wind sock. About 40 percent of the Berkgren Chemical and Fertilizer Company's business calls for aerial spraying to help farmers grow more productive

Berkgren Chemical and Fertilizer Company

crops. The company applies chemicals to control field pests and weeds, as well as fertilizer to satisfy the plant food requirement for growing the major crops—sunflower, corn, wheat, and sorghum.

In some places the top layers of soil have blown away after the native prairie sod was replaced with crops. Then the natural cycle of plant growth, death, and decomposition was broken because every year crops are harvested and sent around the world to feed people. When leaves, stems, grain, and other plant matter leave the field, they carry away nutrients taken up from the soil. Nutrients must be replaced if production is to be sustained. Most farmers use chemical fertilizers to compensate for the loss of nitrogen, phosphorus, and other minerals needed for growing plants. If excess chemicals are applied, though, some leach into the groundwater. In some Kansas counties, drinking water has been polluted. Farmers and specialists like Berkgren are continually developing better application techniques to maintain soil fertility and water quality while still producing bountiful crops. Likewise, conservation farming techniques are being developed to reduce soil loss while improving productivity. One strategy is to leave the dead plant residue from the previous season on the field to hold the soil and to stimulate the natural soil-building cycle of decomposition of plant matter.

Eliminating weeds is another part of the Berkgren business. The company applies herbicides to fields within a fifty-mile radius of its business to stop weeds from using precious moisture and nutrients needed by the crops. The most difficult to kill, according to licensed chemical operator Jim Dirks, is bindweed. Also, plenty of unwanted cheat grass, pig weed, and thistle grow in the fields. In late summer you may see wheat stubble being sprayed after harvest. Farmers prefer to stop all green growth so water can be conserved for the next crop that will be planted.

At Berkgren's a plane may be picking up supplies or heading out to the fields anytime from sunup to sundown during the growing season. On days when the wind speed is more than eighteen miles per hour, spraying must shut down to prevent pesticide from drifting into the wrong places. You'll also see big-wheeled, high-clearance ground rigs with spray nozzles on boom arms. These travel through fields of tall crops but also have to come back to the center on windy days. Hot days also interrupt application, since chemicals lose their effectiveness when temperatures exceed 100 degrees.

38 Time Zones [36W; page 124]

Don't speed up, but it's later than you think! At the Thomas County line marker, you left the mountain time zone and lost an hour. Turn your watch and car clock ahead one hour for central time. Four Kansas counties bordering Colorado use mountain time; the rest of Kansas is on central time.

39 Kansas Is Not Really Flat

Notice the rolling landscape. Western Kansas is thought of as flat, but it is really just open spaces and wide horizons that give this impression. Later in the trip across Kansas, you will drive through the Smoky Hills and the Flint Hills—regions that are not at all flat.

40 Homes on the Range

Cattle ranches are common throughout the High Plains. Most ranches are large compared with those farther east. It takes more acres to support each head of cattle out here where grass is short and sparse. A herd that could live on a few acres in Missouri would need hundreds of acres to survive on the High Plains. Here on the short-grass prairie, the only plants that survive are those that tolerate very dry conditions. Plants like cactus or yucca and grasses such as buffalo grass and blue grama can survive the long, hot periods between rains. These grasses are important for holding the soil and are good for grazing livestock.

Ranches here grow more than beef. Grama grass is a good source of food for jackrabbits and prairie dogs, which in turn are good food for hawks and coyotes. Finches, longspurs, and other birds eat the grama seeds. North America's only kind of antelope, the pronghorn, grazes these grasslands.

41 Bison

Imagine this entire landscape covered by a lawn of short green grass. That is the way it looked at one time. Then imagine buffalo, more accurately called bison, by the millions roaming and grazing on this green carpet. That is the way it was before settlers arrived. Between 12 and 20 million bison roamed the Plains, with some herds large enough to cover an area five miles wide and fifty miles long. Herds were so densely packed that one observer in 1860 described the scene as a "monstrous moving brown blanket" that would take days to pass by a campsite.

The arrival of the railroad quickly eliminated bison from Kansas. At first, the white men killed the bison only for their meat and hides, but soon after the railroads arrived, bison were killed from trains by sport hunters and often left to rot. By 1875, there were so few bison left that Kansas passed laws attempting to protect the remaining few. But it was too late. This slaughter of the bison not only eliminated a source of fuel and food for settlers but also helped to seal the fate of the Plains Indians, who depended on bison herds for their own survival. In fact, this dependency provided additional motivation for some "buffalo" hunters.

Today bison can be seen on ranches where they are raised commercially like cattle, for example, near Fort Hays (mile 157), between miles 234 and 235, and at Konza Prairie (mile 306). Although the meat is still mostly a novelty, many Kansas restaurants serve buffalo steaks and buffalo burgers as an alternative to beef. Watch for small herds of these impressive mammals as you drive along I-70 and try to imagine what it must have been like when millions of bison roamed this land

43 How Did People Survive?

Depending on the season, as you travel I-70, outside the comfort of your car it may be 100 degrees above zero or 10 below. Besides being a land of temperature extremes, western Kansas is an environment with little precipitation and, as a result, few trees. When settlers came west, they could not find wood to build homes or make corrals. There was not even enough wood to make campfires for cooking and certainly not enough to provide fires for warmth during the long, severe winters. To survive, settlers had to make use of the few resources the land offered—sod and buffalo chips (40W; page 122).

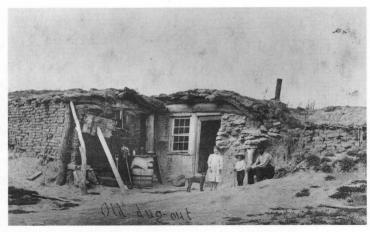

Sod house, 1895 (Kansas State Historical Society)

45 Levant [46W; page 121]

Several theories exist, but nobody knows how this town got its name. No other Kansas town along I-70 has such a mysterious name.

46 Dust Bowl Days [5oW; page 119]

In the 1930s western Kansas became part of the dust bowl. Skies were blackened, and roads and buildings were blanketed with blowing soil. Read about these storms at 50W and 143W (page 89).

49 Feedlots

At the Moser feedlot on the hill to the right, about 10,000 cattle are fed each year. Some of the cattle are purchased from farms throughout the area, where they have been raised on the grassland pastures. Others come from farms in Pennsylvania and Virginia. The 600- to 800-pound animals are fed rolled-corn, silage, and alfalfa hay. They also eat the protein-rich sunflower hulls and cracked seeds from the Red River Commodities plant in Colby. This makes productive use of 10,000 pounds per day of what otherwise would be a waste product. Supplying each of these animals with the twelve gallons of water they need every day is as critical as providing enough corn and hay.

When the cattle weigh 1,200 pounds, they are sold to the beef market. Ken Moser explains that the biggest challenge in operating

a feedlot is marketing at a price that will pay for all the work, the feed, and the investment in facilities. Severe cold and blizzards present another challenge to the cattle farmer because they make it difficult to get feed out to the bunks, and then snow gets into the bunks, or water tanks freeze. Snows and winds are more critical in the feedlots on the west slope. Here the feedlots on the east side are protected from the winds. According to Moser, another critical time for cattle is during hot spells when it becomes dusty, creating conditions that make it easy for the animals to contract pneumonia.

Cattle feeding is one of Kansas's major industries—a \$500 million industry at the turn of the twenty-first century. The state ranks among the top five in beef feeding in the United States.

51 Colby

This town was named after Civil War hero J. R. Colby. Read about its early settlement at 54W (page 118).

52 The Prairie Museum of Art and History [55W; page 117]

At the next exit, a restored farmhouse from 1930, a sod house with furnishings from the late 1880s, and a one-room schoolhouse can be seen at the Prairie Museum of Art and History. The museum houses an interesting collection of artifacts from people and places on the Plains. From the interstate you can see to the left a most striking feature, one of the biggest barns in Kansas.

54 Sunflower Snacks [57W; page 116]

On the left at Exit 54 you see silver grain storage elevators at the Red River Commodities confection sunflower processing plant. In contrast to elevators that store sunflower seeds pressed for oil (like the one back at mile 10), the products of this plant are mostly intended for human consumption. Sunflower seeds are a popular snack in Kansas and are sold in virtually every convenience store. The sunflower seeds you munch on may have come from nearby fields or from this processing plant.

55 Wheat for the World [58W; page 116]

Wheat collected in the tall yellow elevator at the left is destined for export. Rail grain cars filled here will head for cities along the Gulf of Mexico, where ships will take Kansas wheat to Europe, Africa, and the Mideast. Other trains will unload this wheat in

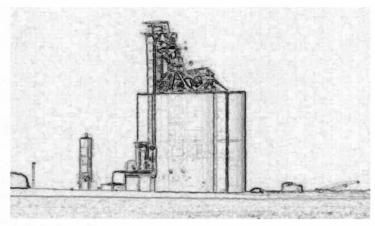

Grain for the world

the Pacific Northwest to ships destined for China and other Pacific Rim markets.

56 Kansas Skies [141W; page 89]

Although Montana calls itself the Big Sky Country, Kansas, too, has impressive skies. There are about 300 sunny days each year, and when skies are not clear, they often are embellished with beautiful and powerfully majestic clouds. In the westbound story read what playwrights and poets have written about these skies.

58 Serious Skies

We hope you enjoy the spectacular Kansas sky. But Kansas skies are not always a pleasant diversion (see 285W; page 48). As you travel across Kansas, be aware of the serious sky. Regardless of the season, if skies look threatening, listen for weather warnings. You can hear weather reports at each rest area.

59 Rails to Riches

Here you cross over more railroad tracks. Read about the importance and lasting impact of the railroads at 337W (page 30).

As towns sprung up along the railroads, wagon roads and then state and federal highways were built alongside the railroad routes to connect the towns. For most of its route, I-70 follows one of the Union Pacific lines across Kansas to Kansas City.

Today, railroads transport large quantities of grain from small

farm communities to larger markets where the grain is sold and processed. The white grain elevators, regularly spaced about eight to ten miles apart, mark the location of the railroad tracks and serve as a continual reminder that railroads are still vital to the economic survival of western Kansas.

62 Mingo

On the right, you can see the town of Mingo and the Co-Ag Elevator, a farmer cooperative. Mingo is named after a branch of the Sioux tribe.

63 Energy Trails

Electricity is routed along overhead transmission line "trails" as another avenue of commerce across the state. The line paralleling I-70 is a major corridor for carrying electricity. One determination of the amount of power is voltage, or pressure that moves current through the lines. To move electricity through your home takes 115 or 230 volts. To move power through lines along the city streets or out to the farms, about 6,900 volts are used. For the long lines that connect eastern and western Kansas, much bigger lines are required. This line operates at 115,000 volts.

You will see structures that support double that voltage and higher. The construction will be more rugged steel frame towers with longer, and thus heavier, insulators used to separate the cables from the support beams, such as at mile 280 ahead. This line connects the power-generating plants in Colby with plants in Great Bend to the southeast. From Colby, transmission lines carry electricity east and west along the same trail you are following. Watch as other lines operating at different voltages cross I-70.

65 Pocket Gophers [66W; page 113]

You may have noticed the mounds of sandy soil along the roadway. They are made of soil excavated from the tunnels of plains pocket gophers.

66 Monument Rocks

The Monument Rocks Natural National Landmark is located on private property twenty-six miles south of Oakley (Exit 70). These rocks are impressive chalk bluffs and pyramids poking high out of the prairie. Native Americans used them as a lookout perch, and they were a landmark for travelers along the Butterfield Overland

Despatch (BOD) stagecoach line on their way between Atchison (near Kansas City) and Denver. I-70 closely parallels the route of this passenger and express stagecoach from here to Kansas City. It was the shortest, but most dangerous, route across the Plains. The stage ran three times a week, taking eight to twelve days to make the one-way trip. The BOD began on August 1, 1865; however, it ended operation less than eighteen months later because of lack of protection from Indians and decreased gold mining in Colorado. Just think, you can make this same trip in about eight *hours* rather than eight *days*, and with nothing to fear and watch out for except other drivers.

68 Kansas Sharks [79W; page 109]

At one time this area was a warm, shallow tropical sea. Shark teeth, coral, and other remnants of this ancient ocean are found in this area and can be seen up close at the Fick Fossil Museum (Exit 76).

70 Eliza, not Annie [77W; page 110]

People assume that the town of Oakley, founded in 1885, was named for the famous female sharpshooter Annie Oakley. But it was named for Eliza Oakley Gardner-Hoag, mother of David Hoag, who founded the town. This does not make for quite as good a story, but who can argue with a son honoring his mother?

Oakley is tucked into the northeast corner of Logan County. In 1963 it finally became the county seat after decades of fighting to get the seat moved from the more isolated, but centrally located, Russell Springs.

72 Jackrabbits [34W; page 124]

Another interesting mammal found in the High Plains is the black-tailed jackrabbit, which is larger and has longer ears and hind legs than the familiar cottontail. It can quickly accelerate up to forty miles per hour. Watch for jackrabbits as you travel through western Kansas.

73 Yucca [75W; page 111]

Yucca, or "soapweed," grows on both sides of the interstate along banks ahead at mile 74. It looks like a shrub, with spikes pointing out in all directions, and has large white flowers during spring and early summer. The sharp, spiny leaves stay green even in winter. Read about the many uses of this interesting plant at 75W.

74 Logan County

You will just clip the corner of Logan County, named after General John Alexander Logan, a Civil War veteran and U.S. senator from Illinois during the years 1871–1877 and 1879–1886. The story of this county's name illustrates the rancor and divisiveness of early politics on the Plains. The county was originally named for John P. St. John, a Kansas governor. But St. John lost to a Democrat in the race for governor in 1882 after receiving an unprecedented third-term nomination. When he ran for president as a Prohibition Party candidate, some Republicans blamed him for taking enough votes from the Republican candidate to cost them the election. St. John's role in these losses to Democrats infuriated Republican legislators, so they changed the name of the county to Logan. Governor St. John was not totally wiped off the map, though. The town of St. John in south-central Kansas is still named after him

75 Gove County

You now enter Gove County, created in 1868 and named in honor of Captain Grenville L. Gove, who had died four years earlier in the Civil War. The soldiers of Company G under Captain Gove's command had been so famous for being the best drilled that when they marched, people came just to watch. For the first few years, the only residents of Gove County were a few railroad workers and buffalo hunters. The first settlers arrived in Gove County in 1871. Many early settlers came from Pennsylvania.

Before Gove County existed, many people traveled through it and kept right on going. The discovery of gold near Pikes Peak in 1858 caused many people to head west along the Smoky Hill Trail, which crossed the county.

76 Dryland Farming [85W; page 107]

Farming without the use of irrigation helps conserve precious groundwater and involves strategies such as leaving fields unplanted in alternate years to let moisture accumulate in the soil.

79 Frozen Cattle Pools [84W; page 108]

In 1886 a blizzard killed thousands of cattle near here. Winter weather still can be dangerous to livestock as well as travelers on I-70. Listen for weather reports before crossing western Kansas.

81 Hellendale Ranch [82W; page 108]

To the left, notice the trench bunkers right along the highway on the left where "haylage" (fermented hay used for feed) is produced. You may see as many as 1,200 Holstein dairy cattle, with their familiar black-on-white patches, in the pens at Hellendale Ranch headquarters. New heifer calves are added every six to eight weeks. As they grow, they move from small pens to the larger lots.

Farm manager Cheryl Madison produces most of the feed for the cattle on the ranch, which was founded in the 1930s and extends for about three miles along I-70.

84 Grinnell: Home of Early Jerky

Grinnell, established in 1870, was named after Captain Grinnell, an officer stationed at Fort Hays. German farmers founded the city and shipped wheat and cattle out by railroad. In 1872, Grinnell had two large sod buildings for drying buffalo meat. The air was so dry here that meat could be stripped off in layers and hung to dry. People called this meat "jerked" because of the way it was torn from the buffalo's carcass. You can buy similar jerked meat in the form of beef "jerky" at convenience stores along I-70.

86 "Going to the Dogs"

Quickly glance right at the mile marker, and you will see pens for greyhound dogs. Raising and racing greyhounds is both a serious vocation and a popular pastime in Kansas. The greyhound pedigree goes back 4,000 years. The dogs, which are designed for speed, have been clocked at speeds of forty-five miles per hour! The Greyhound Hall of Fame is ahead at Abilene (Exit 275).

87 The Dinosaur War [90W; page 105]

The chalk beds of Gove County were a gold mine of prehistoric bones. Read details about the work of paleontologists Edward Drinker Cope and Othniel Marsh in this area in the late 1860s and early 1870s at 90W.

90 A Gambrel Roof

That barn at the farmstead ahead on the right has a gambrel roof. There are two added ridges parallel to the center peak ridge extending the length, giving it a flatter slope at the top, with steeper sections at the sides. The design is created with a truss-type bracing inside that strengthens the roof. The primary advantage of this

Gambrel-roofed barn

type of construction is to provide a high, open loft where a large volume of loose hay can be stacked. That is why the gambrel-roofed barn became popular on farms in this hay and cattle country. Of course, with the availability of big round bales and tractors to move them, no longer is anyone seen putting loose hay in a hay loft.

You will see other types of roofs at farmsteads, including simple one-slope lean-tos, simple gable roofs, and two-slope roofs. There will be roofs that slope up from all four sides, called a hip roof if there is a single slope or a mansard if there is a double slope similar to a gambrel on four sides.

91 Skyscrapers [II2W; page 99]

The white grain elevators are sometimes called prairie cathedrals. The westbound reference has a poem about these rural skyscrapers.

92 Grainfield [97W; page 103]

In an area of many grainfields, this name was appropriate back in 1879 when a little girl riding down the trail in a wagon commented to a Union Pacific Railroad official, "Oh, what a pretty green field!" The man who had been sent by the railroad to lay out the town site, recalled the girl's comment and decided to call the new town

Grainfield. Today, wheat grows right up to the edges of town, making it one of the most obvious and appropriate town names along I-70.

At one time grain was purchased at harvest by elevators, then sold back to farms within a twenty-mile radius as winter feed. Today most of the 1.9-million-bushel capacity is dedicated to accumulating grain for shipment to other locations. Most of this wheat stays in the United States. Eighty percent of the wheat is shipped by rail to markets.

Corn production has increased in recent years due to development of new drought-resistant varieties and because demand has been boosted by the need to feed cattle at the rising number of feedlots. Corn is shipped mostly by truck to locations such as Texas and Georgia.

This elevator specializes in shipping grain of a specific quality. A state grain inspector certifies the grade and quality before the rail-car or truck leaves the property.

95 The Wheat State

One of Kansas's nicknames is "the Wheat State." Nearly one-fifth of all wheat grown in the United States is grown in Kansas. In most years Kansas produces more wheat than any other state, typically 400 million bushels. There are 61,000 farms in Kansas, and about 31,000 of them grow wheat. If all that wheat produced was loaded onto railcars, the train would stretch from western Kansas to the Atlantic Ocean. Half of the crop is exported to other countries every year. About 10 percent is used for animal feed, and another 4 percent is required as seed for the next year's crop.

Kansas grows winter wheat, which is planted and sprouts in the fall, becomes dormant during winter months, then grows again in the spring and is harvested in early summer. Wheat is a grass whose seed belongs to the cereal group. It contains gluten, the basic structure needed to form the dough for breads, rolls, and other baked goods.

Kansas is number one in flour milling in the United States. The state is also the number one producer of wheat gluten, the natural protein derived from wheat. Gluten, when dried, is a tan, free-flowing powder with a high protein content. High-protein flour from hard red winter wheat is best for making bread. Medium-

protein flours can be used for making biscuits, all-purpose flour, quick breads, mixes, and other baked goods.

One 60-pound bushel of wheat seeds provides about 42 pounds of white flour, enough for about seventy 1-pound loaves of white bread. Recent statistics show the average American consumes about 144 pounds of wheat flour per year. Whole wheat flour includes the insoluble bran outer coat of the kernels and would yield about 14 percent more loaves.

The gluten (protein) and starch that make wheat suitable as a food product are finding increased use in nonfood and industrial applications. Gluten, which is elastic and can form films, is useful for preparing adhesives, coatings, polymers, and resins. Wheat starch is used as an adhesive on postage stamps and is used to hold the bottom of paper grocery sacks together. One acre of wheat stubble produces approximately two bales of wheat straw. This becomes the main component of straw particle board used for furniture, flooring, and cabinets.

One bushel of wheat weighs 60 pounds. A gondola railcar will hold 200,000 pounds, or 100 tons; that's about 3,333 bushels. A highway truck typically carries 40 tons (1,350 bushels), which equals the production from about twenty-five acres. As you drive for a mile past a wheat field along I-70 and look a mile beyond the highway fence, imagine enough grain being harvested from this field to fill eight to ten railroad cars or twenty-five to thirty truckloads.

In 1820, army explorer Stephen Long reported that this land was "almost wholly unfit for cultivation, and of course uninhabitable." If he could only see it now and see how wrong he was about these productive lands!

99 Park

The tall white "prairie cathedrals" and the steeple of the beautiful Sacred Heart Church, built in 1898, mark the town of Park. Originally called Buffalo Park, this is another of the stations on the Union Pacific Railroad. The town was named for the great herds of bison that roamed the area. Gove County was a popular place to hunt buffalo. An early resident of Park was allowed to join an Omaha Indian buffalo hunt. The man's journal described how the specific posture of a scout on his horse would indicate buffalo were in the area. He noted how the Indians' arrows were grooved to

indicate the tepee the hunter came from. These grooves also allowed the blood to flow out of the wound they created. The Indians used all parts of the buffalo: skins for shelter and warmth, meat for food, and sinews for sewing and bow strings. Most of the meat was cut into one-inch-wide strips and dried in the sun.

101 Farms in the Forest

Notice how the farms here are hidden among a dense stand of trees. Weather conditions are harsh on the High Plains. Farmers plant rows of trees, called "farmstead windbreaks" or "shelterbelts," on the north and west sides of their farmsteads. Settlers planted trees because the treeless plains seemed empty and they missed the forests of their eastern homes. Today farmers and ranchers plant and maintain these shelterbelts for protection from the brutal winter winds and for shade during the hot summers. Read more about the importance of shelterbelts at 123W (page 95).

103 Cottonwoods [104W; page 101]

Notice the cottonwood trees on both sides of the interstate, growing in low spots where water can collect. The cottonwood is the state tree of Kansas. In the westbound story, read about the uses of cottonwoods and what author Ian Frazier had to say about these common trees.

105 Two Pounds a Day!

At the farmstead on the left as many as 1,200 head of cattle can be seen in the Reinecker Feedlot. The calves come into these feedlots when they weigh 400 to 500 pounds. Some calves are bought at local auction barns, but most come from Kentucky farms. After five or six months, when they weigh about 800 pounds, they are sold as market beef. That's correct, calves can add about 2 pounds every day.

This feedlot is typical of many Kansas family enterprises that choose to market grain by feeding it to animals. It was started in 1978, and it is already a three-generation operation. Corn for feed is grown on the 2,200-acre ranch. The cattle also eat oats and hay purchased from neighboring farms. The other major crop grown on the ranch is grain sorghum, which is sold as a cash crop.

Llamas can usually be seen at this ranch in the field just beyond the feedlot (see 106W; page 101).

106 Quinter

This town was founded in 1886 by a group of Dunkards, also known as Baptist Brethren. It is named after the Reverend James Quinter, a Pennsylvania immigrant and church elder.

Castle Rock Road is named for a delicate chalk formation with a tall spire towering above the prairie, on private land about twenty miles south of Quinter. The formation, a remnant of the ancient sea bed, is known as Castle Rock. Fossils of more than 200 organisms have been found around Castle Rock.

107 Corn Bunkers

Look right to see long, flat bunkers that provide supplemental onground storage for the Midwest Coop, which also owns the tall storage bins in Quinter. The "temporary storage" was created in 1998, a particularly good year for corn production, and has been used in succeeding years. Each bunker holds a million bushels of corn!

Although the railroad was important for the development of the Midwest Coop business, today all the grain both arrives and leaves by truck. Some corn is fed to cattle in nearby feedlots. Most, however, is trucked to grain millers for processing into corn products such as starch, corn sweeteners, and ethanol fuels. Midwest Coop affiliates have storage elevators in eleven surrounding towns. They cooperate with each other by specializing in the storage and marketing of different grains.

108 Corn [132W; page 92]

You have been driving past many cornfields. Corn leads the nation in acres planted, bushels harvested, and dollar value of the harvest, making it America's number one crop. Kansas is a leader in corn production. The many uses of this native grain are described at 132W.

110 Strong Sorghum

Compared with corn, grain sorghum is typically a shorter, stronger, and bushier plant. The plant may reach three or four feet tall and will have a large seed head on top. Since both sorghum and corn are grass crops, the plants look somewhat alike, especially early in the growing season. But unlike corn, sorghum can be grown in dry, windy regions because it can tolerate longer periods with no rain.

Its roots go deep into the soil to get moisture, and the seed heads are produced late in the year, generally after the hottest weather. The low, stocky plants resist being toppled over by the strong winds of western Kansas. Anyone who has seen a cornfield after a severe thunderstorm will understand this choice.

Kansas leads the United States in production of grain sorghum, growing more than 40 percent of the nation's crop. More than 80 percent of the rounded, starchy seeds are used as livestock feed. It also is a useful source of clean-burning ethanol fuel for automobiles. The by-product of ethanol production is distillers' grain, another valued high-nutrient livestock feed.

Sorghum is one of the world's oldest crops, believed to have grown among the wild plants of Africa. The first seeds may have been brought into the United States on slave ships during the late 1700s. Besides grain sorghum (often called "milo"), three other sorghum groups are grown in Kansas: grass sorghum for animal feed (Sudan grass and johnsongrass are in this family); sweet sorghum for making syrup; and "broom corn," whose fibers are used to make brooms.

113 Trego County

This county was established in 1867 and named in honor of Captain Edward P. Trego, who died in the Civil War battle of Chickamauga. This county was hit hard by the dust storms of the 1930s, as explained at 143W (page 89).

114 Collyer

This town is named for the Reverend Robert Collyer, a poet, author, and Unitarian minister. Collyer was president and financial supporter of an organization in Chicago that in 1878 formed a Soldiers and Sailors Colony here for veterans of the Civil War and their families. Collyer never came to his colony; in fact, he left Chicago in the 1890s to be pastor of the Church of the Messiah in New York City. However, he sent one or two books each week to Collyer, creating a circulating library for the settlers.

Many soldiers did not know how to farm, and others were physically unable to do farmwork. Few veterans came with any money, so when crops failed, most veterans headed for cities to look for work or return to homes in the East. Those who remained were eventually joined by a colony of Irish settlers and a Czech colony.

115 The Lipp Farm

The red barn on the Lipp farm has been at the center of the farm operation for nearly a century, since Phillip Lipp arrived from Russia in 1907. The family's first house was built of sod; the two-story farm home was added much later.

By 1917, Lipp had built this traditional barn to house fifteen milk cows and the horses needed to do the field work. The barn was the farmer's factory, where grain was converted into milk and cream, eggs, and meat. It was the warehouse for animal feed. The high center loft provided storage for hay. Grain was housed in bins in the shed roof wings.

You will see many barns of this type as you drive across Kansas. However, few have animals, and little grain or hay can be found in them. They may house a car, a tractor, or field machinery. They no longer serve as the production center, and some are in disrepair. Economic changes and machines to reduce the drudgery of farming have greatly expanded farm operations, while reducing the need for these large barns.

The Lipp farm now encompasses 1,500 acres. Winter wheat is the primary crop, but some Sudangrass is raised. Sudangrass, a tall grass in the sorghum family that is cultivated for livestock feed, was introduced from Khartoum, Sudan, into the United States in 1909 by the Department of Agriculture. It is one of the best drought-

Lipp farm barn

resistant plants known, and so is well adapted to the drylands of western Kansas. Sudan hay has a higher feed value than most other grasses. Livestock, especially pigs, like it. However, livestock is not fed grain on the Lipp farm. Instead, all the grain is trucked from the field to elevators along the railroad track and started on its way to distant domestic or international markets.

117 Capturing an Iron Horse [114W; page 98]

See the westbound reference for a story of how Indians tried to capture a locomotive here.

118 Windmills

Windmills have been used by Kansas farmers and ranchers since the late 1800s. Windmills harness an ever-present, inexhaustible Kansas resource—the wind. Windmills attached to pumps lift water from wells for livestock, crop irrigation, and occasionally household needs. Here on the right, you see a windmill pumping water into a tank from which cattle can drink. Wind continues to be a welcome power source for pumping water and for some farms a method to generate electricity. A new generation of wind turbines is designed to more effectively convert the wind force to electric power; although several major wind farms are being developed in Kansas, no projects are within view of I-70. These turbines will dwarf the windmills you see along the interstate, with their blades sweeping a circle the equivalent of half a football field from the top of a 200-foot-tall steel tower.

119 Volga-Germans [119W; page 97]

Like the Lipp family back at mile 115, most of the original settlers in this area were Volga-Germans. The Volga-Germans descended from German families who migrated to the Volga River region of Russia in the 1700s. Although they lived in Russia, they maintained their German language and customs.

The Germans discovered the landscape and climate in western Kansas to be similar to that of Russia. They adapted well to this region, having been hardened by conditions in the Ukraine. They used what nature provided, perhaps better than any other immigrant group. Many other European pioneers moved on as the frontier moved westward, but the Volga-Germans stayed to raise their families and crops.

121 Rocks on Their Way to the Sea

Because soil is made up of particles that have been weathered and worn from rocks and because erosion by wind and water is a universal natural phenomenon, it has been said that "soil is rocks on their way to the sea." Although the movement of soil into the sea is inevitable, farmers try to slow down the trip.

Farmers are using more environmentally friendly techniques that conserve topsoil, moisture, and nutrients. They use minimum tillage and leave residue plant material from previous planting seasons on the surface to hold moisture and slow the wind. They practice contour plowing (planting crop rows that curve across the slope) and create raised "terraces" that catch the rainwater, allowing it to soak into the soil rather than run off, carrying soil with it. Ahead on the right you can see the concrete outlets of terraces that direct excess water runoff into the roadside ditch. All these strategies help hold soil particles in place and prevent them from moving toward the sea. Watch for these farming practices as you drive through Kansas.

123 Big Creek Valley

Off to the south for the next thirty miles or so you can see the Big Creek valley. Lines of trees hugging the edge of the creek mark the location of this stream. You are in the Big Creek watershed, meaning water from all the surrounding fields runs downhill into Big Creek (another indication the land is not flat). King Solomon wrote in the Old Testament Bible that "all streams flow to the sea." Big Creek eventually flows into the Smoky Hill River, which becomes the Kansas River ahead (mile 298). The Kansas River flows into the Missouri River at Kansas City, which in turn flows into the Mississippi near St. Louis. The Mississippi then empties into the Gulf of Mexico beyond New Orleans. Indeed, even the waters of Big Creek here in the middle of the continent eventually flow to the sea.

125 WaKeeney

"Beautiful location and surrounded for scores of miles by the most fertile agricultural land in the world." This is how some settlers saw WaKeeney, Kansas, as farming drew them to settle here. WaKeeney was named by combining the names of Albert Warren and James Keeney, owners of the Chicago real estate company that surveyed and plotted the town site in 1878. These men chose this spot along the route of the Union Pacific Railroad exactly halfway, 322 miles, from Kansas City and from Denver. They had big plans for their "Queen City of the Great Plains," including eighty-foot-wide brick streets. The town was established in 1878. That same year, people from throughout Trego County fled to WaKeeney for protection from a group of Cheyenne Indians.

In 1974, the Trego County Courthouse was used to film several scenes for the movie *Paper Moon*.

126 Merry Christmas

Since 1950, WaKeeney has gained a reputation for being the "Christmas City of the High Plains." It claims to have the largest Christmas tree and lighting display between Kansas City and Denver. Each year, prior to Thanksgiving, the residents build a 40-foot Christmas tree using 2,300 pounds of fresh evergreen branches, 1,100 yards of hand-tied green roping, and more than 6,000 lights.

WaKeeney welcomes visitors at Exit 128 with a 25-by-40-foot American flag on a 100-foot-tall flag pole and a sculpture replica of the Iwo Jima victory flag raising. WaKeeney is proud of its veterans and was chosen as the site for a new veterans' cemetery, dedicated here September 11, 2002.

128 Ring-Necked Pheasants [71W; page 112]

Watch for pheasants along the roadside and in the fields. Kansas is consistently one of the top three states for pheasant hunting. Hunters from all over North America come to Kansas during the opening week of pheasant season in November, and pheasant hunting contributes well more than \$75 million to Kansas's economy annually.

130 The Lifeline

As I-70 parallels the Union Pacific Railroad tracks on the left, consider how the railroad affected every facet of life on the Plains for more than fifty years until paved highways were built in the 1920s. Besides all sorts of people, food, furniture, fuel, and other freight also arrived by train—a lifeline from the East. In return, buffalo skins, grain, cattle, and stories of romance and rowdiness on the range traveled the tracks eastward. As railroads die off, many towns that were linked from birth with this economic lifeline struggle for survival, often unsuccessfully.

131 Kansas Pines

At the next rest stop and at locations all along I-70 (particularly at interchanges and rest stops), you will see pine trees. Most of these are Austrian pine, a species native to Europe. Kansas has the distinction of being the only state other than Hawaii that has no native species of pine. In other words, until settlers and others planted them, there had been no pines growing in Kansas. All the pines you see here today are native to other lands.

132 Field Windbreaks [144W; page 88]

We have seen how people plant rows of trees as shelterbelts or windbreaks around their farmsteads to provide shade and protect themselves from the winter winds. But on the right you may also notice rows of trees along a field. These "field windbreaks" have many benefits for people and wildlife. They prevent the wind from blowing the soil from fields; they help crops conserve moisture by reducing evaporation; they protect livestock and wildlife from winter winds; and they are used as snow fences to prevent snow from drifting across roads.

134 Midwest Coop [135W; page 91]

The four-bin storage complex of Midwest Coop at the west side of Ogallah is operated in conjunction with the Westland Terminal of Farmland Industries in WaKeeney. Sitting along the Union Pacific Railroad tracks, this is one of the smaller grain shipping centers. Even so, it is a significant facility. Trains of 100 cars are loaded every week destined for the export market. In the busy harvest season, three or four trainloads are shipped weekly.

135 Ogallah [136W; page 91]

"Ogalla" is a Sioux Indian word. Read in the westbound reference about the town name and the many recreation opportunities at Cedar Bluff Reservoir.

137 Buffalo Bill

Here, as you cross over the Union Pacific Railroad tracks, imagine Buffalo Bill Cody galloping along this way. He did just that. The stretch of railroad you just crossed was completed in 1868 as part of the Union Pacific Railroad that connected Kansas City to Denver. Buffalo Bill came here to supply the railroad construction workers

with buffalo meat during those years. He claimed to have killed 4,280 buffalo near here in only eighteen months!

138 Growing Precious Trees

Many more trees grow in western Kansas now than during settlement days. When settlers first arrived, a single tree was a precious commodity—almost an oddity. Shade was scarce, but so was wood for building or burning, so settlers cut and used most of the few trees they encountered.

Ogallah was the location of the first state tree nursery in Kansas. The Kansas State Forestry Station was established in 1887 along the Union Pacific tracks. It seems strange to locate a tree nursery so far west in such an inhospitable climate for trees. This location demonstrates the early recognition by the state that trees are a valuable resource on the High Plains for fuelwood and construction. In 1865, just four years after statehood, the Kansas legislature passed a law that said anyone who planted 5 or more acres of trees for wind protection or timber would be paid fifty cents per acre for twenty-five years. Subsequent amendments increased the payments to two dollars per acre and later required plantations of at least 160 acres. In 1873, the U.S. government passed the Timber Culture Act, which gave settlers 160 acres of land for free if they planted 40 acres to trees. The trees had to be planted no more than twelve feet apart. Such a 40-acre "timber claim" planting required

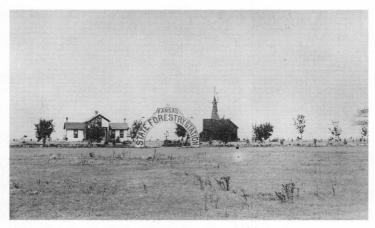

Kansas State Forestry Station (Kansas State Historical Society)

about 12,000 seedlings. In 1878, the act was amended to require only 10 acres of trees to receive the 160 acres of land. Over 2 million acres of trees were planted under this act. The Ogallah Tree Nursery raised the seedlings to supply to settlers participating in these programs. In 1887, it grew 1,960,200 trees. Most trees did not survive long, and in that sense the program was a failure. But those that did survive provided the settlers with welcome summer shade and protection from the winter winds, if nothing else. The Timber Culture Act was repealed in 1891 due to widespread fraud, and the forestry station nursery closed in 1913.

140 Riga Road

The trees with a grain elevator rising above them mark the location of Riga, a small town located on the Union Pacific Railroad. The town was named by the Volga-Germans and means "ridge of sand."

142 Plows

The original tilling of the tough Kansas sod was done by plows pulled by oxen, which, unlike horses, did not need supplemental feed but could maintain their energy by eating range grass. Now farmers pull plows with powerful tractors complete with airconditioned cabs and guidance from computers, lasers, and even satellite positioning data to ensure straight rows.

144 Ellis County [175W; page 79]

Ellis County is named for George Ellis, a Pennsylvania man who came to Kansas and enlisted in the Twelfth Kansas Infantry. This has been one of the best oil-producing counties in the state. On the right, you can see two of the many oil wells in Ellis County. Where does the crude go after it is lifted from the ground? A network of pipes connects the oil wells with those storage tanks. It is then picked up by tanker trucks and transported to refineries. In some cases it is piped directly to refineries near Wichita or as far away as Texas.

145 Ellis: Museums and Antiques

The town of Ellis has three museums and several antique stores. The railroad museum focuses on Union Pacific Railroad history and offers a 2.5-mile, one-third-scale train ride. The Bukovina Society of America Museum honors the immigrants and culture from the province that was once part of the Austrian Empire and now is di-

vided between Ukraine and Romania. There is a small collection of books and artifacts from Bukovina emigrants. The Walter P. Chrysler Boyhood Home and Museum tells the story of inventor and automobile manufacturer Walter Chrysler, who grew up in Ellis during the 1880s and gained experience as a mechanic. Chrysler's boyhood home is a museum that contains some of his personal memorabilia. A first-year model 1924 Chrysler auto is parked at the museum.

148 White Roads

The crushed limestone used to pave the county roads is particularly white in this area. Ahead, past mile 149, you will see a road cut that clearly reveals the limestone layers similar to those that provide the road-surfacing rock. These layers were formed at the bottom of a warm, ancient sea.

151 Yocemento [156W; page 86]

Across the valley on the right, the grain elevator marks Yocemento. "Yocemento" is the combination of the words "Yost" and "cement." In 1906, I. M. Yost and Professor Erasmus Haworth met in Hays and decided to build a cement plant on a ridge called the "hog back." Behind the elevator, you can still see this ridge, now much reduced by quarrying operations.

154 "When in Rome ..."

Looking up the Big Creek valley to the right, you will see another area where Buffalo Bill Cody left his mark. At the young age of twenty-one, he cofounded Rome, the first settlement in Ellis County, located near Big Creek. Fully confident that he was going to get rich selling lots in the new town, Cody sent for his wife and child back in St. Louis, and they joined him in Rome to start this new life. The town boomed, and within just a few months it had a population of over 2,000 people, mostly railroad workers. Five saloons thrived on Main Street! But when Cody unknowingly offended a railroad official, the official decided to have the railroad depot built in newly formed Hays City. This marked the end of Rome, as the citizens and businesses, including the Cody family, moved to Havs City. Instead of making money in real estate, Cody lived up to his nickname by shooting buffalo for the railroad. It paid him \$500 a month, plus expenses, to provide buffalo meat for railroad workers.

156 Big Batteries [158W; page 84]

The EnerSys Inc. plant on the right employs more than 400 workers who make batteries—big stationary batteries that provide uninterrupted power backup for the telecommunications industry, medical instrumentation, utilities, and a host of other industries. Batteries from this plant are shipped to customers in fifty-five countries.

The Roth house near the highway was built of native limestone blocks in 1866. The family with their eight children operated a 160-acre wheat farm and in 1904 purchased additional farmland to triple the acreage, where the boys continued to farm. When the property was sold to a battery manufacturing company, the house was restored in 1975 and a buffalo grass prairie reestablished around it to preserve a reminder of how early settlers lived. Notice the post rock fence along the property; you'll see many more in the miles ahead, with a story at 200E.

157 Fort Hays [166W; page 82]

Use Exits 157 or 159 to reach the Fort Hays State Historic Site. There you will find a visitor center and three original buildings from the fort.

Forts such as this one provided some measure of peace of mind for settlers. As railroads moved west through Kansas, so did the settlers. This encroachment into "Indian" territory sparked conflicts between settlers and Native Americans. To protect the settlers traveling along the rails and trails, the I-70s of the 1800s, the federal government built military posts along the way. One of the forts on the Smoky Hill Trail was Fort Fletcher, built along the Smoky Hill River in 1865 (see 173E; page 170). After a flash flood in 1867, that fort was relocated and renamed Fort Hays to honor General Alexander Hays, a hero at Gettysburg who had been killed in 1864 at the Battle of the Wilderness.

159 Sternberg Museum of Natural History

The white dome beneath the water tower ahead on the right is Fort Hays State University's Sternberg Museum of Natural History. The museum, with a collection that includes 3.7 million specimens, is named to honor two generations of the Sternberg family that collected spectacular fossils. George F. Sternberg joined the university in 1927. He established the fossil collection and played a major role

Sternberg Museum

in the study of North American fossil vertebrates and the science of paleontology. Here you can see the famous "fish-within-a-fish" fossil along with life-size models of a *Tyrannosaurus rex* and other prehistoric creatures. The museum's paleontology collection has the third-best collection of flying reptiles in the world, mostly from Kansas. If you have already passed Exit 159, you can still visit this fine museum by exiting at Commerce Parkway (Exit 161) and turning left to Twenty-seventh Street. Canterbury Drive leads directly into the museum parking lot.

162 Boot Hill [160W; page 84]

In Hays, Boot Hill was the final resting place of many an overzealous cowboy or unwary pioneer. A statue known as *The Homesteader* marks the location. Hays is believed to be the home of the original Boot Hill Cemetery, where men were buried with their boots on.

166 Cathedral of the Plains

Devout Catholic Volga-German settlers built three churches prior to the construction of the "Cathedral of the Plains," with its twin steeples. The present church's construction was begun in 1908 and completed in 1911, using native fence post limestone, quarried south of Victoria. The stone was cut by hand, loaded on wagons, and hauled to the building site. Masons dressed the stone and placed it by hand. Each stone weighed between 50 and 100 pounds.

More than 125,000 cubic feet of rock were used to complete the church. Read more about the church, including how an Englishman contributed to the church fund, at 171W.

167 A British Colony

The town of Victoria was founded by Sir George Grant, who wanted to form an aristocratic British colony in the United States. In 1871 he bought land from the Union Pacific Railroad and named the settlement after Queen Victoria. In 1873 he arrived with a group of wealthy young men who would be supported from home while the colony was being established. According to The WPA Guide to 1930s Kansas, they brought along fine horses, Aberdeen Angus cattle, and Southdown sheep. However, the young men, being far away from home, took no interest in farming. Instead, they spent nights partying in saloons and dance halls and days riding across the prairie chasing coyotes and jackrabbits for entertainment. Homesick for England's lakes, they dammed Big Creek to make it navigable for eight or nine miles. Then they used their parents' wealth to buy a steamboat and have it floated west on rivers and pulled across the Plains on a large oxcart until it reached Big Creek. The WPA Guide to 1930s Kansas quotes a historian as saving, "Kansas has witnessed many incongruous spectacles. . . . but never before or since was there such a mirage-like sight as a steamboat chugging along in the midst of the prairie filled with a cargo of young British merrymakers."

Volga-Germans also formed a colony adjacent to Victoria. They were well trained for conditions on the Plains and, unlike the young British men, were skilled in agriculture. They prospered and eventually absorbed Victoria when the British abandoned it during the inevitable hard times.

169 Abandoned Air Base [172W; page 80]

On the left behind the trees, you can see a hangar and other structures of the abandoned Walker Army Airfield.

171 An Avenue Exit

This is one of only two exits for an "avenue" along I-70 in Kansas. The other one is First Avenue in Topeka, about 200 miles east of here. Having only two exits for avenues in more than 400 miles across the state illustrates the rural character of Kansas.

172 St. Ann's Church

St. Ann's Church in Walker, with its towering steeple, is a prominent landmark. It was constructed in 1904 using local limestone. Although close to the Cathedral of the Plains, it reflects a simpler construction. The smaller parish benefits by having a priest come from the big cathedral at Victoria to conduct services.

173 Fort Fletcher

Five miles south of here was Fort Fletcher, which was built to protect travelers on the Smoky Hill Trail that parallels I-70 along the Smoky Hill River to the south. The fort provided security for the mail and freight being carried along the trail by the Butterfield Overland Despatch. In 1867 a flash flood killed several soldiers and a civilian at the fort. General George Custer's wife, Elizabeth, barely escaped drowning. The flood, the bankruptcy of the Butterfield Overland Despatch, and the coming of the railroad along this more level land to the north of the river prompted the relocation of the Fort to Hays.

174 Water-Loving Willows

Ahead, notice the willows growing along the stream. Willows and water go together. Old Testament prophets, Shakespeare, and a multitude of writers and artists for centuries have linked willows and water. Read more about willows' characteristics and how the trees have been used at 177W (page 78).

176 Russell County

You are now in Russell County. This county, which was established on February 26, 1867, and the city of Russell ahead were named after Avra P. Russell, a captain in Company K, Second Kansas Cavalry who fought in the Civil War. He died of battle wounds in 1862.

177 Buffalo "Wallows"

Watch closely on the right in the low wet area for a circular patch of grass that looks different from the rest of the area. This is a small buffalo wallow. During the spring calving season, when the weather got warm, the bison would wallow on the ground to try to rid themselves of their heavy winter hair. This would compact the soil and make a depression. If water was present, they would wallow in it and later carry the mud away, creating a bigger depression. As a result, buffalo "wallows" would form, some two to three

feet deep and spreading across several acres. These wallows became dust baths or water holes for the bison. Even now, more than 120 years later, you can see different plants growing on that spot because of soil changes caused by the wallowing buffalo. Wallows are common throughout the region; in fact, golfers on the Ellsworth Golf Course (mile 217E ahead) play through a buffalo wallow on the number 6 fairway.

178 Sinkhole [18oW; page 78]

The pond just beyond the overpass right at mile marker 179 is the result of a "sinkhole." Note the dip in the road here. Over the next couple of miles you will notice several dips in the roadway, which have been caused by sinkholes beneath the roadway.

180 The Coyote and Doodlebug

As you can see by the many oil rigs, Russell County's economy is largely supported by oil. The oil boom in the county has been credited, oddly enough, to a coyote and a "doodlebug," as described in the account at 186W (page 76).

182 Wonderful Wetlands

Wetlands such as the marsh you will see ahead on the right are extremely valuable areas, as described at 184W. One of the world's most ecologically important wetlands, about thirty miles south of Exit 225, is Cheyenne Bottoms, the 20,000-acre "Jewel of the Prairie." This is the stopping place for large numbers of waterfowl, as well as the endangered whooping crane. Waterfowl numbers can exceed 225,000 ducks and 25,000 geese. It is a wonderful wetland and a wonder-filled place to visit even in its tenuous condition. A detailed description is at 228W (page 63).

184 Oil Patch Russell

The oil-drilling rig right along the interstate at the Oil Patch Museum is evidence that oil remains important in Russell. In the outdoor collection are rotary drilling rigs, pulling units, pump jacks, and the early steam engine power units. You can walk through an actual oil storage tank and see exhibits telling the story of the oil industry around Russell.

Derricks, like the one at the museum, once dotted the landscape. But in the 1950s they were all removed for the scrap metal by teams of men from Texas. Witnesses said it was quite a sight to watch, as the men, by hand, "flipped" each derrick up into the air so it would come down on its top, rather than just tipping over. This prevented joints and beams from being bent on impact with the ground. Then, like a NASCAR pit crew, the men would feverishly dismantle the derrick and load it for shipment back to Texas.

185 "Bob Dole Country"

Russell was once known as Fossil Station because of the rich fossil beds nearby. Fossil Lake, along the right side of the interstate, still reflects that original name. A group of seventy settlers from Ripon, Wisconsin, came here in the winter of 1871. Early accounts state that they were "good, sober, industrious people" who prohibited gambling and saloons. When *The WPA Guide to 1930s Kansas* was written in the 1930s, the authors noted that the German-Russian population was still made up of "good, sober, industrious people." Russell is now most famous for being the hometown of long-time senator and presidential candidate Bob Dole. It is also the birthplace of another prominent U.S. senator, Pennsylvanian Arlen Spector.

187 Rest Area

You have seen trees planted for windbreaks at farmsteads. Here trees protect the perimeter of the rest area, and fiberglass wind screens protect the individual picnic tables, a reminder of how the wind affects many aspects of life here on the Plains. At the rest area a sign makes you aware that you are driving on the Eisenhower Interstate System, which has been designated by Congress for its "legacy of safety and mobility that has brought all Americans together." As you approach Topeka (346E), you will read about the very first section of the interstate system.

188 Big Round Bales [213W; page 68]

The big round one-ton bales are created with machines invented by an engineer from Kansas who grew up having to haul hay by heavy, backbreaking manual labor. Read about Dr. Buchele's big round bale invention at 213W.

190 Water Associations [192W; page 73]

That slim tower off to the right is 110 feet tall but only 10 feet in diameter. It holds 60,000 gallons of water and provides water pressure for the Post Rock Rural Water District. Throughout history the

Round bales of hay

quality and quantity of water resources have been a determining factor in where communities are located and the type of commerce that develops. In Kansas over twenty governmental agencies address water-related issues.

192 Bunker Hill

The next town is Bunker Hill, which was named after a town in Ohio by settlers who arrived in 1871.

193 Chief Spotted Horse

Beyond the water tower just north of town is the Bunker Hill Cemetery. At the east end of the cemetery is the grave of a young Pawnee chief named Spotted Horse, who died of typhoid fever in 1874. His father, a Pawnee chief, had converted to Christianity and requested a Christian burial in the white man's cemetery. The grave of Spotted Horse lies near those of Civil War veterans and early settlers.

194 Hawks [305W; page 42]

As you drive along, notice the large hawks sitting along the highway on fences or trees. Most will be red-tailed hawks, which are common year-round wherever there are trees. They, along with the trees, will become more common as you travel eastward across the state. Between April and September you may also see Swainson's hawks, although they become more rare as you drive east. These hawks have a dark upper breast, like a bib, and a distinct dark and light pattern under the wings when soaring. In the winter, while the Swainson's hawks are in South America, rough-legged hawks

Hawk on fencepost

come down to visit us from the Arctic. They have varying degrees of black and white, with some forms being almost all black.

197 Dorrance: The NBA Comes to Kansas!

Ahead on the right you can see the town of Dorrance. Like many towns in Kansas, Dorrance is named after a railroad man. In this case, O. B. Dorrance was the Union Pacific Railroad superintendent at the time of the town's founding. But today Dorrance is best known as home to a company that has an influential presence in the National Basketball Association and in gyms and stadiums across the country.

Until recently all NBA basketball rims and backboards were made in Dorrance. Today, Pro-Bound Sports manufactures the Pro-Bounder ball returner, which is used by the Chicago Bulls and other NBA teams during practices. Pro-Bound also makes many of the basketball goals and backboard supports used in gymnasiums and arenas around the country. This Dorrance firm has played a significant role in shaping the modern NBA basket and backboard.

The company is credited with inventing the snap-back rim used by NBA and college teams. This was an essential development after NBA star Darrell Dawkins began breaking backboards with his powerful dunks. In addition, the size of NBA backboards was changed from 4 feet by 6 feet to 3.5 feet by 6 feet as a result of a suggestion from this Dorrance company. Pro-Bound convinced NBA administrators to cut the bottom 6 inches off the backboard to reduce injury, since that part of the backboard was irrelevant to the shot anyway. Next time you watch an NBA game, think of little Dorrance, Kansas, and its link to the NBA.

199 Wilson Lake

Wilson Lake is about five miles north of the interstate at Exit 199. It is considered by many to be the prettiest lake in Kansas. The U.S. Army Corps of Engineers created the lake by damming the Saline River as a flood control measure in 1964. The grasslands upstream along the Saline River keep it one of the clearest lakes in the state. The grass holds the soil in place when it rains, unlike areas with extensive cultivated fields, where more soil washes into the water from the cropland. Wilson Lake has over 9,000 acres of water and over 100 miles of shoreline. Good numbers of walleye, striped bass, and smallmouth bass make fishing popular. Waterskiing, windsurfing, picnicking, camping, and hiking nature trails are also popular activities here. The drive along the south shore is one of the prettiest drives in Kansas. Exit 206 also leads north to the lake.

200 Post Rock

Over the past 20 miles or so you may have noticed stone fence posts. You are entering the heart of "Post Rock Country." Post rocks will be visible along I-70 until you leave Lincoln County, about 40 miles ahead. Stone fence posts created from limestone have been used so extensively in this area that they are an identifying feature of the landscape. The Post Rock Country is from 10 to 40 miles wide and stretches about 200 miles from the Nebraska border south to Dodge City.

This area's development is strongly tied to the limestone. As the saying goes, "Necessity is the mother of invention." With so few trees around, the settlers, some skilled in masonry and stonecut-

Post rock fence

ting, used the area's limestone in place of wood. Limestone is unique in that while the stone is covered with earth and protected from the elements, it remains relatively soft. Upon exposure to the air, however, chemical changes take place that turn the stone hard. Here, the limestone is in thin layers and near the surface for convenient excavation. Limestone post rocks and block houses were a natural outcome. Read the whole story at 190W (page 75) about the 40,000 miles of post rock fences that remain.

202 Abandoned Homes [204W; page 71]

The abandoned yellowish limestone farmhouse along the right side of the interstate was built sometime before 1910 and abandoned in the late 1950s when the last residents moved to Wichita. The many abandoned home sites that can be seen over the next twenty miles signify the end of efforts to make a living from this land.

204 Scenic Byway to the Garden of Eden

At Exit 206 you can connect with the Post Rock Scenic Byway and go north to the Garden of Eden, which contains dozens of concrete sculptures, a glass coffin with the corpse of the sculptor, and a limestone and concrete "cabin" that is listed on the National Register of Historic Places (see 209W; page 70).

205 Czech Capital

To the right you can see Wilson. The Midland Hotel here was used in the movie *Paper Moon*. A Czechoslovakian named Francis Swehla promoted settlement in Wilson, and today it is the Czech

capital of Kansas. Ethnic foods and traditional handicrafts are available. During festivals, original Czech costumes are worn, and traditional meals are prepared.

At Exit 206 the products of 1,200 Kansas artists, craftsmen, and cooks are sold at the Kansas Originals Market. This cooperative association has been featured in the magazine *Midwest Living* and has sold Kansas products to people in all fifty states and more than a hundred countries, bringing in more than \$2 million to the artists and craftsmen.

Wilson claims a unique relation with Alaska. Alaska's first governor, Walter Eli Clark, married Neva McKittrick, a Wilson resident. The very first First Lady of Alaska was from here.

207 The Smoky Hills

Back about fifty miles near Hays, you left the High Plains region and entered the Smoky Hills region. The changes are not abrupt between the regions. Instead, gradual changes occur in the land and vegetation. The Smoky Hills were so named because in the summer the hills are obscured by a smoky-looking heat haze.

The elevation of this region is about 2,500 feet at its western edge and drops to 1,400 feet at its eastern border. Although the overall elevation change is only 1,100 feet, considerable ruggedness is evident over short distances. I-70 generally is located along the upland surface, while along the Saline River, just north of the interstate, the river has cut canyons 300 feet below the upland in places. There is a little more rainfall here than on the High Plains, an average of twenty-four inches annually.

The Smoky Hills are rich with natural resources. They provide much of Kansas's prosperity. Oil, natural gas, and salt are taken from underground. On the surface, the rich soils produce sorghum, wheat, soybeans, hay, and new varieties of drought-tolerant corn.

Throughout the region you can expect to see sunflowers and other wildflowers such as plains indigo and prairie primrose. Upland vegetation called midgrass prairie consists mostly of buffalo and grama grass interspersed with taller grasses such as bluestems. Increasingly, you will see patches of forest along streams.

Buffalo, elk, grizzly bears, and wolves once roamed the Smoky Hills. Today, you might see coyotes, wild turkey, and/or deer in the fields along I-70.

210 Black Wolf [210W; page 69]

This small hamlet is named after an Indian chief. The westbound story includes a humorous road sign that made national news reports.

211 The Lighted Cross Church [214W; page 68]

The small white Excelsior Lutheran Church at the top of the hill ahead is known as the "Lighted Cross Church." The cornerstone for this church was laid in 1908. The church continues to serve this rural area with Sunday morning services. In the adjacent cemetery, many markers are for people with birth dates in the early to mid-1800s.

213 Don't Fence Me In

The fences at the side of the I-70 right-of-way have been installed to deter animals from wandering onto the roadway. Read more about the use of fences and the development of barbed wire at 92W (page 105).

214 Deer Crossing [200W; page 14]

You may see two different kinds of deer in central Kansas—white-tailed deer and mule deer. White-tailed deer are found throughout Kansas, whereas mule deer are found only in the western two-thirds of the state. Deer were eliminated from the state in the 1930s, but their numbers have increased dramatically since then as they adapted to agriculture and even city life. Deer annoy farmers and gardeners by eating crops. But more serious problems are caused when deer try to cross highways and tragic accidents result. About 10,000 deer-car accidents occur each year in Kansas. Be alert, especially in the fall during rutting season.

217 Ellsworth

You are traveling through Ellsworth County. This county was established on February 26, 1867, and named after Allen Ellsworth. Second Lieutenant Allen Ellsworth of Company H, Seventh Iowa Cavalry, established a small fort here in June 1864 on the banks of the Smoky Hill River. In 1866, this fort was renamed Fort Harker and moved to a new site a mile or so away (see 222E; page 179). During its short history, Fort Ellsworth was attacked twice by Indians; on one occasion a raiding party drove off fifty horses and five mules from the fort. No deaths were reported from these attacks.

Exit 219 ahead leads south to the town of Ellsworth, which was constructed near the fort site in 1867. A branch of the Chisholm Trail ran here from just south of the Kansas border in Oklahoma. The other branch ran to Abilene, Kansas. Ellsworth prospered from the cattle trade, as explained at 224W.

218 The Twenty-First-Century Farmstead [220W; page 66]

At the top of the Exit 219 ramp, back of the service station, there is a cluster of buildings. This is the center of the Helvey Farms operations, a 2,000-acre spread. The self-contained farmstead of old, with home and garden, livestock barns, barnyards, and silos, has given way to this machinery repair and parking center with fuel and chemical supply tanks.

221 "Metropolis, Kansas"

South of Exit 225 ahead is the town of Kanopolis. It got its name from the vision of a new town to be called "the Capital Metropolis" or "Kansas Metropolis." *The WPA Guide* called it "one of the most extensive 'paper' towns ever conceived" and reported that "the promoters kept the presses busy day and night printing advertisements of what they dreamed would be a big city by 1900." The town was designed for 150,000 people! Four city blocks were set aside in the plans for the state capitol building. However, despite the best efforts of the Populist Party in 1893, the statehouse remained in Topeka. These ambitious plans never came to pass, but the town has survived. One mile east of Kanopolis is the Independent Salt Company, the oldest continually operating salt mine in the United States. In 1887, rock salt was discovered at the site 850 feet below the surface by people drilling for gas and oil.

222 Fort Harker

Established as Fort Ellsworth in 1864, the fort was renamed Fort Harker in 1866 to honor Captain Charles Harker, who died of wounds received at the Battle of Kenesaw Mountain during the Civil War. This fort provided protection to the stagecoaches and military wagon trains traveling the Fort Riley Road and Smoky Hill Trail. The fort could hold about 700 soldiers and 1,400 civilians. It is reported that a young Bill Cody took his first scouting job at the fort in 1866. It was while hunting buffalo for the railroads the next year that he became known as Buffalo Bill. Distinguished generals

who visited the fort included Grant, Sheridan, Sherman, and the infamous General Custer.

For three weeks in 1867, cholera swept through the fort. That experience led the post surgeon, Dr. George M. Sternberg, to become a leading authority on communicable diseases.

Fort Harker provided protection for the Butterfield Overland Despatch when it began operation in 1865 along the Smoky Hill route to Denver. A lack of protection to the west of here contributed to the BOD's demise after eighteen months. The Fort Harker Museum in Kanopolis contains artifacts and war memorabilia displayed in one of the fort's original buildings.

After Fort Harker was closed in 1872, many families headed out along the river and dug homes out of the earth and lived underground like the common prairie dogs. Charles Grifee became a modern cave man. The son of a miner from Colorado, he chiseled his way into the Dakota sandstone with a pickax to create caves that served as his permanent home in the rock. Carvings and petroglyphs created by Native Americans and early settlers can be seen on the walls of caves in this area.

224 Mushroom Rock Rest Area

There is a history plaque about the Smoky Hills region at this rest area. Here you can photograph and climb on a mushroom rock outcropping. This formation is typical of the ones on eroded bluffs in the Smoky Hills. The wind- and water-eroded limestone layers create a menagerie of forms and imaginary figures.

225 Elkhorn Creek Valley

Ahead, as you cross the Elkhorn Creek valley, you are in the heart of the Smoky Hills. Just past Exit 225 you will cross the creek and experience more of the rugged terrain of the Smoky Hills. Here is another indication that, at least along I-70, Kansas isn't flat. The name Elkhorn reminds us that before the settlers arrived, elk were common residents here on the Kansas grasslands.

228 Land of Lincoln

Lincoln County was established on February 26, 1867, and named after Abraham Lincoln, who had been killed two years earlier. Because Kansas was antislavery and remained part of the Union, President Lincoln was a hero here. After George Washington's

Mushroom rocks at the rest area near 224

name, Lincoln is the most popular choice among political placenames in the United States. In fact, this Lincoln County is one of twenty-two Lincoln Counties in the United States.

Note the rows of redcedar trees planted as another living snow fence along the left side of the interstate.

229 Spite Fence

On the right, just down the slope, there are two stone post fences running parallel with each other just a few feet apart. These parallel fences, with woody vegetation between them, are sometimes called "spite fences." They have been built where there was a dispute or at least confusion between landowners about the exact location of the property line or where there were disagreements about fair and equal maintenance of a fence that was directly on the property line. The space between the fences is sometimes called the "devil's lane." You will see more of these devil's lanes that are filling in with shrubs where cattle cannot graze.

230 Pioneer Problems

Kansas farmers still face hardships, but they pale in comparison to the ones faced by the original pioneers. Early settlers cut fence posts from rock, lived in houses of sod, burned buffalo dung for

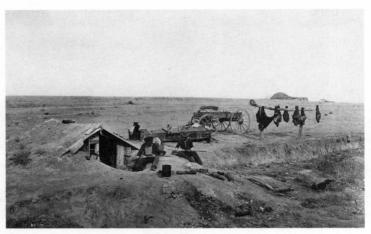

Buffalo hunters' dugout (Kansas State Historical Society)

fuel, and lived in a lonely land. Until they planted trees, they had no shade to protect them from the harsh summer sun nor shelter from the cold winter winds.

The Plains Indians resented the invasion of settlers who were taking their land and killing their buffalo. Kiowa and Cheyenne war parties responded by attacking settlers. Lincoln County was the site of many deadly Indian raids during the 1860s and 1870s. The worst year for Indian attacks was 1874. Cheyennes raided settlements along the Smoky Hill and Saline Rivers, killing soldiers and settlers and destroying or stealing their property.

Early farmers faced other hazards: drought, economic depression, blizzards, and grasshoppers. National economic depressions affected Kansas in 1887 and 1893. Blizzards in the mid-1880s killed hundreds of thousands of livestock and many people. But many pioneers withstood economic difficulties and bad weather and stuck it out.

The one thing pioneers could not be prepared for was the grass-hopper invasion of 1874. According to *Kansas: A Land of Contrasts,* the grasshoppers appeared suddenly in late July and August in such numbers that they blotted out the sun. In some places, they covered the ground four to six inches deep. People watched in amazement and consternation as food and grain disappeared al-

most instantly. Clothing was eaten off people's backs, and even the soft wood of tool handles was devoured.

The victims fought back using kerosene as an insecticide and beating grasshoppers with sticks and boards. They raked grasshoppers into piles, like leaves, and set them on fire. But their efforts to fight the insect enemy were in vain.

From *Kansas: A Land of Contrasts*, one Kansas resident gave his account of the incident:

We were at the table; the usual midday meal was being served; one of the youngsters who had gone to the well to fill the water pitcher came hurrying in, round eyed with excitement. "They're here! The sky is full of 'em. The whole yard is crawling with the nasty things." Food halfway to the mouth fell back upon the plate. Without speaking the whole family passed outside. Sharp spats in the face, insects alighted on the shoulders, in the hair, scratchy rustling on the roofs, disgusted brushing of men's beards, the frightened whimper of a child, "Are they going to eat us up?" Turkeys gobbling the living manna as fast as their snaky heads could dart from side to side; overhead the sun dimmed like the beginning of an eclipse, glinted on silver wings as far as eyes could pierce; leaves of shade trees, blades of grass and weed stems bending with the weight of clinging inch-long horrors; a faint, sickening stench of their excrement; the afternoon breeze clogged with the drift of descending creatures.

Not much was said, children huddling against their mother, whose hand touched lightly the father's arm. . . . The garden truck had disappeared, even the dry onions were gone, leaving smooth molds in the ground empty as uncorked bottles. Fruit hung on the leafless branches, the upper surface gnawed to the core. The woods looked thin, as in late autumn. Water troughs and loosely covered wells were foul with the drowned hoppers.

234 Buffalo Ranch

Look to the right and you might see a herd of bison. As mentioned previously, buffalo ranching provides buffalo burgers and buffalo steaks that are served in many Kansas restaurants. Just like the early settlers, modern people make coats and blankets out of the pelts. Flocks of gulls often are seen feeding around the bison.

235 Dog Soldiers [215W; page 67]

During the late 1800s, ruthless bands of renegade Indians called Dog Soldiers roamed these hills. They attacked settlers, ignoring peace treaties and the orders of their own chiefs.

236 Saline County: Salt Water in Kansas

In 1806, Lieutenant Zebulon M. Pike, traveling to what is now Pikes Peak, camped near here. During his stay, Pike sampled the stream water and found it tasted salty, or "saline." In his report to the government, Pike wrote that the region was "The Saline River Country," hence the name of the river and the county. Saline County was organized in 1859.

Pike was not the first European to visit this county. That distinction was earned by the Spanish explorer Coronado, who came this far east on his 1541 expedition from Mexico City in search of the Seven Cities of Gold. Can you imagine his disillusionment with coming upon a salty stream with no sign of gold or cities?

237 Eastern Redcedar [292W; page 46]

This is the evergreen tree that you see growing in the grasslands and along the roadside. This beneficial tree has many uses. Pencils, chests, and other small items are made from the wood, and the tree is often used as a Christmas tree. If you have been traveling from western Kansas, you have seen redcedars planted in windbreaks and living snow fences.

239 Brookville

About five miles south of the interstate lies the town of Brookville. Once a cattle-shipping site and division point on the Union Pacific Railroad, in the 1870s the town bustled with 2,000 residents, several general merchandise stores, two lumber yards, flour and feed stores, and two hotels. As a division point, train crews lived here and took the trains a specified distance in either direction, where they would turn the train over to the next crew. They would then work on another train for the return trip to Brookville.

One business that remained in town after the Union Pacific moved its division farther west was the Brookville Hotel. Originally known as the Cowtown Café and then the Central Hotel, the Brookville Hotel has had notable guests, including Buffalo Bill Cody, J. C. Penney, and Henry Chrysler, father of Walter Chrysler, founder of

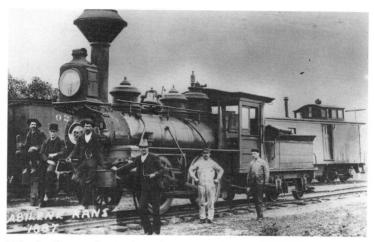

Union Pacific steam locomotive and crew (Kansas State Historical Society)

Chrysler motors. It became famous for its fried chicken dinners. During World War II, military personnel at the nearby Smoky Hill Air Force Base patronized the hotel by the hundreds. The owners recently moved their business to Abilene. At this new location, Exit 275, a replica of the Brookville Hotel still serves family-style chicken dinners to travelers just as the original hotel did in the 1800s.

241 Sunflowers

This is wild sunflower country. Throughout the summer months, watch for many varieties of these yellow flowers, which were chosen as the state flower in 1903.

Again, as in western Kansas, you are entering an area where farmers grow commercial varieties of sunflower. You may have already noticed large sunflower fields along I-70. The sunflower is an American original. Unlike corn, which came from Central America, and wheat, which came to Kansas from the eastern United States and even as far away as Russia, sunflowers are native to the Great Plains. American Indians cultivated the sunflower and used the nutty kernels for a quick energy food. They produced a yellow dye from the petals. Spanish explorers enjoyed sunflowers so much that they sent them back to Europe, where they were widely used as an ornamental plant. Sunflowers were never really viewed as a

food plant until they reached Russia. There sunflower oil was commercially manufactured, and the Russian Orthodox Church left it off the list of foods prohibited from being consumed during Lent.

When sunflowers are blooming, notice how their heads all follow the sun across the sky in unison. In fact, that is how they got their name, from always facing the sun. Sunflowers are an important crop here. Kansas is regularly one of the top three states in sunflower production. As seen in western Kansas, companies process sunflowers to make oils and bird seed and, of course, to produce the sunflower seeds you buy at convenience stores to munch on as you travel down I-70.

243 Rhinos on the Plains

The next exit takes you to the Rolling Hills Zoo, a ninety-five-acre zoological park that opened in October 1999 and is dedicated to conserving rare and endangered wildlife. To the right across the valley, you can see the silver roofs of this unexpected oasis on the prairie. Visitors can see two rare white rhinos and more than eighty other kinds of exotic animals.

245 Bombs Away!

You can see a long way here in the Smoky Hills. Back across the valley to the right, the small, flat hill forming the highest point

B-29 bombers (Kansas State Historical Society)

along the southern horizon is called Soldier Cap. That particular hill is eleven miles away. From this distance the landscape seems pastoral and peaceful, but looks are deceiving. Soldier Cap is located on the Smoky Hill National Guard Range, where jets from McConnell Air Force Base in Wichita and other bases conduct target practice with their air-to-ground delivery of precision guided weapons.

During World War II the Smoky Hill Army Air Field was the training center for the first B-29 "Superfortress" units. B-29s built in Kansas were credited with key roles in the success of European and Pacific operations.

248 Breadbasket of the World

The first railroad car full of wheat was shipped from Saline County to New York City in 1870. By 1880, Salina had three flour mills and six grain elevators. More than 120 years later, wheat still plays a major role in Salina's economy, as evidenced by the enormous Cargill-Salina grain elevator seen to the right, with its 140 bins that are 150 feet tall.

Sixty percent of the storage at this elevator is used for hard red winter wheat that comes by truck from farms within a thirty-mile radius. About 85 percent of the wheat is destined for export to hungry people in the rest of the world. It is shipped out in 100-car trains to be loaded on ships at Texas and Louisiana seaports. The elevator also purchases sorghum, corn, and soybeans.

140-bin Cargill grain elevator

249 Salina [257W; page 56]

William A. Phillips, a lawyer and newspaper writer, and several other men founded the town of Salina in 1858, at the confluence of the Saline and Smoky Hill Rivers.

251 Blue Beacon

The original Blue Beacon truck wash can be seen here on the left. Read about this company's origins at 253W (page 57).

253 Aviators

Salina has been the home of several famous aviators, including Glen Martin, who in 1908 flew the first flight that took off under its own power, and who invented the parachute and the first bomber. Tom Braniff, founder of the now-defunct Braniff Airlines, and astronaut Steve Hawley, who flew on the maiden voyage of the space shuttle *Discovery*, are also from Salina.

254 Bottomlands and Uplands

As you cross the Saline River, notice how the flat bottomlands are planted in wheat, soybeans, and other crops, whereas the hilly uplands are covered with grass. Besides the obvious difference in terrain that limits the operation of farming equipment, the bottomlands have deep, rich, productive soil from the silt deposited when the river floods. The hills have relatively poor, shallow soil that needs to be protected from erosion with grass cover.

256 Iron Mound

For the next five miles as you look back across the Saline River valley, on the southern horizon you can see Iron Mound. This apparent "mountain" has an elevation of 1,497 feet. Iron Mound is capped with Dakota sandstone. The mound was formed because the sandstone is less prone to erosion and remains in place while the surrounding soil erodes.

257 Nature's Sanitation Crew [216W; page 9]

From mid-March until October, turkey vultures will be seen along I-70 performing their cleanup duties. You can distinguish these scavengers by their red, unfeathered head and by their distinctive soaring, tipsy manner of flight on black wings held upward above the horizontal.

259 Hedgerows

At the top of the hill on the right is a hedgerow. Throughout this region you will see fields bordered by hedgerows—a single row of rather short, rounded trees. The trees are Osage orange, often called "hedge" or "hedge apple." Before the days of barbed wire fences, hedgerows were planted to serve as natural fences. Osage orange is a dense, bushy tree with thorns on the branches. When planted close together, the trees make a nearly impenetrable fence that is touted as being "horse-high, bull-strong, and pig-tight." Although native only to Texas, hedgerows were a common sight as far away as New England even before the Civil War.

The wood of the Osage orange is hard and strong. It is used to make fence posts, cross ties, and archery bows. In earlier times it was used to make wagon wheels. The "hedge apple" or "hedgeball" is a softball-size, lumpy, yellow-green fruit that is not edible. Hedgeballs are sold at farmer's markets to people who believe they repel insects and spiders from homes.

260 New Cambria

Exit 260 south leads to New Cambria. It was named in 1872 by the town's founder, S. P. Donmyer. This settler was born in Cambria Township, Pennsylvania, so the name honors his Pennsylvania birthplace and his Welsh heritage.

261 Alfalfa

Alfalfa was introduced to Kansas here in Saline County. According to *The WPA Guide*, Dr. E. R. Switzer planted the alfalfa seed he had bought in California for 50 cents a pound. That year, 1874, a grasshopper plague and drought seemed to destroy the new crop. However, when rains came in September the alfalfa came back to life. Switzer thought that any crop that could withstand drought and grasshoppers would be just the thing for a place like Kansas.

Alfalfa can be identified by its small, round leaves and bluish to purple blossoms. It is not planted in rows, and so it appears to cover the whole field. When the plants are twelve to twenty inches tall, the alfalfa is cut, dried, and baled. The crop then grows back and can be cut again. Some farmers chop the green plants to make silage, as explained at 33E (page 141). Depending on the amount of rain, farmers take three or four "cuttings" of alfalfa from a single field each year.

Alfalfa is a major crop for Kansas, with over 3 million tons being harvested according to the USDA Census of Agriculture. As mentioned previously, those big round bales of alfalfa weigh about one ton each, so if all of Kansas alfalfa hay were hauled to market, it would require 75,000 trucks. Of course, much of the hay stays on the farms to be eaten by livestock. Alfalfa is nutritious feed for livestock. It is rich in proteins, minerals, and vitamins. Cows fed alfalfa produce sweet-tasting milk.

Alfalfa knows how to get a drink. Its roots penetrate deep into the soil in search of water. For some varieties the long, stringy roots go down 25 feet. The crop also enriches the soil with nitrogen. Bacteria on the roots take nitrogen from the air and change it into plant food. Look for this beneficial plant as you drive east. It will become increasingly common.

263 Motherly Love [258W; page 56]

Mary Ann "Mother" Bickerdyke, the famous Civil War field nurse, lived in Saline County and was responsible for bringing more than 300 families into the county after the Civil War. She cared for veterans and their families during Kansas's days as the Soldier State.

264 Solomon River

This river was not named for the Old Testament biblical king. Instead, it got its name from French fur trappers who called it "Salmon," for a leader of the Louisiana Territory. Explorer Zebulon Pike passed across this river in 1806 and in his journals interpreted it to be Solomon's Fork. Explorers reported witnessing this river being drunk dry by an enormous herd of buffalo.

265 Rest Area

At this rest area a historical information marker introduces you to the historic Abilene area just ahead.

266 Dickinson County

This county was created by an act of the Kansas territorial legislature and signed into law by Governor John W. Geary on February 20, 1857. It perpetuates the name of Daniel S. Dickinson, a U.S. senator from New York, who introduced legislation that helped create the Kansas Territory.

Just across the county line (Exit 266) is the town of Solomon. It

is located at the junction with the Smoky Hill River, but it was named in 1865 after the other river, the Solomon. Early expectations were for the county seat of Dickinson County to be located near here, but instead Abilene gained that distinction. Solomon built its economy on salt. By the 1870s, salt producers were shipping about 10,000 barrels a year from salt mines in the area.

268 Historic Abilene

A lot of history is associated with the area you are now approaching. Abilene played a pivotal role in the development of Kansas and the United States. It was one of the first cattle boom towns as a terminal of the Chisholm Trail. It's the birthplace of winter wheat planting in Kansas. In Abilene is General Dwight D. Eisenhower's presidential library, the Eisenhower Museum, and Ike's boyhood home, all open to the public. James Butler "Wild Bill" Hickok made a brief appearance as the town marshal in the early days of Abilene. Some independent or non-Bell telephone companies originated in Abilene, including the company that became Sprint.

The Museum of Independent Telephony collection in Abilene includes a silver-dollar pay phone, candlestick phones, a Wonderphone, a potbelly phone, and a little pink Princess. You are invited to operate the switchboard and touch many pieces of telecommunications gear to feel how they operate. C. W. Parker, who became known as the "Amusement King," built his first carousels in Abilene in the 1890s. One of his early carousels, operated by its original steam engine, is at the Dickinson County Historical Society Museum. Abilene is known as the "Greyhound Capital of the World." The Greyhound Hall of Fame presents facts and stories about greyhound dogs and racing. And don't forget that now in Abilene is the historic Brookville Hotel, described back at mile 238. Those famous chicken dinners are served in the re-created hotel just to the left at Exit 275. There is a lot more about Abilene's contributions at 275E (page 193) and 279W (page 51).

270 Sand Dunes

Notice, particularly on the right, that the sculptured landscape is different from the hills you have been seeing. Under the blanket of grass are sand dunes. These dunes formed over many thousands of years as sand blew up from the Smoky Hill River valley on the right. The coarse sand particles piled up leaving these uneven sur-

faces on which grass took root and developed a thin stabilizing top soil layer. Read about sand and loess (windblown) soils at 270W.

271 Abilene Ahead

The blue water tower ahead signals that you are fast approaching the edge of the historic town of Abilene, which was founded by Timothy F. Hersey in 1858. Mrs. Hersey chose the name of the town by allowing her Bible to fall open and picking a name from that page. The Bible opened to the third chapter of the book of Luke, where the name Abilene appears in the first verse. Appropriately enough, Abilene means "city of the plains."

272 Chocolate Factory [274W; page 52]

At Exit 272 you can see candy being made at the Russell Stover plant. Help yourself to samples and buy a wide assortment at bargain prices.

273 Bulgur Wheat

Each of the 72 grain elevator bins, sporadically seen over the next two miles on the south horizon, is 143 feet tall. The bins store wheat for another important wheat market. Bulgur wheat is produced at this mill in Abilene. Every day 25,000 bushels of wheat are cooked at the mill to produce the bulgur, which is one of the most important products that the Agency for International Development supplies when there is a famine or other international disaster.

Bulgur is wheat kernels that have been steamed, dried, slightly scoured, cracked, and sifted for sizing. The result is a parboiled, cracked wheat. Arab, Israeli, Egyptian, and Roman civilizations record eating dried cooked wheat as early as 1,000 B.C. It is sometimes sold in supermarkets as pilaf or tabouli mix. Stored in airtight containers, it will keep well for six months. Bulgur more than doubles in volume when it is cooked in water or a liquid broth. The 110-pound red, white, and blue bags of bulgur wheat are shipped by rail from this Abilene plant to ports in Louisiana and Texas to be transported to famine and disaster sites. When it is not being used as disaster relief, bulgur is used in meat loaf, soups, stews, and casseroles or stirred into waffles, pancakes, muffins, salads, and baked goods to add a nutty flavor without adding fat.

275 Abilene: End of the Chisholm Trail

At the end of the Civil War, Texas cattle ranchers faced a big problem: they had more than 5 million longhorns on their rangelands but no way to send them to cities in the North or East. Joseph McCoy, an Illinois livestock dealer, knew he would be a wealthy man if he could move the longhorns to eastern markets. The railroads could haul the cattle if he could get them to a pickup point. In 1867, McCoy selected Abilene.

McCoy immediately bought land for his stockyards and built a hotel. He sent messengers south to spread the word to aim cattle toward Abilene. On September 5, 1867, the first rail shipment of cars, filled with cattle, left Abilene for Chicago.

The route of cattle drives to Abilene was an extension of the Chisholm Trail. The trail, which had been used by Indians, traders, and the army before cattlemen began using it, ran from the Canadian River in present-day Oklahoma, north to a trading post at Wichita, and then on to Abilene. After four years of cattle drives, the trail was 200 to 400 yards wide, bare of vegetation, and lower than the surrounding country. The trail was marked only by the occasional bleached skull of a longhorn or the grave of an unlucky cowboy.

Abilene marked the end of the trail for many a cowboy, and so it also marked payday and the comforts of "civilization." Abilene became a wild and open frontier town. Nightclubs, saloons, and gambling establishments contributed to Abilene's reputation as the wildest town in the West. In 1869, soft-spoken Tom "Bear River" Smith took the job of sheriff and held it for over a year. One of Smith's first official acts was to issue an order that no one was allowed to carry a firearm within the city limits. His ability and courage were respected, and even the most troublesome cowboys obeyed this law or paid the consequences. Unfortunately, in 1870, Smith was shot while trying to arrest a man in a nearby town.

James Butler Hickok, better known as Wild Bill Hickok, replaced Marshal Smith. Wild Bill's manner of dress and his deadly shot were legendary. According to *The WPA Guide*, his wardrobe changed from the well-known fringed buckskin to a Prince Albert coat, checkered trousers, embroidered waistcoat, and silk-lined cape. Wearing a fancy two-gun rig (either silver, pearl-handled

Wild Bill Hickok (Kansas State Historical Society)

pistols when formally attired or a pair of army revolvers when in casual dress), he set up office in the Alamo Saloon. As for his shooting, he could hit a coin tossed in the air or keep a can dancing in the dirt. The exact number of men he killed is unknown (only two killings have been documented in Abilene, and one of those was a case of mistaken identity), but Hickok was not at all shy about shooting at more than cans and coins. He is quoted in *The WPA Guide* as saying, "Killing a bad man shouldn't trouble one any more than killing a rat, or a mad dog." Wild Bill bore out the saying "live by the sword, die by the sword"; he was killed by a gunshot to the back of the head while playing cards in Deadwood, South Dakota.

Soon after Wild Bill left, the railroads connected with towns farther west, thereby diverting the cowboys and crime to those towns. But before it was over, almost 3 million head of cattle had been shipped from Abilene to eastern markets.

279 Enterprise [283W; page 49]

The town you see across the valley to the right is Enterprise, which was founded in 1873 and quickly became a milling center for wheat.

280 The Four Seasons Trail Rider [282W; page 49]

Seeing a modern campground and modern "wagons" meant for moving families across the country reminds us of the tremendous changes in transportation along Kansas trails in a mere 150 years.

282 Another Power Trail

That two-circuit, six-cable electric transmission line to the right is operating at 115,000 volts, although its design capacity is for more than twice that (345,000 volts). Running nearly parallel with I-70, it crossed the interstate at mile 280 and will cross again when the road curves at mile 287. It brings electricity from the Jeffrey Energy Center (see 320E; page 204) to Salina, and then it continues south to Hutchinson. These modern power trails vividly contrast our lifestyles against those of past travelers across Kansas who never saw a power line and could only imagine the wonders of electricity.

285 Chapman [287W; page 48]

This town was once known as Little Ireland because it was settled by Irish immigrants. It is home to the first county high school in the United States and to Joe Engle, one of our nation's premier pilots and astronauts.

286 Wings over the Prairies

More than 450 different kinds of birds have been seen in Kansas. In about fifteen minutes you will be entering an area of expansive tallgrass prairie. Read descriptions of prairie birds such as upland sandpipers, nighthawks, and meadowlarks at 328W (page 34). The most distinctive prairie bird is the prairie chicken. Read about this interesting bird at 308W (page 41). Watch for all these prairie birds as you drive through the miles and miles of rolling prairie ahead.

288 Why Are Barns Red?

That barn ahead on the right is typical of the red barns across the countryside. Red was the color of choice for painting barns for many years, probably because the ingredients for red paint were inexpensive and easy to mix. Read more about traditional red barns (and other colors used more recently) at 196W (page 73).

289 Geary County

This county was originally named Davis County after Jefferson Davis, secretary of war from 1853 to 1857. During the Civil War,

Davis became president of the Confederate states. Legislators tried to change the name of the county, but locals objected to having a new name, and the efforts failed. In 1889, long after the war was over, the legislature finally changed the county's name to honor Kansas's third territorial governor, John W. Geary. Geary went on to be mayor of San Francisco, and the famous Geary Street there is named for him.

290 Kansas's Largest Lake [297W; page 45]

Exits 290 and 295 ahead will take you to Milford Lake, the largest lake in Kansas. The lake was created by damming the Republican River. Below the dam are a nature center and a modern fish hatchery operated by the Kansas Department of Wildlife and Parks. These facilities are open to the public and offer nature trails, exhibits, and educational tours.

292 Head of the Kaw

Just a few miles ahead at mile 298, I-70 will cross the Smoky Hill River near its junction with the Republican River. Two miles from the bridge, these two rivers form the Kansas River, commonly called the "Kaw." Several attempts were made to create a town where the rivers join, but they all failed until one appropriately named Junction City was finally established in 1858. Once settlers wanting to establish a town there tried to reach the spot by steamboat traveling up the Kansas River, but they got stuck on a sandbar before they made it and settled at that location (see 314W; page 39).

Explorer Captain John C. Fremont, heading west in 1843, camped near this spot. "The Pathfinder," as Fremont was called, reported great numbers of elk, antelope, and friendly Indians here. An elk herd has been reestablished on Fort Riley and the animals once again roam the region.

293 Rest Area

History is presented about the area surrounding the junction of the Republican and Smoky Hill Rivers just ahead.

294 Sausage Factory

The large manufacturing facility on the left is the Armour Swift– Eckrich processed meats manufacturing plant. Your sausage could have been produced here if it has the brand name Healthy Choice, Armour, Swift, Eckrich, or Butterball. Details about this factory are at 296W (page 46).

295 Fort Riley

Built in 1853, Fort Riley was originally named Camp Center because of its location near the geographic center of the United States. The name was changed to Fort Riley to honor Major General Bennett C. Riley, from Buffalo, New York, who led the first military escort along the Santa Fe Trail in 1827. A cholera epidemic broke out during its construction, and more than 100 people died. Most soldiers were spared because they were away on an Indian campaign. Fort Riley provided protection for travelers on the Santa Fe and Oregon Trails, and later for the builders and passengers on the railroad. Before the Civil War, cavalry units stationed at Fort Riley "policed" the recently opened territory because of bloodshed between pro- and antislavery factions.

General George Custer was second in command at the fort, and he rode to the Little Big Horn from here. After the Plains Indians were removed from the area, many forts closed. However, Fort Riley remained open at the request of Lieutenant General Philip Sherman, who wanted it to serve as the army's cavalry headquarters.

Fort Riley's cavalry school became the only one in the United States and the largest in the world. Horse soldiers were trained until 1950, when all the units became mechanized. Because of the

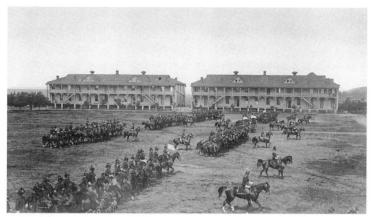

Fort Riley parade ground, 1897 (Joseph J. Pennell Collection, Kenneth Spencer Research Library, University of Kansas)

emphasis on horses, the fort produced the U.S. Olympic equestrian team for every Olympics between 1894 and 1947. Many of our best-known military leaders trained and served here, including Jeb Stuart, Robert E. Lee, and George Patton, who passed though Fort Riley several times. When duty called for World War I, World War II, Korea, Vietnam, and the Persian Gulf, tens of thousands of soldiers went to war directly from Fort Riley. During World War II alone, 150,000 men were inducted and trained here. Until recently it was home to the First Infantry Division, known as the "Big Red One." This unit was made famous by the movie of the same name, which stars Lee Marvin.

The base covers 157 square miles, making it the largest nontraining military base in the nation. The U.S. Cavalry Museum (Exit 301) features dioramas that depict life in the cavalry and show the progression of the equipment and uniforms from the Revolutionary War to World War II. There are original artworks by Frederick Remington and memorabilia from George Patton and other famous military heroes. The house that Custer lived in at the fort has been preserved and is open to the public.

298 First Capitol

Exit 301 leads to the first territorial capital of Kansas. Andrew Reeder, the territory's first governor, had real estate investments here, obviously influencing his decision on where to locate the capital. Reeder told the Pawnee Town Company, in December 1854, that he intended to meet with the legislature at the town of Pawnee on July 2, 1855, provided a suitable building could be made available. As soon as it became known that Pawnee might be the capital, settlers began to arrive in droves and camped on the prairie beside the Kansas River.

Work began on the capitol building in the spring of 1855 and continued through Sunday, July 1. Although there was a hole in the west side of the upper story and several floor boards were not nailed down, the legislature convened in the still-unfinished building on July 2 as planned.

However, the legislators were not happy with Pawnee as the capital because it was too far from their homes. So just two days later, they passed a bill transferring the seat of government from Pawnee to Shawnee Mission, near Kansas City. Governor Reeder

Atomic cannon

vetoed the bill, but his veto was overridden. The legislators hastily gathered their belongings and headed for Shawnee Mission, leaving the unfinished stone capitol behind. Pawnee's days as the territorial capital of Kansas were over.

Governor Reeder was opposed by the pro-slavery faction because it saw him as too favorable to free-staters. On July 28, 1855, he was removed from office and charged with purchasing Indian lands, speculating in town property, and endeavoring to influence the value of town lots in Pawnee. Fearing for his life, Reeder left Kansas disguised as a woodcutter.

300 Atomic Cannon

Straight ahead on top of the ridge you can see an "atomic cannon," one of only three in the world! This cannon was designed during the cold war to shoot a nuclear warhead and hit targets more than twenty miles away. At Exit 301 there is a small park called Freedom Park. Several cannons and other weaponry can be seen there, and a path leads up to the atomic cannon. An outstanding view of Fort Riley and the surrounding countryside awaits hikers who make it to the ridge top.

301 Marshall Field

Fort Riley's Marshall Airfield is on the left. Vehicles and helicopters stored here were used in the Persian Gulf War. The vehicles were

painted tan, rather than the normal army green, to blend in with the desert sands. The fort museum has artifacts from Desert Storm.

Hap Arnold, the first commander of the U.S. Air Force, got his start in aviation by flying biplanes from this field in 1912. Today the field is used primarily by helicopters based at Fort Riley.

302 The Flint Hills

The Flint Hills region began just east of Salina, but the hills will be more pronounced over the next forty-five miles. The Flint Hills may be the most picturesque region along I-70, and indeed one of the most pleasant landscapes in the United States. They form a band running north and south from Nebraska to Oklahoma across the entire width of Kansas. The area is named for the chert or flint rock that covers the slopes. As you will see by looking at the flat-topped hills, the Flint Hills could be more accurately called the Flint Valleys because erosion has cut into the otherwise flat terrain to create these "hills." The eastern edge of the Flint Hills forms Kansas's most rugged landscape, with slopes rising more than 300 feet.

Besides the picturesque scenery, the Flint Hills provide unexcelled pastureland. Eighty-eight kinds of grass grow here. The region averages about twenty-eight inches of precipitation per year. Flint Hill streams are usually clear, with rocky limestone bottoms and banks, because their watersheds are mostly grass, and grass holds the soil in place even after a rain.

At one time 142 million acres of prairie existed in the United States. Today less than 5 percent of that prairie remains, most of it right here in the Flint Hills. Tallgrass prairie remained in the Flint Hills because the soil was too shallow and rocky to be plowed up and converted to cropland, as was done in Illinois and other prairie states. On both sides of I-70 over the next thirty miles, you can see that the construction of I-70 involved cutting into the hills to level out some of the ups and downs of the terrain. The limestone layers are a sedimentary rock, made by sediments accumulating one layer at a time. Materials such as the remains of mollusks and corals settled to the bottom of the ancient sea, as mentioned previously in western Kansas.

The rainbow of layers in the road cuts results from a colorful type of shale interlaced among the limestone layers. Shale is formed from clay or silt being compressed and hardened into rock, in this case after the articles settled to the sea bottom. Notice the very shallow surface soil layer. It is no wonder that these Flint Hill prairies have never been converted to cropland.

306 Konza Prairie [311W; page 40]

McDowell Creek Road (Exit 307) leads to the entrance of Konza Prairie. This 8,616-acre prairie, which continues along the left side of the interstate between here and Exit 313, is an important ecological research site. Visitors can hike nature trails to experience the prairie firsthand.

The name Konza comes from one of the more than 100 variations of the name of the Kansa Indian tribe. This is also the source of the name Kansas.

309 Rest Area

A sunflower sculpture about twenty feet tall on display at the rest area was carved from limestone in conjunction with a stone symposium held in October 1986. Artist Robert Rose was joined by a nineteen-member carving team for the project in partnership with the Kansas Department of Transportation and the Kansas Sculp-

Sunflower sculpture

ture Association. Stone for the sculpture was donated by the Bayer Stone Company. A historical marker at the rest area interprets the Flint Hills area.

310 The Little Apple

Exit 313 north leads to Manhattan, which calls itself "the Little Apple" to avoid confusion with the *other* Manhattan. This Manhattan is the home of Kansas State University. Besides its internationally recognized agriculture programs, the university has colleges of engineering, architecture, business, and veterinary medicine. Read more about the founding of the town, about KSU, and why radio commentator Paul Harvey called the university the "student scholar capital of America" at 314W (page 39).

312 Council Grove

About 30 miles south at Exit 313 is the historic town of Council Grove, located along the Santa Fe Trail. This route, which started in Missouri, had been used by Native Americans for centuries, and then by fur traders and explorers to reach Santa Fe, the Spanish capital of the Nuevo Mexico province. The United States negotiated with the Osage Indians for passage across their lands along the route of the trail. It was from this council with the Osage that the town took its name.

On September 1, 1821, William Becknell and several other men left Missouri, and by mid-November they were in Santa Fe. Becknell was so encouraged by the success of his first journey that he decided to try another the following year. His second trip was not as easy as the first, as run-ins with Osage Indians and near dehydration almost ended the men's lives.

The following story tells of one of the hardships the men of the second party faced after they left Council Grove on their journey in western Kansas:

The men proceeded along their forward course without being able to procure any water, except for what was in their canteens. As these sources were exhausted the men were reduced to the cruel necessity of killing their dogs and cutting off the ears of their mules, in the hopes of quenching their thirst with blood. This only served to aggravate the already parched members of the second party.

The men searched many days for water and were frequently

led astray by mirages and false ponds. Not realizing they had almost reached the banks of the Cimarron River, their last hopes fading quickly, the men believed they were about to die. Suddenly, a buffalo fresh from the river's side, and with a stomach full of water, was discovered by a couple of men in the party. The hapless intruder was immediately dispatched and an invigorating draught procured from its stomach. One of the men mentioned afterward that nothing ever passed his lips which gave him such exquisite delight as his first draught of that filthy beverage.

When the Santa Fe Trail was the main highway between Missouri and Santa Fe, Council Grove was the most important point along the trail because it was on the Neosho River and surrounded by forests and lush grasslands. Trail animals such as horses, cattle, and oxen were fattened on tall prairie grass and allowed to rest and drink before heading out on the long journey to Santa Fe. Timber was critical for repairing wagons and their axles. Since large trees were scarce west of Council Grove, timber suitable for replacement axles was gathered here and slung under wagons headed west.

Seth M. Hays established a trading post just west of the Neosho River in 1847. Hays's business grew to include a restaurant along the trail—the Hays House Restaurant, which opened in 1857 and is still in operation today. It is said to be the oldest restaurant west of the Mississippi River. Famous guests visited the Hays House, like General George Custer and Jesse James. Seth Hays himself was close to fame, with Daniel Boone as his great-grandfather and Kit Carson as his cousin. The Hays House Restaurant is still a popular restaurant with travelers along modern-day trails.

Beyond Council Grove on K-177 is the Tallgrass Prairie National Preserve, a recent addition to the U.S. National Park System.

316 Camels in Kansas [317W; page 38]

As you enter Riley County just past Exit 316, you might see camels grazing in Deep Creek valley. You most often see the camels in the valley on the right, but they might also be on the left side.

318 St. George [319W; page 37]

Not one, but three men named George founded this town. The westbound story explains why they did it and why one of the men was considered a saint.

320 Jeffrey Energy Center

Ahead over the next twenty-five miles from hilltops you will see three smokestacks on the horizon to the left. They are part of the Jeffrey Energy Center, the largest power plant in Kansas. This plant, more than twenty miles north of I-70, can produce 2,250 megawatts of electricity. It burns relatively clean coal brought in by rail from eastern Wyoming. Thousands of acres of land and lakes around the power plant have been designated as a wildlife refuge and the Oregon Trail Nature Park. Those high-voltage electric power lines that have crossed I-70 are interconnected with the Jeffrey plant to carry electricity across Kansas.

321 OK Corrals

The fencing and structures on both sides of the interstate make up corrals. Corrals are needed to treat sick cattle and to herd them together for loading on trucks headed for market, feedlots, or other pastures. They were made famous in cowboy movies and are still an essential part of ranching.

The newest corrals have curving alleys and solid panels that help calm the cattle. They are designed to effectively direct the livestock into different pens and sort them safely and efficiently. Attention is given to providing smooth surfaces and control gates that protect animals from injury. The corrals include features that make it practical for one cowboy to manage a herd alone when necessary.

322 Wabaunsee County [346W; page 27]

You will be entering one of the few Kansas counties whose name was taken from a Native American tribe or chief. Wabaunsee, a warrior chief of the Potawatomi tribe, never lived in Kansas but was born in Indiana in 1760 and died there in 1845. The first settlers in the county were a band of outlaws known as the McDaniel Gang, who preyed on wagon trains traveling on the Santa Fe Trail.

323 Skeet Tower

In a pasture at the right just before Exit 324 is a wooden tower from which targets are launched for shooting skeet. Skeet is a sport in which shooters use shotguns to fire at saucer-shaped targets. As in trapshooting, the target is thrown into the air from a metal-sprung trap. Some targets are thrown in pairs at different levels, and the

Skeet tower

shooter is challenged to bring down both of them. Although sometimes called "clay pigeons" because they were originally made of clay, the targets actually are made from a mixture of silt and pitch.

The word "skeet" is a Scandinavian term for "shooting." The sport was invented in 1920 in Massachusetts and gained nation-wide popularity in the 1930s. Today it is a popular competitive shooting sport, and it also provides bird hunters with opportunities to develop their shooting skills during the off-season. This tower belongs to the Pine Ridge Sporting Club.

Exit 324 takes you to Grandma Hoerner's Gourmet factory and store, where you can see applesauce being canned (explained at 325W; page 35).

324 Beecher Bible and Rifle Church

About six miles north of this exit is the Beecher Bible and Rifle Church. In May 1854, the Kansas-Nebraska Bill passed in Congress, giving each of those two territories the right to vote to be either a slave state or a free state. Consequently, people living in free or slave states relocated to Kansas in hopes of influencing the vote. Charles Lines of New Haven, Connecticut, favored a free state and raised money to send colonists to the Kansas settlement of Wabaunsee.

In the spring of 1856, sixty people met at the North Church in New Haven, Connecticut, and prepared to leave their jobs and move to Kansas to cast their votes. Henry Ward Beecher opened the meeting with an eloquent antislavery address and promised the congregation that he would donate twenty-five rifles and some Bibles for the Connecticut Company going to Kansas if the audience would provide twenty-five more. When the group left Connecticut, the rifles were packed in boxes labeled "Bibles" in an effort to smuggle them into Kansas.

In April 1856, the group arrived at Wabaunsee and set up camp. Some New Englanders found pioneer life too difficult and returned home. The ones who stuck it out banded together and formed the Prairie Guard, which fought in many skirmishes with pro-slavery groups, including traveling to Lawrence to defend it against proslavery border ruffians from Missouri. The New Englanders completed the Beecher Bible and Rifle Church in 1862. Kansas became a free state as a result of efforts of antislavery groups such as this one.

326 Wamego

Exit 328 leads to the town of Wamego, named after a Potawatomi Indian. A Dutch windmill rises above the quaint Wamego City Park. Joph Schonoff, a Dutch immigrant, built the windmill on his farm in 1879. His family used wind power to grind flour and livestock feed. However, there was not enough grinding business in the area, so the mill was shut down in the late 1880s. The windmill was moved to the park, stone by stone, and reassembled in 1923. Today it has been reopened to grind Old Dutch Mill flour for sale to visitors and by mail.

Wamego residents also are proud of their Columbian Theater. A local banker built it in 1895 to house artifacts purchased at the 1893 Columbian Exposition in Chicago, which celebrated the 400th anniversary of Columbus's discovery of the New World. Windows in the Columbian are from the Brazil Building at the exposition and were among the first metal-framed windows ever built. The most valuable artifacts are six large murals (each nine by thirteen feet) depicting American prosperity painted by Francis David Millet. Millet had been the art director for the exposition and was famous for his larger-than-life murals. This larger-than-life painter was also a larger-than-life hero in death. He died on the *Titanic* after

Sleeping Buffalo Mound

saving many women and children by helping them into lifeboats. The Columbian Theater was one of the top playhouses west of Chicago well into the twentieth century. It has been restored and is an active venue for plays and concerts.

Wamego is the birthplace of Walter Chrysler of automotive fame. You may recall that his boyhood home was back in Ellis (see 145E; page 165).

328 Sleeping Buffalo Mound

The hill on the distant horizon ahead is often referred to as "Sleeping Buffalo Mound." It is eleven miles away! You will see it up close and cross over it at mile 339 ahead.

329 Truckin' Through [330W; page 33]

Freight has always been carried on Kansas trails. Today, the Kansas Corporation Commission determines what can be hauled and which routes commercial traffic can travel through Kansas. Trucks are weighed, and special permits can be obtained at inspection stations such as this one. The weight and size limits are described in the westbound story.

330 Mill Creek

For the next three miles you will pass through flat bottomlands surrounded by hills. This is the floodplain for Mill Creek, which provided waterpower to a grist mill. It is one of fourteen Mill Creeks in Kansas!

This bottomland is planted to crops of corn and soybeans, rather than grazed by cattle. The deep, rich soil was deposited over thousands of years from the flooding of Mill Creek.

331 Wine Country [334W; page 31]

At Exit 333 ahead you will see the Fields of Fair Winery, the first licensed winery in Kansas. The vineyards were planted in the early 1980s, and the first wine was ready for market in 1989.

332 Paxico: Antique Town

Paxico, between Exits 333 and 335, is famous in the region for its antique stores. Anyone interested in antiques should take a few minutes to explore this charming town. Pottery made here has been featured in national magazines.

Paxico got its name from a Potawatomi medicine man named Pashqua. This land was part of the Potawatomi Reservation, but in 1868 the government sold some of it to the Atchison Topeka and Santa Fe Railroad. The railroad decided to build its tracks farther south and so, in turn, sold the land to the Rock Island Line. Two towns of Paxico and Newbury were vying for the railroad to come to their site. The Rock Island decided to build along the banks of Mill Creek, so both groups compromised and jointly chose a new site along the railroad. On December 30, 1886, six blocks with 100 lots were laid out. By July, the new Paxico had a three-story hotel, two dry goods and grocery stores, two blacksmith and wagon shops, a billiard hall, barber shop, restaurant, shoe shop, drugstore, two lumber yards, and several other buildings under construction. The population peaked in the early 1900s, with about 400 people living there. Population is less than 200 today.

335 Guard of the Plains

Notice the sculpture ahead, on top of the hill. Many local people believe that this work, titled *Guard of the Plains,* represents a howling coyote. From any angle, and to a viewer who has a bit of imagination, it does resemble a coyote with its head thrown back, howling skyward. However, the sculptor, James Kirby Johnson, created the piece to symbolize a windmill and honor the important role windmills played in harnessing the wind for the good of humans on the plains. You can hike the trail at the rest stop to get an up-close look at the sculpture.

336 Rest Stop

The next rest stop features modern picnic shelters, a historical marker telling about the settlement and development of this region, and a memorial to highway workers killed on the job. It also offers native wildflower plantings and a woodland trail that leads to the top of the hill and provides panoramic views of the Flint Hills.

337 Real Coyotes

You may have already spotted coyotes in the fields along the interstate. Sometimes you'll see them crossing the interstate, and often, if you pay attention to roadkills along the shoulder, you'll see coyotes that did not make it. Coyotes are most active at night, but you may see one during the day, especially in the morning and evening. They eat almost anything—plant or animal—and this versatility is one reason why their numbers are increasing in Kansas and throughout the United States. Now, they even can be found in cities, howling at a streetlight rather than the full moon!

338 Sleeping Buffalo [341W; page 29]

You first saw Sleeping Buffalo Mound ten miles back. Notice as you drive over the mound and head down the back side that on the right side, the vegetation is grass. On the left side shrubs are growing. This difference has come about because the rancher on the right side burns the prairie annually to promote lush, nutritious grass for grazing. Burning controls weeds in the prairie, as well as the invasion of woody plants. The left side has not been burned as frequently, and so shrubs and trees have invaded the grassland.

340 St. Marys [342W; page 28]

St. Marys, located about twelve miles north of I-70 on what was the Oregon Trail, originally was a Jesuit mission to the Potawatomi Indians. The mission later served as a training school for the Indians, then a school for Catholic children and a Jesuit seminary, and finally closed in the 1960s.

341 Hudson Ranch

For the next three miles you will be driving by the Hudson Ranch. This ranch is more than 10,000 acres and is just one of the large ranches owned by the Hudson family in Kansas. Parts of this ranch

extend for miles along the interstate. You may recall the camels back at mile 316 were part of this ranch's operation.

The Hudson Ranch is a "cow-calf" operation. At any given time, 1,200 mother cows may be on the range. Some calves are sold, whereas others are sent to Oklahoma or Texas to graze or sent to feedlots to gain weight. Some calves are raised all the way to market weight and then sold. Every year is different on the ranch as ranchers respond to weather, forage conditions, and market prices.

The ranch is mostly native grass, but a few thousand acres are pastures of nonnative "cool season grasses" to allow year-round grazing. Providing water for the cattle is just as important as providing nutritious grass to eat. Farm ponds are visible on the right. The ranch has about fifty ponds, with at least two in each square mile of ranchland.

Other members of this family own the Hudson Oil Company. Their home is perched high on a hill to the right at mile 343.

343 Gullies

You may notice some depressions and gullies in the pastures on the right, especially near the ponds. Erosion is increased when cattle use the same trails every day to drink from the ponds. Grass near the trails is eaten and trampled and no longer holds the soil in place. Water washes down these paths and causes depressions and then gullies. Banks form along the gully. As cattle walk on the banks, the soil collapses and crumbles. The next rain washes away this soil, thereby making the gully deeper and wider. This process will continue until the banks are stabilized with new grass or shrubs.

344 Tall Towers [349W; page 26]

For the next few miles you will be able to see the 1,440-foot-tall KTKA-TV transmission tower on the right. Read about the impact of structures like this on bird life at 349W.

345 Willard and Rossville

About three miles north of the next exit is the town of Willard. It was once the site of Uniontown, which was established as a trading post for the Potawatomi Indians in 1848. Uniontown suffered two outbreaks of cholera and was burned and abandoned in 1859.

Just north of Willard across the Kansas River is the town of

Rossville. Rossville was named for William Ross, who came from Wisconsin in 1855 and later served as a Potawatomi Indian agent. William's brother, Edmund Ross, became a U.S. senator in the 1860s and cast the deciding vote against the conviction of President Andrew Johnson after his impeachment by the House of Representatives.

346 Shawnee County: Home to a Historic Highway

Pioneers first settled in Shawnee County along Mission Creek, which you will cross ahead near mile 351. The county, established in 1855, was named for the Shawnee Indians.

You are traveling on a historic stretch of highway. The eightmile stretch of I-70 from the Shawnee County line to the Topeka city limits was the first section of the U.S. interstate system to be completed. It was opened on November 14, 1956, less than four months after President Eisenhower signed the Interstate Highway Act of 1956. This is the birthplace of the nation's interstate system, the largest public works project in U.S. history.

Ike had traveled across the United States from Washington, D.C., to San Francisco on what is known as the Great Motor Truck Convoy of 1919. This convoy of army vehicles was meant to test both our nation's roads and the vehicles that had been used in World War I. Most roads were dirt, bridges collapsed along the way, vehicles constantly broke down, and the convoy averaged only a few miles per hour. Ike personally wrote the dismal trip report for the tank corps, concluding that our nation's road system needed great improvement, as did our military vehicles. An early piece of legislation leading up to the Interstate Highway Act was in fact called the National Defense Highway Act.

Eisenhower had additional experience with roadways in Europe during World War II. Hitler's autobahn moved military and civilian vehicles efficiently. This impressed upon Ike the importance of having good highways to move military personnel and equipment, and of being able to evacuate cities quickly in the event of attack. In fact, one of the goals of the act was to link all cities having a population greater than 50,000 people. So, to a significant degree, interstate highways are an artifact of war and especially the cold war with the Soviet Union. They were born out of the need for evacuations, not vacations. President Eisenhower apparently envi-

sioned the ultimate "rush hour," but he may never have imagined motorists dealing with daily morning and evening rush hours, using traffic reports from helicopters to guide them along these interstates to safe havens of home or work.

350 Kansas Forests [352W; page 25]

Over the next two miles you will see substantial forests along the banks of Blacksmith and Mission Creeks. Only 3 percent of Kansas is forested, but those 1.5 million acres of forests—mostly in the eastern third of the state—are important ecologically and economically.

352 Topeka: A "Capital" Place to Dig Potatoes

Just ahead is Topeka, the state capital and the fourth-largest city in Kansas. Colonel Cyrus Holliday, who became the first mayor, wanted to name the town Webster after Daniel Webster, but others wanted a more colorful local name. The name "Topeka" comes from three Indian words that have the same meaning among the Otoes, Omahas, Iowas, and Kaws. "To" means "wild potato" (or other edible root), "pe" means "good," and "okae" means "to dig." Thus, Topeka means "a good place to dig potatoes."

Among the first settlers in the Topeka area were the French-Canadian Pappan brothers. They married three Kansa Indian sisters and established a ferry over the Kansas River in 1842. The Oregon Trail crossed the river at Topeka, and as a result several ferryboat services were established here.

On December 5, 1854, nine antislavery men met on the banks of the Kansas River at what is now Kansas Avenue and Crane Street and drew up the first plans for establishing a town here. These plans resulted in the city of Topeka being incorporated in 1857. It became the capital of Kansas in 1861. Mayor Holliday, a Pennsylvania native, became better known as the founder of the Atchison, Topeka and Santa Fe Railroad, which spawned further growth and made Topeka an important railroad town.

Topeka is the home of Astronaut Ron Evans, commander of the pilot ship on the *Apollo 17* flight to the moon. It's also the home of popular musical group Kansas. Other famous Topeka residents have included noted psychologist Dr. Karl Menninger and Charles Curtis, who served as vice president during Herbert Hoover's ad-

ministration. Curtis is the only partial Native American to have served in this post.

Another interesting resident was Sergeant Boston Corbett, the man who shot John Wilkes Booth, assassin of President Lincoln. Corbett defied specific orders to take the assassin alive, claiming that God had told him to avenge the assassination of Lincoln. He served as doorkeeper at the Kansas capitol building, which you will see shortly. While serving there, he became violent—shooting his pistol off in the building and threatening visitors and employees. He was arrested and sent to the State Hospital for the Insane. But Corbett stole a visitor's pony from a hospital hitching post and escaped. He lived in a dugout shelter in Concordia, Kansas, for a while and eventually escaped to Mexico.

354 Museums and Menninger [359W; page 23]

The Kansas History Center, which includes the Kansas Museum of History and the Center for Historical Research, can be reached by taking the Wanamaker Road Exit 356. You can just see the top of the museum and the bell tower from an old school above the highway median barrier at the left just before Exit 355. The museum is located on a branch of the Oregon Trail. It offers information and artifacts from the Indian era to present-day Kansas. You will be able to view many objects related to the history found in this book. The vast and rich history of Kansas is told through exhibits and objects that make living in a log house or traveling in a covered wagon come to life. A nature trail provides an opportunity to stretch your legs and learn about the natural surroundings.

If the spire rising above the trees on the hill to the left beyond the exit looks familiar, it is because it is a replica of Independence Hall in Philadelphia. For many years this building was the home of the Menninger Foundation, a world-famous center for the study of psychological disorders founded by author and psychologist Karl Menninger.

357 Governor's Mansion

To the left, on a hill and set back in a parklike setting, is Cedar Crest, the Kansas governor's mansion. The land around the mansion is open as a public park and includes trails, and ponds for fishing and ice skating.

Governor's mansion

358 Twisters

Ever since Dorothy and Toto were carried off from Kansas to the Land of Oz, Kansas has been associated with tornados. One of the most disastrous was right here in Topeka. That tornado came through shortly after 7:00 p.m. on June 9, 1966, claiming 16 lives and injuring more than 500 people. The F5 tornado (the most intense category) cut a twenty-two-mile path through the heart of the city. According to the *Topeka Capital-Journal*, "Trees were ripped helter-skelter. Homes were wrecked, roofs blown away and residents, who had sought safety were staring at the ruins of their homes, sobbing in disbelief. . . . The Capitol Dome sustained damage from tremendous flying debris, as did many downtown Topeka buildings."

Although tornados have occurred in all fifty states, only Texas and Oklahoma have more than Kansas. However, Kansas has the distinction of having more F5 tornados than any other state because it's located where cold fronts coming down from the North meet hot, moist air from the South. To see a tornado from afar is awe-inspiring. To witness one up close is terrifying. If you see a tornado along the highway, do not try to outrun it. Experts suggest leaving your vehicle and lying flat in a roadside ditch.

Topeka also suffered from floods. In the spring of 1903, a flood left hundreds of people marooned, killed twenty-nine, and caused more than \$4 million of damage to property. There was another devastating flood in 1951. Dikes built along the Kansas River can be seen to the left as you travel along the river valley and approach the downtown area.

In spite of the threat of floods or tornados, like Dorothy, most Kansans believe there is no place like home.

360 The Capitol

Ahead, as you curve through downtown Topeka, you will see the capitol dome to the right of the interstate. The Kansas capitol, completed in 1903, was modeled after the Capitol in Washington, D.C., but wings were added to the rotunda section to create the shape of a cross, emphasizing the strong role of religion in the state. Inside the rotunda are murals depicting the story of Kansas painted by native Kansan artist John Steuart Curry. One mural depicting famed abolitionist John Brown is particularly impressive. Curry also painted the murals at the Wisconsin state capitol. Read about the statue on top of the capitol dome at 363W (page 21).

361 Twin Spires

From a certain angle the two spires of St. Joseph's German Catholic Church appear to contain the faces of owls, with the clocks forming the eyes. This Romanesque-style church was built in 1899 to serve the large German community here. For many years, the notably long sermons were preached in German.

364 Topeka Industry

You have continued to see grain elevators that emphasize the importance of the food industries in Topeka. Frito-Lay, Quaker Oats, and Hill's Pet Products have factories here. On the left just before mile 365 you will see the tortilla and taco factory of Reser's Fine Foods. Other major industry employers include Goodyear Rubber and Tire and Hallmark Cards.

363 Symbols of Kansas

While in the capital city, you might reflect on Kansas's official state symbols. If you have been traveling from western Kansas and reading along, you have already been introduced to our state flower, the wild native sunflower, our state tree, the cottonwood, and our

St. Joseph's German Catholic Church

state bird, the western meadowlark. Likewise, if you read the accounts from western stretches of I-70, you will not be surprised to learn that the American buffalo or bison is the state animal (really, they meant state *mammal* because birds are animals, too). However, you might not guess that Kansas's official state reptile is the ornate box turtle, the state amphibian is the barred tiger salamander, and our state insect is the honeybee.

366 Woodlawn Dairy Farm

The white board fences outline the Woodlawn Farm property ahead on the left. When the new toll plaza was built in 2001, much of the land came from Woodland Farm. Read about this farm at 186W (page 19).

After mile 366, I-70 joins the Kansas Turnpike. Note that the mileage number system now reflects the distance along the turnpike from the Oklahoma border. The mile markers to this point have indicated the distance from the Colorado line. Thus, Woodland Farm is about 366 miles from Colorado and 183 miles from Oklahoma. The stories continue to refer to mile markers as they appear on the roadside.

Woodlawn Dairy Farm

184 Kansas Turnpike

Construction of the Kansas Turnpike began on December 31, 1954. The state legislature had authorized the Turnpike Authority to sell bonds to private investors to pay for construction and the expenses of the Turnpike Division of the Kansas Highway Patrol. Motorists pay for the road only when they drive on it, since no tax dollars are used for the toll road.

The 236-mile Kansas Turnpike was completed in a record twenty-two months. After the interstate system was created in 1956, federal planners chose to incorporate the turnpike, but with no reimbursement to the state. There are twenty-one interchanges where other highways intersect the turnpike. The limited access reduces stop-and-go traffic and improves safety. As you travel the turnpike, your car is one of more than 51,000 vehicles a day that make a trip, each averaging more than forty miles.

186 The Oregon Trail

At the crest of the hill this modern trail crosses a historic trail. Specifically, the Oregon Trail intersects I-70, then follows the ridge to the right of I-70 for the next several miles. The Oregon Trail generally went along the ridge tops of rolling Kansas hills to avoid stream crossings and the ups and downs of the terrain, thereby

reducing stress on the animals pulling the wagons. In a sense they were taking care of their "engines" to improve their mileage and reduce maintenance.

What became the Oregon Trail was first used by fur traders returning from the mouth of the Columbia River in 1813. In 1830, William Sublette took the first wagons along this route to the Rocky Mountains. Traffic increased dramatically in 1849 as a result of the California gold rush. Some things never change, as Kansas is still a state that is experienced mostly by people passing through along cross-country "trails." But what a contrast it is to be traveling at seventy miles per hour along the I-70 trail in the comfort of a smooth-riding, temperature-controlled vehicle, rather than being exposed to rain, snow, ice, heat, wind, and cold in a slow and bumpy oxcart for weeks on end.

188 Douglas County

This county is named for Senator Stephen A. Douglas of Illinois, who wrote the Kansas-Nebraska Bill that allowed the formation of Kansas and Nebraska and gave them the right to choose whether they would be free or pro-slavery. Many assumed that Nebraska would be a free state and Kansas a slave state. But shortly after President Franklin Pierce signed the antislavery bill, immigrants from New England and other antislavery states came to Kansas to tip the balance in favor of freedom. Clashes erupted between the pro-slavery and antislavery settlers, resulting in the new territory becoming known as "Bleeding Kansas."

Many eastern Kansas towns from Manhattan to Lawrence trace their histories to people who migrated from eastern states to make Kansas a "free state." These "abolitionists" were successful, and Kansas sided with the Northern states during the Civil War.

189 Big Springs

South of the interstate is the small farming community of Big Springs. When William Harper and John Chamberlain established Big Springs in the fall of 1854, it was known as an excellent watering place along the Oregon Trail. The town became an important trading post as travelers immigrated west. The springs that gave the town its name have since dried up. Read about two noteworthy events that occurred in Big Springs at 191W (page 17).

190 Numbered Signs

Along the fence row at the right you may have noticed yellow signs with three-digit black numbers on them. These signs, which are angled so they can be seen from an airplane, are used by utility companies to check for leaks, vegetation in need of removal, and other problems as planes fly over their buried pipelines or cables. Problems are reported to ground crews, which are then dispatched to make repairs. The orange signs on the white posts indicate a buried telephone communications line.

192 The Clock House [193W; page 17]

The clock over the front porch on the house at the right was added in 1985. George and Debby Davis, the present owners, found the clockworks at the Catholic church in Fairbury, Nebraska. It was restored, but it occasionally needs adjustment—so don't correct the time on your car clock! When installing the clock, the Davises added the face from a clock that was at the Harvey County Court House in Newton, Kansas.

The house was built in 1905 from a kit ordered from Sears, Roebuck. All the parts, including window glass and doors, were

Clock House

shipped by rail to Lecompton, then hauled the final six miles by horse and wagon. It was erected at the high point of a 640-acre farm as a summer home. In 1908 it was selected as the National Farm House of the Year.

The house originally was a square, two-story design. The first floor consisted of the kitchen, dining room, living room, and parlor with a fireplace. Upstairs were four bedrooms. This house had many amenities that were not generally found in rural homes of that time, such as a 5,000-gallon water cistern and an electric generator. A classic original bathtub is still in use.

The house is furnished with collectibles from all over the world. These are selected from items obtained for the Davises' business, which, not surprisingly, is called Clock House Antiques, located in Big Springs.

194 Roadside Gardens

Ralph Waldo Emerson said, "The earth laughs in flowers." During the summer, stretches of I-70 laugh in wildflowers. You may have noticed the native wildflower signs along the road back at Exit 366 just before the tollbooths. Between here and Kansas City, notice the wildflowers growing along the road. Because a variety of flowers grow here and because their blooming periods are short and varied, it is impossible to know what will be blooming when you drive by, but possibilities in the roadside garden include the following: pinkish or purple flowers might be prairie phlox, purple prairie clover, bee balm, various gayfeathers and milkweeds, verbena, ironweed, or *Echinacea*, sometimes called purple coneflower, a popular medicinal plant. Blue flowers may be chicory, a plant whose roots can be used to make a coffee.

White flowers might be Queen Anne's lace, white evening primrose, white prickly poppy, daisy fleabane, and the greenish and creamy white "snow-on-the-mountain"; in autumn, heath aster may be blooming.

Yellow flowers include black-eyed Susan, flannel mullein, Missouri evening primrose, compass plant, various kinds of coreopsis, goldenrod, and of course the ubiquitous sunflower.

The most conspicuous orange flowers are those of the butterfly milkweed, which brighten roadsides and prairies in June and July.

196 Lecompton: "Bald Eagle, KS"

Ahead is the exit to Lecompton. The town, founded in 1855, was originally named Bald Eagle for the eagles that roosted in trees along the Kansas River. Later it honored Judge Samuel Lecompte, who presided over the town company that surveyed the 600-acre site halfway between Topeka and Lawrence on the Kansas River.

The pro-slavery leaders made it their territorial capital, and workers began building the state capitol as well as the governor's house. However, three years later, when the free-state forces were victorious in Kansas, Topeka became the capital, and the booming town went bust. There is more about Lecompton at 198W.

Today, Lecompton is a small farming community with 600 residents. The eagles still roost here along the Kansas River, and bald eagles nest at Clinton Lake just south of here. Watch for eagles soaring overhead, especially during the winter months.

198 Lawrence

The city of Lawrence, ahead, traces its roots back to Eli Thayer of Worcester, Massachusetts, who organized the New England Emigrant Aid Company to resist pro-slavery powers in Kansas. The company's first settlers arrived in the Lawrence area in August 1854. Soon after the pioneers arrived, they adopted the name of Lawrence in honor of Amos Lawrence, a Massachusetts financier of the New England Company. Interestingly, Lawrence deplored naming the Kansas town after him. He feared that it would give the appearance of self-promotion, which would lessen his personal influence in the "free-state" cause.

Lawrence had a bloody beginning. The newly arrived New Englanders fought with pro-slavery forces from Missouri. Pro-slavery raiders attacked the antislavery Lawrence residents here on two occasions, first on May 21, 1856, and again on August 21, 1863.

In the 1863 raid, a posse of 450 men led by William Clarke Quantrill attacked Lawrence and its 2,000 surprised and terrified citizens. The first person killed was the Reverend S. S. Snyder, who was shot in his barnyard two miles outside of town. Quantrill and his band then rode into Lawrence and down the main street, Massachusetts Street, burning houses, destroying two newspaper presses, and setting fire to the Eldridge Hotel. After about four hours, Quantrill and his raiders withdrew, leaving more than 150

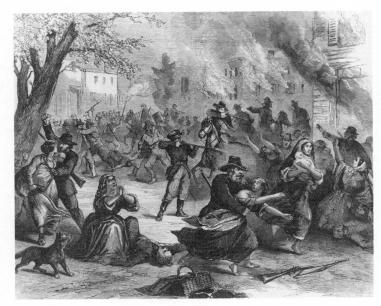

Quantrill's Civil War raid (Kansas State Historical Society)

dead and more than 100 homes and businesses destroyed. Resistance by the townspeople was so weak that only one of Quantrill's men was killed in the raid.

Today, Lawrence is a thriving community supported by the University of Kansas and local industry. Crafts and antiques can be bought in the downtown area, and restaurants cater to the eclectic appetite. Lawrence has a resident population of more than 80,000 and continues to grow.

200 Jayhawks

In 1866, Lawrence's significance to Kansas and the world changed forever. A solitary building was erected on Hogback Ridge. This building was the start of the University of Kansas. Use Exit 202 for the campus. Hogback Ridge seemed to be an undignified name for the location of a dignified institution, and so the name was changed to Mount Oread. Oreads, according to Greek mythology, were nymphs of the mountains, and the name seemed to be more appropriate for a place with such a grand hilltop view of Lawrence. Mount Oread also happened to be the name of a girls' seminary

in Worcester, Massachusetts, home of previously mentioned Eli Thayer. By looking right over the next few miles, you can glimpse red-roofed campus buildings perched high on Mount Oread.

Today KU is a world-class university with more than 27,000 students. The jayhawk mascot is a familiar image throughout the state. The jayhawk is a mythical bird whose name combines the names of two groups of intelligent and aggressive birds, jays and hawks. While the origin of the word "jayhawk" is unknown, one story tells of a pioneer who crossed Kansas with a bare minimum of provisions, saying he would survive the remainder of his journey by "jayhawking" his way. Jayhawk was used to describe anti-slavery individuals who raided Missouri, and it has been applied to any particularly tough, resilient group of individuals.

KU has a long history of excellent basketball teams. In fact, the inventor of basketball, Dr. James Naismith, was a faculty member from 1898 to 1937. A coach here for thirty-nine years, Phog Allen was a driving force behind basketball becoming an Olympic sport in 1936, and behind organizing the NCAA basketball tournament. Many KU basketball players have gone on to stardom in the NBA, including the great Wilt Chamberlain.

202 The Kaw [203W; page 14]

You will be crossing the Kansas, or "Kaw," River. As mentioned at 292E (page 196), this river begins in Junction City where the Republican and Smoky Hill Rivers come together. It continues on to join the Missouri River in Kansas City.

203 Grass Farm

The Pine Family Farm produces sod at the farm ahead on the left. Its crop is grass, which is rolled up and delivered for new lawns. A most interesting delivery was made to the Kansas Speedway ahead near mile 226. The farm also raises the traditional crops—corn, soybeans, and potatoes. Since the early 1970s, sod has been sold as a way to stretch out the harvest season and to hedge against the weather-sensitive potato crop. Read more about the Pine farm at 205W (p. 13).

204 Sand Pit/Phosphorus Factory

The lake on the right was a sand quarry. Because of its depth, waterfowl use its open waters during their fall and spring migrations.

Across the lake the Astaris factory has the appearance of a chemical plant. It is. It's also a food industry facility. This plant is a major North American supplier of food-grade phosphates and phosphoric acids. Did you ever drink an effervescent "phosphate" at an ice cream parlor or soda fountain? You'll see phosphoric acid on the nutrition label of soft drinks.

Phosphate is an essential ingredient for baking powder. Products from this plant find their way into cereals, cakes, pancakes, and waffles. Phosphates for dentistry are made here, and for processed cheese and meat as well. Phosphate is important for metabolism in both plants and animals. It is essential in plant food fertilizers and is added to cattle rations. People need phosphate for bone, nerve, and muscle health.

Phosphate rock is mined in Idaho and shipped here in rail gondola cars. After processing, rail tank cars and trucks take the phosphoric acid to food plants all across the country for use in the food we eat.

Astaris is a new company, organized in 2000, but the plant was first opened in 1951. There are 190 workers in the plant. Three generations of workers are employed here, many from families who have had long affiliation with agriculture and the food industries. The company workers have an active concern about the environmental impact of their products. They have created habitat on the property for migratory birds and other wildlife.

206 Leavenworth County

You have entered Leavenworth County, established in 1855, one of the first counties in Kansas. Named after Fort Leavenworth, the first fort west of the Missouri River, this county was carved out of Delaware Trust Lands of the Delaware Indians.

207 Fort Leavenworth

Fort Leavenworth and the town of Leavenworth lie about fifteen miles north of I-70 (Exit 224). Colonel Henry Leavenworth was ordered to set up a fort to protect wagon trains from Native Americans who were angry at the intrusion of settlers. The fort was supposed to be located on the east bank of the Missouri River. However, upon arrival, Colonel Leavenworth noted that the east bank was an unsuitable marshy area. He sent a message to the War Department, saying that, with its permission, he would build the

fort upon the west bank's bluff overlooking the river. Permission was given, and on May 8, 1827, he established Fort Leavenworth.

The fort was used as an army headquarters during the Mexican War of 1846. Abraham Lincoln made a campaign stop here when he was running for president in 1859, and during the Civil War the fort was used to muster volunteers into Union service. Fort Leavenworth was never attacked by Indians or Confederates.

The 8,000-acre fort is the site for the army's Command and General Staff College. More than 80,000 U.S. and international officers have passed through the army's senior tactical college since its inception in 1881. A United States federal penitentiary is also located nearby. The fame of this prison and the infamy of its inmates have made Leavenworth synonymous with prisons.

The city of Leavenworth was created after Fort Leavenworth had been built. Politically, early Leavenworth was pro-slavery and had a strong pro-business philosophy. Leavenworth prospered because of its proximity to the fort and the Missouri River. Today, Leavenworth has more than 35,000 residents and still prospers by being adjacent to the fort and an easy drive from Kansas City.

213 Ice Age Kansas

The gentle rolling hills indicate that you are traveling in the Glaciated Region of Kansas, which is bounded roughly by the Kansas River on the south and the Blue River (near Manhattan) on the west. Read more about the effects of glaciers in this eleven-county area of northeast Kansas at 214W (page 10).

214 Woodland Wildlife

The woodlands of eastern Kansas, interspersed with farm fields and pastures, provide ideal habitats for many kinds of wildlife. White-tailed deer and wild turkey are conspicuous from the interstate as they stand in the fields. Bobcat and badger populations are increasing here. The red-tailed hawks mentioned previously are abundant in this area. Look for a white object in the trees. It will undoubtedly be the white breast of a red-tailed hawk.

216 Silo Collection [218W; page 9]

Just past the tollbooths on the left is a large group of grain storage bins. Bill Theno collects them to store grain, 100,000 bushels of grain. The buildings are equipped to house cattle or hogs. So, depending on market conditions, there may be 7,000 to 8,000 head of hogs being fed, or the grain may be shifted to feed beef cattle. The long, horizontal buildings (180 by 70 feet) at the rear of the farmstead hold 150 head of beef cows and calves.

220 Four Houses [221W; page 7]

To the south along the Kansas River is the location of the first fur trading post in Kansas, called Four Houses. It was built in 1822.

222 Welcome to Wyandotte [418W; page 2]

This county is the last one you will encounter before leaving Kansas. It is named for the Wyandot Indians, who were relocated here from their lands in Ohio in 1843.

223 Agriculture Hall of Fame

This exit can take you north to historic Fort Leavenworth. Also, you may want to visit the National Agricultural Center and Hall of Fame just off the interstate. The Hall of Fame was chartered by Congress to honor America's farmers. It contains a collection of thousands of historic relics and pieces of farm equipment, including Harry Truman's plow. Interesting tales celebrating the achievements of farmers are told on this 172-acre site.

224 Trail's End

You are nearing the end of the trail—at least in Kansas. If you have been using this guide since western Kansas, you will recall reading about locations along the Butterfield Overland Despatch stage line and the Smoky Hill Trail, the quickest but most dangerous route to the Denver gold fields. North of here in Atchison, Kansas, the Smoky Hill Trail began. You may recall that David Butterfield's stage line, the Butterfield Overland Despatch, traveled the Smoky Hill Trail from near here three times a week. Early pioneers followed the major river systems westward from Kansas City because they provided water for people and livestock and because the river valleys were relatively flat compared with the surrounding hills. Later, state and federal highways followed these same routes. As you have traveled across Kansas, you, too, have been following trails used by both Native Americans and the pioneers many years ago.

At mile 226 the Kansas Turnpike ends. There is no indicator other than that the mile is now 410, indicating the distance from Colorado.

Kansas Speedway

226 The Kansas Speedway [411W; page 5].

The large complex on the right is the Kansas Speedway motor sports complex. Since it opened in June 2001, Indy Racing League and NASCAR races have included the Winston Cup Series and Craftsman Truck Series. The track features a motor home terrace and reserved infield motor home parking. Attendance at races here can exceed 100,000 people, more than the entire population of most Kansas counties! A speedway gift shop and Kansas Travel Information Center are located here (Exit 410).

412 Kansas City, Kansas

Kansas City, Kansas, is not the biggest or most populated city in Kansas. Many people think Kansas City is the largest city in the state because they consider the whole Kansas City metropolitan area, most of which is in Kansas City, Missouri.

Lewis and Clark passed by here in 1804 and 1806 and reported that the site had potential for commerce, a perfect place to construct a trading house. But it was not until 1868 that businessmen organized the Kansas City, Kansas, Town Company.

Kansas City has always benefited from being centrally located on the continent. Originally, it attracted meat-processing companies because of its proximity to the railroad and the prairie pastures where beef cattle were raised. The meat-processing business was so good in the beginning that there were labor shortages in the city. Demand for labor caused wages to skyrocket. The high wages attracted many immigrants with the promise of a good job and a better way of life. From 1890 until the start of World War I, Kansas City, Kansas, became home for thousands of European immigrants,

each nationality settling in certain areas of the city. This made Kansas City a culturally diverse urban center.

Eventually meat processing lost its position as the leading economic force in Kansas City because of the development of feedlots in the western part of the state. However, other industries took over. Kansas City developed the first planned industrial park in the United States. A B-25 aircraft bomber plant was opened there in 1940. After World War II, General Motors purchased the plant and used it for a new car assembly plant. From that point on, Kansas City never looked back as more manufacturers located or relocated to the area because of the ample supply of labor and the central location.

414 Grinter House and Ferry

Two miles south of I-70 at Exit 414 lies the Grinter Place Museum. The Grinter House was built by Moses Grinter in 1857. This two-story home is the oldest unaltered building in Wyandotte County. Grinter maintained the first ferry to cross the Kansas River. For a time, it was the only ferry serving an important military road between Oklahoma and Fort Leavenworth. See 415W (page 4).

415 Another Indian Battle

North of here is the Huron Indian Cemetery. Although this site is not significant for bloody battles fought between the U.S. Army and the native Indians, a battle was fought here nonetheless. After the Wyandots had been manipulated into ceding their Ohio lands to the U.S. government, they decided to set up camp on a government-owned strip of land near the junction of the Missouri and Kansas Rivers. The Delaware tribe, distant relatives of the Wyandots, owned land on the north side of the Kansas River. They sold the Wyandots thirty-six square miles of land between the fork of the two rivers so they could have a home.

The Wyandots liked their new home but soon encountered difficulties. The tribe had come to the area 700 members strong, but an influenza epidemic swept through, killing 60 tribe members. Then a flood killed 40 members because the dead vegetation left behind by the flood waters decomposed in the summer heat and spread a disease through the tribe.

The Wyandots deemed an area, now known as the Huron Cemetery, as a burying ground for tribe members who had died as a

result of the flood or flu. Speaking of this cemetery, Mrs. Lucy Armstrong wrote in the year 1890: "To the best of my recollection and belief I think that between the years 1844 and 1855 there were at least 400 internments there and most of those graves are not perceptible and cannot be identified or ever found." Famous chiefs such as Warpole, Tauromee, Squeendehtee, Serrahas, and Big Tree are buried there.

As the years passed, the land became neglected. Businessmen from Kansas City thought the area was an eyesore and slipped through Congress an item in the Indian appropriation bill authorizing the secretary of the interior to sell the land. The item, buried in the middle of the sixty-five-page bill, said the secretary had the right, with financial compensation to existing tribe members or heirs, to remove the remains of persons buried at the Huron Cemetery and relocate them to another site.

Helena and Lyda Conley, descendants of Wyandot tribe members, learned of the bill and became determined to save their ancestors' graves. The two women padlocked the cemetery gate, constructed a small fort, and placed signs that said "Trespass at Your Peril." The women vowed to kill anyone who tried to enter the cemetery or remove its contents.

The women also filed suit against the secretary of the interior to restrain him from selling the cemetery. A federal judge threatened to incarcerate the women for contempt. Later the two were charged with disturbing the peace. Their small fort was even burned. But the women persevered and eventually aroused public sentiment in their favor.

Seven years later, Congress repealed the statute. The women had won the battle. In 1918, the government made an agreement with Kansas City for the city to maintain and preserve the site forever. The cemetery remains as a monument to the Indians buried there and the sisters who kept them there.

419 Railroads

The train yards to the right of I-70 are another reminder of the importance of railroads in determining the Kansas landscape. Railroads determined which towns lived and which towns died. They brought people to Kansas. They transported the state's resources and products. Kansas City's central location has made it a transfer

and consolidation point for numerous items shipped by rail. Today the rail yard is primarily a railcar repair yard for Union Pacific Railroad cars you see waiting to be fixed or refurbished.

The importance of the railroad cannot be overstated. For fifty years, until the 1920s when autos and paved highways crossed the country, every facet of life was affected by the railroad. Union Pacific Railroad alone has 2,335 miles of track in Kansas and employs more than 1,700 people. It is fitting that we find a major rail yard near the end of our journey through Kansas.

422 Modifying the Missouri

The junction of the Kansas and Missouri Rivers is just north of where you will be crossing into Missouri at Kansas City. This river junction looks much different from when the Lewis and Clark expedition poled upstream. The river has lost its natural meander, wide marshes, and sandbars. Instead, it looks like a big ditch with clean, well-defined banks. This is to allow for barge traffic and because about every fifty years since records have been kept, this area has experienced a major flood. The most destructive flood was in July 1951, when floodwaters thirty feet deep spread throughout neighborhoods and industrial areas, killing forty-one people and causing \$900 million in damages. To counter this history of flooding, you will see that the river has been diked and channelized to cause the water to flow more quickly away from the city, and levees have been built to keep the water confined to the river channel. In 1993, all these engineering efforts were thwarted in some areas by another great flood, and these structures actually contributed to flooding downstream. It is very expensive and often impossible to fight the forces of nature.

423 Low Point of Your Trip

As you approach the Kansas River ahead, you will be near the lowest elevation along I-70 in Kansas, 760 feet above sea level. If you have been traveling from the Colorado line, you have dropped more than 3,000 feet in elevation as you drove east across Kansas. Traveling more than 400 miles to drop 3,000 feet is not the sort of elevation change that makes your ears pop, but it does mean there is a more moderate climate here in eastern Kansas. And for one last time it reminds you that much of Kansas is not flat!

HAPPY TRAILS!

When Lewis and Clark camped along the river near here during their famous expedition, they reported that the area was "by no means bad." We trust that you feel the same way as you leave Kansas. Our hope is that as you traveled across our state you were pleasantly surprised, by our topography, history, natural beauty, prosperity, and productivity. Most of all, we hope that you will return soon to travel more Kansas trails.

References

The information presented in this book came from publications, personal interviews, and Web sites. We used the publications listed below for background information. Four books published by the University Press of Kansas were particularly useful: *The WPA Guide to 1930s Kansas, 1001 Kansas Place Names, Ghost Towns of Kansas: A Traveler's Guide,* and *Roadside Kansas: A Traveler's Guide to Its Geology and Landmarks.*

Many people provided us with information. We formally interviewed individuals at sites along I-70, as well as knowledgeable individuals at museums and universities in Kansas. On occasion, people shared a few comments to identify a particular sight or provided directions. Individuals whose names we have, and who provided helpful information, are listed below.

We also made use of selected Web sites for specialized information. These are listed below as well.

Publications

- ASAE Standards, Engineering Practices, and Data. St. Joseph, Mich.: American Society of Agricultural Engineers, 2001.
- Bird, R. Heartland History: Stories and Facts from Kansas. New York: Cummings and Hathaway, 1990.
- Buchanan, R. C., and J. R. McCauley. *Roadside Kansas: A Traveler's Guide to Its Geology and Landmarks*. Lawrence: University Press of Kansas, 1987.
- Carter, D. G. "The Unit Space Method of Barn Planning." *Agricultural Engineering* 9, no. 9 (September 1928), 271–73.
- Federal Writers' Project. *The WPA Guide to 1930s Kansas*. Lawrence: University Press of Kansas, 1984.
- Fitzgerald, D. Ghost Towns of Kansas: A Traveler's Guide. Lawrence: University Press of Kansas, 1988.
- Frazier, I. Great Plains. New York: Farrar Straus Giroux, 1989.
- Harrington, G. Historic Spots or Milestones in the Progress of Wyandotte County, Kansas. Merriam, Kans.: Mission Press, 1935.
- Harvey, E. M. "History of Collyer, Kansas." Unpublished manuscript, 1976.
- McCoy, S. Van Meter, and J. Hults. 1001 Kansas Place Names. Lawrence: University Press of Kansas, 1989.
- Muilenburg, G., and A. Swineford. *Land of the Post Rock*. Lawrence: University Press of Kansas, 1975.

Parks, R. *Hays and Northwest Kansas*. Hays, Kans.: Hays Convention and Visitors Bureau, 1987.

Richmond, R. Kansas: A Land of Contrast. Arlington Heights, Ill.: Forum Press, 1979.

Schirmer, S. L., and T. A. Wilson. *Milestones: A History of the Kansas Highway*

Commission and the Department of Transportation. Topeka: Kansas Department of Transportation, 1986.

Self, H. Geography of Kansas. Oklahoma City: Harlow Publishing, 1959.

Interviews

Janice Alfers, Edson SIGCO elevators	Goodland
Steve Boshoff, Northern Sun, Division of ADM	Goodland
Albert J. Brown, resident	Walker
Doug Burr, EnerSys, Inc.	Hays
George and Deb Davis, Clock House Antiques	Lawrence
Ken Deering, Astaris LLC	Lawrence
Frank Drancy, Astaris LLC	Lawrence
Ron Eberle, Grainfield Lions Club	Grainfield
Gordon Fry, Astaris LLC	Lawrence
Gary Gilbert, Woodlawn Farms	Tecumseh
Justin Gilpin, Kansas Wheat Commission	Manhattan
Brian Green, Armour Swift-Eckrich	Junction City
Mike Grove, Berkgren Chemical	Brewster
Lori Hall, Rolling Hills Wildlife Conservation Center	Salina
David Helvey, farmer	Salina
Dan Holt, director, Eisenhower Center	Abilene
John Ingham, Abilene Elevator	Salina
Janet Johannes, Ellis County Historical Society	Hays
Darnelle Keith, Grainfield Elevator	Hoxie
Tom KinderKnecht, Midwest Coop	Ogallah
Judy Kleinsorge, Prairie Museum of Art and History	Colby
Gerry Klema, resident	Wilson
Ron Koehn, Midwest Coop	Quinter
Norbert Korte, Red River Commodities	Rexford
Betty Lipp, rancher	Collyer
Cheryl Madison, rancher	Oakley
Ron Majors, resident	Wilson
Ken Moser, Moser Feedlot	Colby
Clint Pfannenstiel, Yocemento Coop	Hays
Sue Pine, Pine Sod Farm	Lawrence
Rex Reinecker, Reinecker Feedlot	Quinter
Dale Reynolds, Abilene Elevator	Abilene
Evea Rumple, Register of Deeds, Trego County	WaKeeney

Mrs. V. E. Tate, farmer Susie Theno, farmer Steve Wise, Cargill

Bonner Springs Tonganoxie Salina

Web Sources

City of Wakeeney (www.wakeeney.org)

Ellsworth Area (http://kansasprairie.net)

Kansas Corn Growers Association (www.ksgrains.com/corn)

Kansas Forest Service (www.kansasforests.org)

Kansas Grain Sorghum Producers Association (www.ksgrains.com/sorghum)

Kansas Turnpike Authority (www.ksturnpike.com/history)

Kansas Wheat Commission (www.kswheat.com)

Russell County Historical Society (www.russellks.org/attract)

State of Kansas (www.accesskansas.org)

Sternberg Museum (www.fhsu.edu/sternberg)

Union Pacific Railroad (www.up.com)

USDA Census of Agriculture (www.nasa.gov/census/census97)

Index

BUSINESSES AND FARMS ADM Corporation, 131 American Society of Agricultural Engineers, 8, 113 Armour-Swift Eckrich, 46, 47, 196 Astaris Company, 12, 224 Atchison, Topeka and Sante Fe Railroad, 21, 31, 60, 212 Bayer Stone Company, 202 Berkgren Chemical and Fertilizer Company, 123, 124, 142-144 Blue Beacon Truck Wash, 57 Boettcher Cement Company, 86 Butterfield Overland Despatch, 6, 7, 64, 70, 73, 149, 150, 170, 180, 226 Cargill Company, 57, 58, 187 Clock House Antiques, 220 Cornerstone Ag Services, 116 EnerSys Inc., 84, 85, 167 Four Seasons RV Acres, 49 Frontier Equity Cooperative, 131, 137 Grainfield Grain Company, 104 Grandma Hoerner's Gourmet Factory, Hellendale Ranch, 108, 152 Helvey Farm, 66, 179 Hudson Ranch, 28, 38, 209 Iowa State University, 69 Jeffrey Energy Center, 26, 50, 195, 204 Kansas Speedway (NASCAR), 227 Kansas State Forestry Station, 164 KTKA-DTV, 26, 210 Lipp Farm, 98, 159, 160 Midwest Cooperative, 91, 100

Mingo CoAg Elevator, 114, 149 Moser Feedlot, 118, 146 Northern Sun Elevator, 131, 138 Ogallah Tree Nursery, 165 Pine Family Farm, 13, 223 Post Rock Rural Water District, 73, 74, Pro Bound Sports, 174-175 Red River Commodities, 116, 131, 147 Reinecker Feedlot, 100, 101, 156 Rock Island Line Railroad, 31, 121, 123, 131, 142, 208 Ruleton Cooperative, 131, 137 Russell Stover Candy Company, 52, 192 7X Cattle Company, 115 Tate Farm, 7, 8 Theno Farm, 9, 225 Union Pacific Railroad, 30, 60, 65, 90-92, 94, 103, 148, 153, 162, 165, 184, 230 Winery, Fields of Fair, 31 Woodlawn Farm, 19, 20, 24, 216 Yocemento Coop Elevator, 87 Yocemento U.S. Portland Cement Company, 86, 87

CITIES AND TOWNS
Abilene, 46, 51–53, 152, 191, 192–194
Big Springs, 17, 18, 218, 220
Black Wolf, 69, 178
Boot Hill, 168
Brewster, 123, 142
Brookville, 60, 184, 185
Bunker Hill, 73, 173

Caruso, 130, 138 Chapman, 48, 195

Colby, 111, 114, 118, 121, 147

Collver, 89, 98, 158

Council Grove, 39, 202, 203

Dodge City, 62 Doniphan, 31 Dorrance, 72, 174 Edson, 126, 141 Ellis, 87, 88, 165

Ellsworth, 64, 65, 178, 179

Enterprise, 49, 194

Eustis, 127

Goodland, 126-130, 132, 136, 139

Grainfield, 103, 104, 153

Grinnell, 107, 152 Harveyville, 27 Hays, 83, 84, 167, 168 Hutchinson, 50

Junction City, 14, 45, 196 Kanopolis, 64, 179,

Kanorado, 134

Kansas City, 1, 2, 14, 44, 90, 121, 135,

227-229

Land of Oz, 11, 214

Lawrence, 12, 206, 221-223 Leavenworth, 5, 224, 225

Lecompton, 15, 221 Levant, 121, 146

Manhattan, 39, 202

Mingo, 114, 149

New Cambria, 55, 189

Oakley, 109, 110, 121, 149, 150

Ogallah, 91, 163, 164 Overland Park, 5 Park, 102, 155

Pawnee, 43, 44, 198

Paxico, 31, 208 Quinter, 100, 157

Rome, 166

Rossville, 26, 211

Ruleton, 131, 137

Russell, 71, 76, 77, 170-172

Salina, 50, 56-58, 187, 188

Shawnee Mission, 198

Solomon, 53, 190

St. George, 37, 203

St. Marys, 28, 209

Topeka, 11, 21-24, 80, 212-216

Uniontown, 26, 210

Victoria, 80, 81, 168, 169

Wabaunsee, 205, 206

WaKeeney, 93, 94, 161, 162

Wamego, 33, 206, 207

Wichita, 5

Willard, 26, 210

Wilson, 70, 176, 177

Woodlawn, Maryland, 20

Worcester, Massachusetts, 221, 223

Yocemento, 86, 87, 166

COUNTIES

Dickinson, 47, 190

Douglas, 12, 218

Ellis, 79, 165

Ellsworth, 64, 178

Geary, 195

Gove, 99, 151

Leavenworth, 6, 224

Lincoln, 180, 182

Logan, 110, 151

Riley, 36

Russell, 71, 170

Saline, 54, 184

Shawnee, 18, 211

Sherman, 126, 135

Thomas, 111, 142

Trego, 89, 158

Wabaunsee, 27, 204

Wyandotte, 2, 226

EVENTS, HISTORICAL

Bleeding Kansas, 218

buffalo shooting contest, 110

California gold rush, 16 California Trail, 16 Chisholm Trail, 101, 103 Cincinnati Kansas Association, 39 dinosaur war, 105-107, 152 dust bowl, 89, 119-121, 146 fences, spite, 63, 181 first helicopter flight, 120 Flint Hills, 27, 200, 201 grasshopper invasion, 182 Great Motor Truck Convoy of 1919, 211 High Plains, 87, 144 Ice Age, 10, 225 Interstate Highway Act, signing of, 24 iron horse, capturing the, 98 Javhawks, 222, 223 Kansas Sculpture Association, 201 Kansas Turnpike, construction, 217 Kansas-Nebraska Bill, 218 McDaniel Gang, 204 Oregon Trail, 16, 18, 217, 218 post rock fences, 75, 175, 176 Prairie Guard, 36, 206 Quantrill's raid, 221, 222 rainmaking, 128, 139 Sante Fe Trail, 39, 202, 203 Smoky Hill Cattle Pool, 108 Smoky Hill Trail, 6, 226 Smoky Hills region, 60, 61, 177 steamboat on the prairie, 169 tornado, 214, 215 Windwagon Races, 132

FARMING

Animals
camels, 205, 211
cattle, 28, 37, 100, 108, 115, 144, 146, 147,
151, 152, 156, 193, 204, 209
greyhounds, 51, 152
horses, 7, 8, 44, 94, 165, 197, 198

winning the county seat, 126-128

llamas, 101 oxen, 94, 165

Crops
alfalfa, 11, 55, 189
corn, 11, 92, 93, 100, 154, 157
hay, 37, 61, 68, 69, 100, 125, 175, 200
sorghum, 11, 100, 103, 157, 158, 159
soybean, 12, 177, 188, 223
sunflower, 11, 24, 59, 116, 117, 131, 138,
147, 185, 201, 215
wheat, 11, 55, 57, 103, 104, 116, 147, 154,
155, 187, 192

Farming Practices barns and buildings, 7, 66, 73, 98, 99, 118, 152, 159, 179, 195 bottomland, 56, 57, 188 dairy, 8, 98, 159; Woodlawn Farm, 20 drvland farming, 151, 152, 191 elevators, 23, 57, 58, 99, 116, 137, 147, 153, 154, 187 erosion, 89, 114, 119-121, 175 farm ponds, 59 feedlots, 100, 146, 228 fence, 63, 181; barbed wire, 105; living snow, 63, 130, 138; post rock, 70, 75, 175 fertilizer, 101, 108, 114, 115, 123, 142, 143, grain, handling of, 9, 91, 100, 104, 131, 140, 148, 154, 225 gullies, 136, 210 irrigation, 13, 94, 95, 112, 138-140 plowing, 114, 115, 165 rainmakers, 128 round bales, 69, 172 shelterbelts, 96 silage, 32, 125, 141 silo, 32, 140-142, 225 sod, 13, 94, 107, 118, 119, 122, 146, 152 soil, 53, 125, 141, 142, 161, 191 terraces, 20, 67, 96, 161

wetlands, 77, 171 wind, 95, 108, 132, 142–144, 147, 165, 172, 214 windbreaks, 88, 96, 113, 118, 163 windmill, 72, 160, 206

FORTS AND MILITARY BASES
Fort Ellsworth, 64, 179
Fort Fletcher, 82, 167, 170
Fort Harker, 64, 178–180
Fort Hays, 82–84, 126, 167, 170
Fort Kearney, 18
Fort Leavenworth, 5–7, 224–226
Fort Riley, 3, 43, 44, 197–200
Fort Sedgewick, 126
McConnell Air Force Base, 58, 187
Smoky Hill Army Air Base, 85, 187
Walker Air Force Base, 80

INDIAN TRIBES
Cheyenne, 94, 126, 162, 167, 182
Delaware, 2, 6, 224, 228
Kansa, 31, 40, 201
Kiowa, 67, 182
Oglala Sioux, 91, 163
Pawnee, 73, 173
Potawatomi, 26–28, 31, 204, 208–210
Shawnee, 18, 211
Teton Sioux, 91
Wyandot, 2, 226–229

Abrahams, John V., 20
Allen, F. C. "Phog," 223
Arnold, Hap, 43, 200
Atchison, Fred, 132, 133
Becknell, William, 39, 202
Beecher, Henry Ward, 36, 206
Bergen, Richard, 21
Bickerdyke, Mary Ann "Mother," 56, 190
Boone, Daniel, 203
Bradley, Col. George, 127

Braniff, Tom. 57, 188 Brewster, L. D., 142 Bryan, William Jennings, 81 Buchanan, Rex. 78 Buchele, Prof. Wesley F., 69, 172 Carson, Kit. 203 Chapman, George, 38 Chouteau, Francis and Sara, 7 Chrysler, Henry, 34, 60, 87, 88, 184, 207 Chrysler, Walter, 34, 60, 87-88, 166, 184, 207 Clark, Walter Eli, 71 Cody, William "Buffalo Bill," 60, 84, 88, 90, 110, 163, 166, 179, 184 Collver, Rev. Robert, 98, 158 Comstock, William, 110 Conley, Helena and Lyda, 229 Cope, Edward Drinkler, 105-107, 152 Corbett, Sgt. Boston, 213 Coronado, Francisco Vasquez de, 184 Cross, Cameron, 129 Curry, John Steuart, 21, 215 Curtis, Charles, 212, 213 Custer, Gen. George, 44, 64, 82, 126, 170, 197, 198, 203 Davis, Jefferson, 45 Dewey, John, 40 Dickinson, Daniel S., 47 Dinsmoor, Samuel Perry, 70 Dole, Sen. Bob, 76, 172 Donmyer, S. P., 55, 189 Douglas, Stephen A., 12, 218 Earp, Wyatt, 88 Eisenhower, Gen. Dwight D., 15, 24, 25, 51, 191, 211 Ellis, George, 79 Elriches, Herman, 89 Emerson, Ralph Waldo, 19 Engle, Joe, 48, 195 Epp, Fr. Hiacinth, 80 Evans, Ron, 212 Fick, Earnest and Vi, 109

Fowler, E. S., 8 Frazier, Ian, 71, 72, 102, 156 Fremont, John C., 44, 196 Geary, John W., 45, 47, 190 Gilbert, Garv, 19, 20 Gove, Grenville L., 99, 151 Grant, Sir George, 81 Grifee, Charles, 180 Grinter, Moses, 4, 5 Hawley, Steve, 57, 188 Havs. Gen. Alexander, 167, 203 Havs, Seth M., 203 Hayworth, Erasmus, 86, 166 Henry, T. C., 55 Hersey, Timothy F., 51, 102 Hickok, James Butler "Wild Bill," 51, 53, 191, 193, 104 Holliday, Cyrus V., 21, 212 Inge, William, 48, 49 James, Jesse, 203 Johnson, James Kirby, 29 Kidder, Lt. Lyman S., 126, 141 Kuska, Joseph and Nellie, 117, 118 Lawrence, Amos, 14, 221 Leavenworth, Col. Henry, 224 Lecompte, Judge Samuel, 15 Lee, Robert E., 44, 100 Lewis and Clark, 1, 2, 227, 230, 231 Lines, Charles, 205 Logan, John Alexander, 151 Marsh, Othniel, 105, 107, 152 Martin, Glen, 57, 188 Maxwell, Hon. Walter C., 80 McCauley, James, 78 McCov, Joseph, 56 McKittrick, Neva, 71 Melbourne, Frank, 128 Menninger, Karl, 23 Naismeth, Dr. James, 223 Parker, C. W., 52, 191

Patton, Gen. George, 44, 198

Phillips, William, 56, 188

Pike. Lt. Zebulon M., 54, 184 Purvis, W. J., 120 Quantrill, William Clark, 221 Reeder, Andrew, 108, 100 Riley, Maj. Gen. Bennett C., 44, 197 Ross, Edmund, 26 Ross, William, 26 Roth. Joseph and Mary, 85, 167 Russell, Avra. 71 Sawver, C. F., 75 Schonoff, Joph. 206 Sheridan, Phillip H., 64, 82 Sherman, Gen. William T., 64, 136 Sherman, Lt. Gen. Phillip, 44, 197 Smith, Tom "Bear River." 103 Spector, Sen. Arlen, 76, 172 Spillman, A. C., 56 Spotted Horse, Chief, 73, 173 St. John, John P., 151 Sternberg, George F., 109, 167, 168 Stover, Clara, 52, 53 Stuart, Jeb, 44 Switzer, Dr. E. R., 55, 189 Thayer, Eli, 14, 221 Thomas, Brig. Gen. George H., 111, 142 van Gogh, Vincent, 129, 139 Wabaunsee, Chief, 27, 304 Whitman, Walt, 90, 104, 141 Whitney, Chauncey B., 65 Wilson, Charles A., 120 Yost, I. M., 86, 166

PLACES TO VISIT

Ad astra sculpture, 21, 22

Agriculture Hall of Fame, 6, 72

atomic cannon, 43, 199

Beecher Bible and Rifle Church, 36, 205

Boot Hill Cemetery, original, 84, 168

Brookville Hotel, 52, 60, 184

Bukovina Society of America Museum, 87, 165

Castle Rock, 157

Cedar Crest, governor's mansion, 23, 213 Chevenne Bottoms Wildlife Area, 63 Chrysler Boyhood Home and Museum, 87, 88, 166 Columbian Theater, 206 Council Grove, 39 Dickinson County Historical Society Museum: early carousel, 52 easel, the big: van Gogh's sunflowers, 129 Eisenhower Presidential Museum, 51 Fick Fossil Museum, 100, 150 Fields of Fair Winery, 31 Fort Hays State Historic Site, 83, 167 Fort Havs State University, 83, 84 Freedom Park, 43 Garden of Eden, 70 Grandma Hoerner's Gourmet, 35 Greyhound Hall of Fame, 51 Grinter Place Museum, 4, 228 Guard of the Plains sculpture, 29, 208 Havs House Restaurant, 203 High Plains Museum, 129 Huron Indian Cemetery, 228 Iwo Jima memorial, 93 Kansas History Center, 24, 213 Kansas Motor Speedway, 5, 227 Kansas State Capitol, 21, 215 Kansas State Forestry Station, 164 Kansas State University, 39-41, 202 Kansas Territorial Capitol, first, 43, 198 Konza Prairie, 40, 41, 201 Monument Rocks Natural National Landmark, 109, 149 Mt. Sunflower, 134, 135 Museum of Independent Telephony, 51, 191

Cathedral of the Plains, 80, 168

Cavalry Museum, U.S., 198

Oil Patch Museum, 77, 171
Oregon Trail Nature Park, 26, 204
Post Rock Scenic Byway, 70, 176
Prairie Museum of Art and History, 117, 147
railroad museum, 87, 165
Rolling Hills Zoo, 59, 186
Russell Stover Candy factory outlet, 52, 192
Sternberg Museum of Natural History, 84, 167, 168
sunflower sculpture, 201
Tallgrass Prairie National Preserve, 203 time zone, mountain, central, 124
University of Kansas, 12, 222, 223

RIVERS, CREEKS, AND LAKES Arkansas River, 63 Beaver Creek, 32, 136 Big Creek, 86, 161,169 Blue River, 10 Cedar Bluff Reservoir, 91, 163 Cedar Creek, 7 Deep Creek, 38 Elkhorn Creek, 180 Kanopolis Lake, 74 Kansas River, 10, 45, 133, 161, 196, 198, 223, 228, 230 Kaw River, 14 McDowell Creek, 201 Milford Lake, 45, 196 Mill Creek, 32, 207 Mission Creek, 18, 211 Missouri River, 5-7, 14, 31, 133, 161, 224 Neosho River, 39, 203 Republican River, 14, 39, 44, 45, 126, Saline River, 54, 56, 61, 70, 177, 178, 184 Sappa Creek, 122 Smoky Hill River, 6, 39, 44, 49, 54, 64,

74, 82, 99, 106, 109, 161, 167, 170, 178,

196

Mushroom Rock, 180

National Farm House of the Year, 219

Solomon River, 53, 54, 190 Wilson Lake, 70, 175

WILDLIFE AND PLANTS

Birds

bald eagle, 15, 221 common nighthawk, 34, 35 prairie chicken, 41 red-tailed hawk, 16, 42, 173, 225 ring-necked pheasant, 112, 162 Swainson's hawk, 43, 173 turkey vulture, 10, 257 upland sandpiper, 34 western kingbird, 103 western meadowlark, 24, 35, 216

Flowers wildflowers, 19, 24, 59, 111, 129, 139, 150, 177, 185, 220 Mammals

bison, 24, 41, 61, 83, 107, 145, 159, 160, 163, 170, 172, 175, 183, 202, 205, 215, 216 coyote, 16, 29, 76, 208, 209 deer, 14, 16, 178, 225 dinosaurs, 105, 106

deer, 14, 16, 178, 225 dinosaurs, 105, 106 jackrabbits, 124, 150 pocket gophers, 113, 149 prairie dogs, 104, 120, 132, 180

Trees
ash, green, 61
cottonwood, 24, 61, 100, 101, 156, 215
hackberry, 61
Osage orange (hedge apple), 53, 54, 189
pine, Austrian, 92, 163
redcedar, 47, 96, 184
willow, 61, 78, 170